THE ENIGMATIC BODY

CAMBRIDGE STUDIES IN NEW ART HISTORY AND CRITICISM

This series provides a forum for studies that represent new approaches to the study of the visual arts. The works cover a range of subjects, including artists, genres, periods, themes, styles, and movements. They are distinguished by their methods of inquiry, whether interdisciplinary or related to developments in literary theory, anthropology, or social history. The series also aims to publish translations of a selection of European material that has heretofore been unavailable to an English-speaking readership.

GENERAL EDITOR: Norman Bryson, Harvard University

The
Enigmatic Body

Essays on the Arts by Jean Louis Schefer

EDITED AND TRANSLATED BY

PAUL SMITH
George Mason University

CAMBRIDGE
UNIVERSITY PRESS

Published by the Press Syndicate of the University of Cambridge
The Pitt Building, Trumpington Street, Cambridge CB2 1RP
40 West 20th Street, New York, NY 10011-4211, USA
10 Stamford Road, Oakleigh, Melbourne 3166, Australia

© Cambridge University Press 1995

First published 1995

Printed in the United States of America

Library of Congress Cataloging-in-Publication Data
Schefer, Jean Louis.
[Essays. English. Selections]
The enigmatic body : essays on the arts / by Jean Louis Schefer :
edited and translated by Paul Smith.
p. cm. – (Cambridge studies in new art history and
criticism)
Includes index.
ISBN 0-521-37204-6
1. Art criticism – France. 2. Arts, Modern. I. Smith, Paul,
1942– . II. Title. III. Series.
NX640.S34 1995
700 – dc20
94-23722
CIP

A catalog record for this book is available from the British Library.

ISBN 0-521-37204-6 Hardback

CONTENTS

ACKNOWLEDGMENTS

The first and last words of thanks are due, naturally enough, to Jean Louis Schefer himself for his cooperation (and notably for his properly enigmatic preface). This book turned out to be a project that not only was never perhaps quite to his taste, but also became protracted enough to be a torture to him. But his patience and humor were unfailing, and the warm reception he has reserved for me again and again over the years has built a valued stock of memories and a debt of gratitude and affection.

I also offer my thanks to the following people, who in their various ways have been especially important to the preparation of this volume: Stephen Bann, who started me off on the Scheferian track many years ago and who should have been spared the long wait for this product; Greg Bolton, who cooperatively and cheerfully shouldered a great deal of the research load necessary to complete the manuscript; Norman Bryson, for his patient deferral of the pleasure of riding Schefer's "waves"; Tom Conley, for his support and shared interest, and because his own translations and readings of Schefer have been vital points of reference for me. Ann Hindry, of the excellent journal *ArtStudio,* graciously offered her help with the final details of the book. I should also like to acknowledge the British Institute in Paris where I held a Quinn Fellowship in 1981, allowing me time to study Schefer's work.

Translation rights have been granted as follows. By Jean Louis Schefer for "On La Jetée" and "Preface" manuscripts; for "Les Couleurs renversées-la buée" and "Roland Barthes," both originally published in *Cahiers du Cinéma;* for selections from "L'Image, la mort, la mémoire," originally published in *Ça Cinéma; La Lumière, la proie, Le Corrège,* originally published by Editions Albatros; for "Cy Twombly: principe d'incertitude" and "Quelles sont les choses rouges?" both originally published in *ArtStudio.* By the University of Michigan Press for "The Plague," an excerpt from *Le Déluge, la peste, Paolo Uccello,* originally published by Editions Galilée. By Editions Flammarion for "Sur l'objet de la figuration," "Thanatographie-skiagraphie," and "Celui qui écrit," all first pub-

lished in *Espèce de chose mélancolie*. By *Wide Angle* for translations from *L'Homme ordinaire du cinéma* (published in French by Gallimard), which originally appeared in that journal under the title "Schefer on Cinema."

The editor and the publisher have made conscientious efforts to obtain all translation rights and permissions for photographic reproductions; in the case of any oversights or errors, they will be happy to make necessary acknowledgments.

INTRODUCTION
Paul Smith

Jean Louis Schefer's work, which now consists of more than ten books and scores of essays, has been appearing in French over the past twenty-five years without attracting a great deal of attention in the anglophone world; indeed, prior to the present collection, scarcely any of it had been translated into English. The first design of this book is simply to remedy that situation and to introduce Schefer's writing by way of a selection ranging from some of his earliest work to his most recent. This is, then, a chronologically organized selection, and it is the chronology which perhaps provides the most secure thread to what is in many respects a heterogeneous body of work. It deals with (or perhaps better, approaches) a varied collection of painting and kinds of painting, as well as the cinema, literature, philosophy, theology, and theory. At the same time, each essay approaches its object with a different task in view, and I attempt to explain the nature of those tasks in the short introductions I have provided for each chapter of this collection. Even though the heterogeneity of the work is quite marked, this collection does try to sketch out what Schefer calls (in a way that recalls Paul Valéry) an intellectual biography. What is important to Schefer in writing these texts is not so much the particular objects about which he writes, but rather the registration of the very complexity, even instability, of his encounters with them.

The series of encounters represented here is, in my view, held together by a focus upon a particular fantasy, a fantasy of something that Schefer proposes is in fact absent from the objects viewed or read – that is, what I have called an enigmatic body. The enigmatic body can be considered a fantasy of Schefer's reading. It is the construct that emerges from the encounter between object and subject, or between a painting and its viewing, a text and its reading. It is, finally, an ideological notion, in that it marks a resistance to the demands of both the object and the codified ways of interpreting. In other words, while the enigmatic body depends in a sense upon the force of the representation at hand and on the habits of interpretation that have been safeguarded for such representations, it is the product

of a resistance to both. Or, to put it yet another way, the enigmatic body is what will not or cannot be accounted for by our legitimated systems of representation or our rationalized procedures of interpretation: the enigmatic body is what is elided or missing, precisely, from those systems and procedures. One might say that it constitutes the unrepresentable and that the impossible task Schefer has set himself is to represent the unrepresentable, to make visible in writing what is invisible in the encounter with the object.

So the idea of the enigmatic body becomes what is probably the privileged trope by means of which Schefer's resistance to what he calls the doxical pressures of representation and interpretation are consistently played out. This enigmatic, *para*doxical body, then, is for him always present as a pressure on the doxical, juridical body. Or else, the enigmatic always remains to be discovered in its relation to the dogmatic. So in that sense Schefer sees his task not as the undertaking of endless hermeneutic analyses of his object (which would always be to submit to the doxa and produce a dogmatic view of the object), but as the solicitation of the object for what it hides, or for its enigma. For him, the enigma consists in that part of ourselves and our histories that has been disinherited in the attempt to represent, rationalize, and regulate. In relation to the doxical body, then, and against the forms of rationality in which it lives on the everyday level, Schefer attempts to construe what he calls the "unknown center of ourselves."

Schefer's rejection of the formulated rationality of interpretative procedures derives from his sense that these are insufficient to register either the historical or the autobiographical aspects of our encounter with the text or image. His perspective may be construed from the way he prefaces a book of essays, *Espèce de chose mélancolie* (1979a). He begins with the remark that his writing is intended to militate against "the image of the good intellectual": "So there's something I don't like. The space, for example, where every intellectual is called upon to interpret the world endlessly . . . to impose the traits of rationality upon the image of the world. . . . So the image of the good intellectual (the one who attaches his writing to a certain kind of immobile world, to the sleep of the species) is uninhabitable so far as I'm concerned."

Schefer's writing, then, cannot constitute a conventional hermeneutical or scholarly project. Yet it is the case that his writing did begin to appear in one of the privileged arenas of contemporary theoretical discourses. That is, the first essay collected here, "Spilt Color/ Blur" (1970c), along with his first book, *Scénographie d'un tableau* (1969), both derived from his collaboration with the group who gathered around the journal *Tel Quel* in the 1960s (writers like Kristeva, Sollers, Barthes, and Derrida whose work marks the transition between structuralism and poststructuralism, and also an increas-

ingly severe departure from the possibilities of Marxist and feminist thinking). "Spilt Color/Blur" explores the codes of painting as system, but in a way that most importantly tries to account for the neglect of color within perspectival systems and within the theory of painting; thus it is an article that, while it is in dialogue with Panofsky and with structuralism, and indeed with the whole history of art theory, already gives a hint of Schefer's dissatisfaction with conventional modes of pictorial and semiological analysis.

In the early 1970s such work already seemed a unique intervention into art theory by dint of its attempt to free critical interpretation from what Schefer then saw as inhibitive traditional methodologies. Yet, despite the successes of these early analyses, Schefer soon abandoned this semiological approach, which he had begun to think of as a merely pseudoscientific pretension. Like his friend and mentor Roland Barthes, he began to lose faith in the project of producing a generalizing and generalizable reading schema (a mathesis) by way of investigation of the system of the text (a semiotic). Like Barthes, Schefer began to recognize the insufficiency of this project and started to write, as Barthes put it, "à découvert" – on the hunt for something but also, as it were, un-covered, without the intellectual protection of presignified methodologies and schemas, and without the goal of producing a universal truth.[1]

In that regard, even in *Scénographie* one can already discern the outline of one of the principal aims of much of Schefer's subsequent work. There he suggests that part of the work to be done is that of "reintroducing the object into one's text, that is, into our history" (1969: 171). Thus, between *Scénographie* and later work Schefer appears to be working out how to do that, how to rearticulate the relation between the text that is the painting and the text that is the writing. This project appears to have involved a shift away from the strict issue of figuration as system, and toward a more flexible sense of figuration as a trope which must be elaborated and made visible within the writer's text. It is a trope that has crucial elements of the word *history* written within it. History, first, in the sense that it implies a historical sense and understanding of the ideological and juridical effects of figurative demands and intellectual schemes of rationality. But history, too, in that it pulls the writer toward a sense of the history of the self, the viewing subject – this is where Schefer's project of the intellectual autobiography perhaps begins in earnest, and where the effort to delineate the enigmatic body that is missing from painting but equally engaged by it has its immediate roots.

Some of the groundwork for such an "autobiographical" project is undertaken in a series of writings that are not directly represented in this volume – Schefer's work on Augustine and on Vico. What is offered here are the traces and sketches of that work, particularly "On the Object of Figuration," "Thanatography/Skiagraphy," and

the excerpt from the book on Uccello, *Le Déluge, la peste, Paolo Uc-cello*. These texts, all in their way, foreground the specificity of the body, and particularly at the point where it is divided (in a skiagraphy) between the sensible and the intelligible in early Christian theology (Schefer's "thanatography"). *L'Invention du corps chrétien*, on Augustine and the early thought of Christendom, appeared six years after *Scénographie* and maps the theoretical and historical ground on which his work built thereafter. Investigating the tension between paganism and early Christianity, especially in relation to the practices of painting and writing, Schefer discovers the beginnings of the problematic of figuration in the cultures of Christianity, or of the representation and conception of the body in our cultures. That is, the book delineates these relationships at their moment of formation during what Schefer sees as the beginning of Christian culture's theoretical consolidation in the work of Saint Augustine and traces the construction of a division in the subject between, on the one hand, the actually existing body and, on the other hand, the idealized moral subject of institutionalized Christianity. As Schefer himself puts it, the book is "a reading of Augustine – a very autobiographical one (I was very heavily influenced by the *Confessions*). The point at the time was the relation between *De Trinitate* and the *Confessions*: the Trinity gives theoretical form – anthropological – trinitarian, thought about time – to the existential aporias posited in the *Confessions*" (private communication, August 1993).

According to Schefer, Augustine's thought institutes a moral division in the subject's perception of itself that is later played out across the art and writing of the Renaissance. Indeed, as he suggests in "The Plague" (Chapter 4), this tension not only constitutes a whole drama for the Renaissance but informs the relation of Western thought to drama itself (that is, to the theater). Schefer's later work will itself replay and reevaluate this division across a number of other cultural texts and practices. Much of this is evident in his work on Vico in *Espèce* where Vico's history and his "new science" are seen as privileged moments in a resistant registration of Christianity's division of the body across the moral and juridical fields. If Vico is important for Schefer at the theoretical level, it is in Uccello that Schefer sees the emergence of the most provocative explorations of this drama in art. (Uccello's important place for Schefer is reflected in the return to him in "What Are Red Things?" [1990c].) But it is a drama that Schefer investigates also in later texts as various as Freud's writing on the paranoiac Schreber, or Chris Marker's film *La Jetée* (Chapter 9). In the present volume, the parameters of this division are perhaps most beautifully set out in "Thanatography/Skiagraphy" (Chapter 3); pass through Schefer's texts on the cinema (Chapters 8 and 9), where questions of the body's memory are foregrounded;[2] and carry on into Schefer's encounter with Cy Twombly's drawing and paint-

ing (Chapter 10), where the division is cast in terms of a "childish knowledge" or memory that resists rational science and legitimated representational strategies in art.

To reduce crudely, then, what Schefer spends several books meticulously demonstrating and enacting, the concerns sketched out here – the figuration of the body, the subject's experience and memory, the moral and juridical (or ideological) pressure exerted on the body by Western traditions of thought, and the particular historical and artistic location of contradictions between all these – are often worked out as questions of time and the subject's memory, and are discovered and continually rediscovered as relations between the subject and painting, cinema, writing, or lived experience itself. The selections here are intended to represent Schefer's elaboration of such relations and to demonstrate how his analyses constitute an ongoing attempt to construct a writing that will figure the contradictions between representations and the subject's processes of consciousness and interpretation. The privileged figure of those contradictions, or the figure he most often wants to make visible, is this enigmatic body (or what he variously calls "an internal being" or a "paradoxical body"), which, he says, constitutes "what is missing" from our encounters with art objects and writing: time and memory separate us from any realizable figuration of ourselves. This separation is the condition of possibility for the residue – the repressed, or even the trace, as it might be described in other discursive regimes – of the "internal body."

So Schefer wants to propose that representation always figures not so much its ostensible referents but rather this "unknown center of ourselves," a fantasy of the experience of the body which has no expression except through the prismatic figuration of other objects. As he puts it at the end of *La Lumière, la proie:* "the question could be asked, whether pictures are mirrors of ourselves. Of course they are mirrors, but it's not our bodies they reflect; what they reflect is what we lack."

This "enigmatic body" is not, of course, some spiritual essence or some mystical entity that Schefer is positing. Rather, it is to be understood as a trope or fantasy that gives shape to the subject's experiencing of the object. This experience is never fixed or essential, but constitutes exactly an ongoing history, a changing relation of two changing entities – the subject and the object. It is exactly this continually shifting relation or construction of what we are missing, the enigmatic body, that lends itself to Schefer's peculiar emphasis on and respect for the act of writing. This emphasis in his work is perhaps best exhibited in "Someone Writing" and "Roland Barthes" (Chapters 6 and 7), where there is what can be called an existential premium placed on this activity which is the locus for the registration of the shifting and unfinished relations of time, memory, and

the body. It is that registration that is important, more than the objects themselves which finally seem to be "only a surface upon which Schefer's commentary acts out its own representational drama, writing the crisis that it concomitantly reads in the objects it describes."[3] Hence some of the difficulty or unattainability of this work as it radically confronts at one and the same time the history both of the object (painting, cinema, writing) and of the viewing/reading subject.

In the context of such complex and unorthodox aims and effects, it is perhaps un-Scheferian to try to suggest a key to his writing. But what might be said is that, in the continual effort to represent the unfinished and relational status of texts and objects (and indeed of knowledge itself), Schefer's writing bears some comparison to the phenomenology of Maurice Merleau-Ponty. In his *Phenomenology of Perception,* Merleau-Ponty describes a view of the subject and its relation to the object such that one might imagine, to conclude, that in a certain sense Schefer's writing constitutes exactly an elaboration (a working out, even an acting out) of what Merleau-Ponty might mean when he proposes that "I am a psychological and historical structure and have received, with existence, a manner of existing, a style. . . . [T]his significant life, this certain significance of nature and history which I am, does not limit my access to the world, but on the contrary is my means of entering into communication with it. . . . Nothing determines me from outside, not because nothing acts on me, but on the contrary because I am from the start outside myself and open to the world."[4]

ALL translators necessarily make some noise about the peculiar difficulties of their projects, and I don't intend to be an exception. The qualities and affects of Schefer's thinking produce an immensely complex and distinctive prose that is fundamentally difficult to read for French speakers and still more difficult to translate into English. Here the severity of my own difficulties can be alluded to by the fact that, in referring to the translations while speaking to Schefer about them, I have always spoken of them as my "traductions," meaning to allude to my feeling of always traducing or betraying the texts even as I translated them. One sense in which I have betrayed Schefer's texts is simply by dint of the fact that I am not a "professional" translator. My view of them is more that of a friend and sympathetic reader, and much less that of a meticulous or rigorously expert conduit of the French into English. I justify the results of what might be considered this demerit by simply saying that Schefer makes sense to me only in the way that I have translated him. More fastidious translations than the ones given here would, I claim, reflect neither Schefer's intentions nor my own sense of the meaning, effect, and affect of those intentions.

One result of this attitude is that I have tried to give something of

both the voice of the English language and my own voice to what can perhaps only be described as the grain of the voice in Schefer's writing. Even when conducting the most complex interrogations, Schefer writes in a manner that is deliberately and provocatively distanced both from the logic of traditional "doxical" argumentation and from the expressivity of traditional lyricism. In his effort to convey the very undefinable nature and the vertiginous excitement of the interaction between objects and the writing subject, he often pays scant attention to orthodox French syntax and punctuation, or sometimes even grammar. He produces long, complex sentences and paragraphs, which intend to produce both an *effect* and an *affect* in the reader as much as to produce a graspable meaning – Schefer's texts are written so as to encourage the invisible and enigmatic body to *appear*. It might be said that the challenge for the translator here has been to balance the requirements of sense with the requirements of sensation, and to allow for the slow emergence of the fantasy of the Scheferian enigma.

I have had to make myself willing to alter Schefer's syntax and punctuation so that the prose can be rendered within recognizable parameters of English usage – for instance, I will often break down his longer sentences, recast the punctuation, paraphrase his ellipses, and so on. But at the same time, I want to lose as little as possible of the peculiar sensation of his work, so I have not sought absolute conformity with English conventions: sentences without verbs, for instance, often take on a kind of exclamatory role in Schefer's work, and such an effect needs to be reproduced, I think.

Another way in which I have perhaps traduced rather than translated Schefer's intentions is in regard to footnotes and references. Apart from the first and early essay translated here, "Spilt Color/ Blur," Schefer's work includes scant footnotes or references. Quotations, when they are marked at all, are usually registered by little more than the name of an author; he frequently interpolates his own words into these "quotations"; sometimes he neither uses quotation marks nor offers the name of the quoted author; every now and then he even invents quotations. I cite Schefer's own explanation for this way of working: "Generally, I hardly ever quote a text as such, but I lightly modify it in such a way as to make it 'meld' into my own text. This is much closer to the effect of memory in a text. The authors I quote are usually 'naturalized' and the origin of the quotations hidden so as to leave the syntax free" (private communication, April 1993). Yet my own process of coming to understand Schefer's work over the years has been greatly aided by following up on some of the points of reference that he does provide. Consequently, I've thought it useful to offer other readers a few more intertextual certainties than Schefer himself might condone. The reader will find here, then, that most of Schefer's "quotations" are either rendered

by standard or readily available English translations of the texts concerned, or footnoted (or both). Often the use of already existing translations has meant distorting Schefer's originals a little bit. To minimize the effect of this I have usually employed the most literal and least stylized translations I could find – for instance, the Loeb translations of Latin and Greek authors have been especially useful in that regard.

I might add here that during the preparation of this book Schefer has appeared rather amused by my requests for help in tracking down sources of quotations, even though he has not fundamentally objected to the procedure. For my own part, I have found it more than a little odd that he can always recite verbatim the quotations he uses while often claiming not to remember precisely where they came from. This is perhaps only to recognize a symptom of the ultimately tendentious nature of Schefer's enigmatic style.

This preface will, I fear, seem indiscreet – it already is, because of the need for simplicity.

Monsieur Teste at the theater (Valéry's *La Soirée avec Monsieur Teste*), or myself at the cinema. A bit of theology, a few paintings, some literature: a variegated forest of the aesthetic objects which, for a long time now, have guided my pleasure and made themselves the point of my studies. If I need to explain the way this collection is composed (and of course that's the least I can do), first of all I have to avow that I've neither the inclination nor the patience to be a scholar, and I don't have the kind of vision needed to become the author of novels. I'm a writer without a story – someone who chronicles, bit by bit, his own intellectual adventure, which is articulated across a collection of multifarious objects. It's in the capriciousness of my own choices and preferences that I've found my universe, my procedures, my way of being – my happiness.

When I was very young, I was educated by Paul Valéry (reading him, his presence around my family): novels and fiction aren't my thing – rather, objects and the construction of ideas constitute my kind of novel. I cling to the faint hope that one day one of my books will make this sheaf of apparently diverse objects cohere.

How can I really explain the mode, the style of my texts? In terms of themes? – that would be a job for the editor of this collection. These texts are one part of my own adventure. What determined that adventure isn't simply what I learned in schools, but the way I had to learn. My education was aesthetic: painters in the family, my father's watercolors, Berthe Morisot; patrons – Gabriel Thomas and Henri Rouart; a tradition of learning (orientalists), and of public service (diplomats). My whole childhood was intimidated by the great men of the family: so I had to undertake to be myself, to write an "other" French language, and that was my first aesthetic concern. This is a classic scenario for postwar children coming out of the grand bourgeoisie of the nineteenth century and from the aristocracy: a rejection of what has survived from that culture only as snobbery. Yet there was still something essential I needed to retain from

it: the idea of an heir's obligation and a sense of personal duty (which I could only translate into a "style," that is, into a particular way of relating to objects).

I hope I'll be forgiven these biographical indiscretions: they constitute, perhaps, the most profound determination of my choice of objects. Coming to France at the beginning of the nineteenth century, we gave up a name that had a much more gothic or chivalric ring to it, the name of our ancestors from eastern Prussia – my schooldays were caught up in a teutonic novel, tournaments, castles, rides across the plains of northern Europe, family legends. . . . Most importantly, I was sure that the truncating of this name had rendered me invisible – a spectator.

The thread or common argument in the texts here could be "thematic" (though only ever in an enigmatic way: which is the insistence of the fantasy of composing). At a distance, whatever thread there might be is for me autobiographical (perhaps it's like those Proustian parentheses, to be understood as digressions within a story). The autobiographical character of many of these texts is no accident: it constitutes, or endlessly proves, the limits of theoretical or philosophical abstraction, of the intellectual treatment of objects – which only "speak" to me once they've been appropriated. The only trick, the only technique that the work had to teach me is like the task of the entomologist: butterflies, insects, they have to be caught alive; to grasp onto, then, a body (of ideas, rhythms, colors . . .) without destroying it and without dissecting it. The accident is that the life that goes on in things actually resembles me.

But what's the real or more precise linkage among these texts or topics? – the constitution of a territory (is it literature, the legible, an unordered catalogue of images of life?).

It's always, in the end, necessary to interrogate oneself about the nature or the procedures of work. I remain marked, beyond the reasons I've indicated, by my reading *Monsieur Teste* (I read it as an adolescent, and for me it replaced Jules Verne; I managed to get to the end of *Five Weeks in a Balloon* because of an illness – linctus and syrups, poultices and wraps, antiseptics, those old-fashioned remedies remain the landscape of that novel). Monsieur Teste, or Valéry himself, accepting only an intellectual biography as a real novel: that's the idea in the end, looking back over these years of work, and that's also my project.

I ought to be able to suggest a way of using these texts; to explain myself, first of all, as to the diversity of these interests that don't readily add up to a single picture. And nor do they form a scholarly corpus. There's no shortage of models for my kind of intellectual or aesthetic vagabondage: Valéry, Bataille, or Barthes, to mention just the moderns; perhaps Cardinal Retz as well, composing his various writings under the rubric "forest" ("I've composed a wood") while

a fever confined him to his room. In fact, this vagabondage and this forest are part of the aesthetic calling of French literature (unless they constitute a faraway German horizon – my whole fantasy?).

I'm trying, by way of these detours, to introduce the texts in this anthology as simply as possible, to explain their mode – which is obviously that of a system of shifts of object (and includes my carelessness about quotations, about which Paul Smith asked me endless and probably despairing questions).

I hope that my English readers will forgive me these indiscretions: in my desire to illuminate at least the mode of these texts, I'm just talking about myself. I've never known how to do otherwise; and yet, when I speak of myself (or speak in my own name), I'm still only speaking about what it is that I'm looking for, rather than about what I am. This is perhaps a slightly better way of explaining the mode of my kind of literature: its objects are inconsistent, with a short and almost intermittent kind of life.

So what crosses these pages, and what might constitute their principle of legibility, is of a different order than what makes up the material of the project of novels (which proceed from the illusory notion, dressed up in bodies or figures, that our lives play out a consistent role). The essayist has other concerns; the essayist animates, or is drawn by, a different fiction; it's the idea (already Valérian) of covering the world with paper, with bits of writing. I recall a conversation with Michel de Certeau as he pointed out a window opposite his house: "Yesterday there was a man there standing on the balcony; I watched him tearing up bits of paper (letters?) and the little squares flew off over Paris. You see, I think that's all I'm doing – I'm haphazardly spreading paper all over the city."

The essayist (an indolent historian, a novelist beset by doubts about the material of fiction, a philosopher without a system) has the good fortune of a Don Juan: incessant choice and the aim of renewable pleasure. That of variation, of the turning prism of a kind of freedom; everything is clear, everything is hidden: not having a system, he reintroduces himself in the course of a work through a series of "themes." Paul Smith has read here, precisely, the theme of an "enigmatic body."

Theology, linguistics, art history, archaeology, music, moments of humor; what's the linkage among these things? – well, it isn't a theme, and it isn't in the things themselves; it resides, more than in myself (which is the most unknown thing), in the very act of gathering of what I steal and appropriate for myself and for my pleasure. The pleasure of stealing away, of appropriating for a moment, of identifying with the subject of a historical text or a distant painting, all this involves profound choices. What emerges most strongly from these years of work is what I've learned from Augustine, or what I've taken from my sympathy for Vico, "attached to his dia-

mond island" and reducing the human fact in his historical project to bits of etymological dust, to a dance of the material as it organizes itself according to the plans and structures that remain the forms of human freedom and thus become the object of his new history; but his science was always infused with the romantic suffering of the self expelled from the center of the world, reliving that primal place only by way of nostalgia and the desire to organize its history: such a history could no longer mobilize a body, it was incapable of a story; because its prism sometimes made visible the atoms (infinitesimal sounds), and sometimes the structures (the institutions, the constancy of the legislator). But Vico pushed me to know: he taught me, through his unfinished and genially ruined work, what Hegel might have taught me through antipathy. I took more to the weakness of his system than to Hegel's severity: following him I sought out all the texts of Roman law (I even bought a volume of Vossius that he might have actually used). I loved him, he opened up a part of my life that's somehow divided between the project of learning and "confessions." For I too am this dance of ideas, of affects, of choices that I can't reassemble into the shape of a character in a novel, am I not? And what might this book be that I'm waiting for, all the while working on something else? Another *Confessions of an English Opium Eater,* another *Gradiva?*

But perhaps there's another available vantage point on these texts: that is, from the point of view of a book I'm now writing on the legend of the Eucharist, where I'm beginning to be able to see the uncertainties of the story's basis coming together into bundles – the adventures of "substance" in theology, the way in which the sensory and the intelligible are cut off from each other, and the way figurational bodies are divided up by the requirements of the juridical, the dogmatic, and the economic. Is that the impulse for these essays, or just an after-the-fact rationalization?

Yet the idea of a plan (a synthesis, a system) is what's most clearly lacking in the subrogation of pleasure at the fulcrum of these texts. A little more than a vagabondage among objects, perhaps something other than the choice of new loves, it's the adventure itself, by an infinite substitution of poles of identification in the human thing; this is historical, intellectual, aesthetic. And what is its final justification? It is I who am the principle and the end of my collection: and the collection resembles me. Such would be – if it's still necessary to justify one's style before the academic bar – such could be the motto of the essayist, of this writer who accedes to fiction only by way of a knowledge rather than by novelistic conventions or inventions.

Perhaps, as I write this preface, I'm gradually forgetting the object of my commentary and beginning to invent another one, tomorrow's object? – but these are essentially the same thing. Within the text there's a labile, fleeting, polymorphous object. Like a prism, it

sometimes sends us the image of the object (a part of the world); or sometimes the image of the constructions that we try out on it (mediating bodies like what semiology was not so long ago – the project of a transparent language, open to other languages, the old dream of "general definition"); but sometimes it also sends us, by way of things, like a stain on the mirror or a fault in the paper, something of ourselves that we'd thought had been quite well disavowed. Less this sempiternal "ourselves" that's mixed in with things, less our indiscreet intellect infesting the thought of others; more a movement of arms, a way of closing the net, those always repetitious inflections by which, bit by bit, we draw things toward us as if, always, the middle of the world that we try to understand (sometimes as a fable, a rediscovered archive, sometimes as a mathematical formula) could only, more and more, be occupied by a body that's invisible but might, all the same, house our own body.

So the title given to this collection by the editor, "The Enigmatic Body," resonates with some part of this admission, this repeated idea, or this obsession.

The texts collected here represent a good number of years of work – they demonstrate less a continuity in my work than, perhaps, its fits and starts, its whole seismographic condition. Since the end of the 1960s (the time of my first book) our sensibility has changed. Principles of classification or interpretative grids (such as those of structuralism, psychoanalysis, and Marxism – an unstable trinity simultaneously guaranteeing the status of the real and the intelligible) have lost something of their power of stimulation (and inhibition). The anthropological object has got closer. It has seized us with its novelistic desire (a hunger that can't be satisfied just by formal experimentation); like some hallucinatory alarm from the eleventh century it has awoken in those of us who are incapable of novels a strange need for "confessions," for the admission of imaginary crimes. Perhaps this latest literature of guilt without religion is actually a compensation for the more or less Leibnitzian constructions that we were all trying out for a few years. As if its teaching were the lesson of the life upon which, just the same, we tried out our nets, our systems, and our seductions. As if the words of those departed were coming back to us: "What have you been doing all this time; how could you have distanced yourself so far from what you owed the duty of affection, so far from what you should have been writing?" There comes a time when this admonition is no longer the voice of our masters and teachers; we recognize it as our own. But too late: we've already changed styles, changed our lives.

I owe, to conclude, a few words of explanation about some of the specific texts collected here. "Thanatography/Skiagraphy" is the remnant of some work I did on hieroglyphs, a little trace. The text on Uccello (from *Le Déluge, la peste, Paolo Uccello*) is, in my under-

standing of the work, a passage between Augustine (my book on Augustine was written the year before) and Vico. This particular "flood" was written in August 1976, a time of drought. The mystical marriage of Saint Catherine (*Light and Its Prey*) was dedicated to another Catherine, who is now a new mother (the distorting mirror of the painting doesn't reflect anything of that story). The excerpts from the *Ordinary Man of the Cinema* (written in August 1979) are contemporaneous with that work on Correggio. *Ordinary Man* was a rather indirect response to a commission from *Cahiers du Cinéma*, which wanted a theoretical book about film: I took the opportunity, in a "Monsieur Teste at the Cinema," to begin a dissertation on time and the images that are in time, tracing the first lines of my imaginary of time. This is written only in figures – which are, without a doubt, what painting usually evokes for me, and that's also the motif of the final texts presented here. "What Are Red Things?": a bit of Aristotle and a few images from Uccello are used only to provoke the return of an image which could be the motif, the speaking center of what might be another text – a novel? not very likely! an intellectual biography? doubtless, but not only that. The origin of painting in me. Rousseau, in his *Essay on the Origin of Languages,* offers us the profound and marvelous idea of language having two origins, the one ruled by the necessity of exchange, the other arising from song, from the modulation of affects. Thus, I can imagine that the origin of what I love, in what I happen to have studied, described, analyzed, in everything that has become the material of my intellectual activity, that origin is contained, like the string at the beginning of a labyrinth, in the image given me by a childhood friend, and because of which, very early, I had to embark upon the hesitancy of interpretation.

I must put an end to this scarcely academic monologue (but I can't feign to be someone else, nor suddenly write a text other than my own) and give my warm thanks to Stephen Bann for his advice and support, and to Paul Smith for the patience, the skill, and the friendly obstinacy of his labors.

Paris, November 1993

SPILT COLOR/BLUR

During the late 1960s and early 1970s Jean Louis Schefer's research was fully involved with structuralist and poststructuralist efforts aimed at redefining the nature of traditional intellectual disciplines by way of a change in methodologies and epistemologies. In the fields of art and art history, this meant, generally speaking, dispensing with, for instance, the iconology and the reading of master codes that had been refined by Panofsky and Gombrich, and installing in their place the practical concept of the artwork as semiological system. Schefer's first book, Scénographie d'un tableau (1969), appeared at this time and in this mode, roughly coincident with important articles such as "Note sur les systèmes représentatifs" (1970a) and "L'image – le sens 'investi' " (1970b). Like "Spilt Color/Blur" each of these not only is concerned with critiquing traditional art historical methodology but also practices the new methods of reading.

"Spilt Color/Blur" has been chosen to represent this period of Schefer's writing for several reasons. First of all, it is the only writing from the period for which Schefer himself still retains much affection: what he now thinks of as the pseudoscientism of the semiological project has for a long time held little further interest for him, despite the fact that this is the genre of work for which he is often recognized. Notwithstanding Schefer's own hesitancy, it seemed important to use this essay to introduce his work, not simply because it is of this early period, nor because it represents a strand of his writing which became quite influential; but rather more because the essay can be considered as a kind of foundation stone for much of the rest of the work translated in this volume. Equally important, it contains and deploys a number of the insights that semiological work was able to generate and can thus can give the reader an opportunity to assess the value of such work, which should perhaps not be so summarily dismissed as Schefer would seem to want it to be.

The sense and import of the semiological approach for Schefer's work is primarily the task of Scénographie to introduce. The basic gesture of that book is a semiological analysis of Pierre Bordone's painting, A Game of Chess, and its gambit is the structural description and designa-

"Les Couleurs renversées/la buée," Cahiers du Cinéma (1971), 230.

tion of the picture's elements into a set of binary oppositions. So, for instance, the painting is structured by the black-and-white oppositions of a chessboard; it organizes the similar patterns of a chessboard and a marbled floor; it distributes its background between architectural and natural elements; it depicts two players and two games (a chess game and a card game); and so on. Schefer's elaboration of these binaries is complex but is put to the use of producing a set of almost Barthesian codes for reading the picture.

Part of the point here is to counter the Panofskian use of code which, Schefer suggests, tends to delimit reading and interpretation to the operation of a single overarching code that will eventually "explain" the picture on the basis of internal organization and thus reduce it to an illustration of that master code. What Schefer is interested in is, in a sense, the opposite of what a Panofskian reading produces: that is, he wants to demonstrate how the elaborate interplay of binary elements actually produces a blurring or leakage of meaning in the picture. That is to say, for him the logic of the signifier in this picture is one of deferral, whereby the elements of the binaries always, as it were, miss each other by dint of being continually taken up into other organizational structures and codes. This deferral of signification is, for Schefer, the important lesson of semiological analysis in general and of Bordone's picture in particular.

This interest in the blurring of signification will be a constant throughout Schefer's writing, in ways that we shall see. But this early semiological work also deploys a concept which will have profound effects in the course of Schefer's writing: that is, the notion of the lexie. This is in effect the intertextual field in which the visual object and its readings exist. The lexie, to paraphrase Roland Barthes, is a field of signifieds that points to a body of practices and techniques that together constitute a given system of knowledge or culture. Barthes calls this set of signifieds "a large unit of reading," which is to say that it constitutes the field of meaning into which the object can possibly be drawn by both connotation and denotation. Importantly, the notion of the lexie points to the possibility of an idiolectic field, a parole, which, "without ceasing to belong to a given langue," implies a degree of interpretative freedom for the reader or spectator.[1]

Schefer's work will continually take advantage of this putative freedom. For instance, he uses several other paintings to help interpret the Bordone, each acting as what he calls a "commutational moment" or switching point for the widening of the lexical field. In this way the Bordone painting comes to be located in a langue which consists of the readings that can feasibly be given of it. Part of what is made possible by this application of the concept of the lexie is the notion of what we might call a nonlinear tradition; that is, the range of intertextual reference for interpretation need not remain within a strict historical context or chronology but may import what traditional scholarship would think of as "anachronistic" elements. Equally, the idea of the lexie points to the possibility (indeed,

the inevitability) of some part of the spectator's experience being included in the reading and therefore in the picture's very field of definition. In sum, then, whereas traditional "objective" criticism of art depends upon the distance of the interpretation from the picture, Schefer attempts to make them one and the same – the work becomes *its readings.*

Like Scénographie, "Note . . ." (1970a) consists largely in a critique of the methodologies of art criticism and theory – iconology and orthodox structuralism come under particular scrutiny. But it also lays out a semiological approach to analysis, the initial move being the analysis of the visual object as system. Since "Spilt Color/Blur" depends somewhat upon Schefer's particular understanding of the system of painting and of the elements within that system, a word or two about "Note . . ." is in order here. As we have said, for Schefer a system is crossed by numerous codes, none of which will exhaust or finally account for the picture's signification. Equally, the picture and the codes themselves are historically located, but not in the sense that one can establish from that proposition a neat duality of "text" and "context," as in traditional art history. Rather, the text and its context are irrevocably marked by acts of reading, such that the codes of picture and readings, as it were, meld to become the constitutive entity, the thing being looked at. In that sense a picture is its readings.

Yet at the same time, there is an internal organization of determinations within the visual object which makes up its system. Notably, for Schefer the analysis of the total system of a picture depends upon a distinction between figuration and representation. The distinction is important because it is not only the condition of possibility for the leakage of meaning, but also allows the analysis in "Spilt Color/Blur" of color as a kind of excrescence – or even a kind of embarrassment – to the systematization of classical painting. Schefer schematically expresses the relationship between figurative and representational systems by the formula $S1/Sx$. The representational system or the system of the space in the picture is called Sx, whereas $S1$ refers to the figurative specification of those spaces or the filling of space with objects. Sx aims at the production of a unity, a unified field, and Schefer tracks this down in Leonardo da Vinci's establishment of grounds for the science of perspective. On the other side, $S1$ is its own signifying economy, attached to objects and their meanings which the system Sx would necessarily tend to delimit. That is, in Schefer's theory Sx exerts a determination over the painting as a whole as it seeks unity and closure; but $S1$ exerts another determination of meaning by dint of its attachment to objects and figures and their signification. If the two systems are conceived as delimited lines exerting determination in relation to each other, the space of their properly overdetermined relationship constitutes the lexie for the picture's reading. Schefer's own schema from "Note . . ." perhaps best illustrates the relations of determination, and thence overdetermination, that exist between the systems (see accompanying illustration).

3

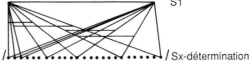

S1/Sx /I...........................I/ Sx-détermination

Schefer proposes, then, that there is, on the one hand, a representational system whose function is to organize space (that is, produce a unity of the visual field). But, on the other, hand there is also a figurative system that functions typologically *and is thus bound up with signification as such. These two systems overdetermine each other, and not to the benefit of simple or unified meaning; rather their interference leads to the blurring of signification that we have mentioned.*

These notions of the system of painting are exploited in "Spilt Color/ Blur" as a basis for understanding the function of color in classical painting. Always considered in classical painting as a mere supplement to these systems, color cannot be absorbed into the frameworks which systematize painting and attempt to unify it. Schefer demonstrates that color is, in this sense, a difficulty for classical painting. This is why it is often assigned to the function of "symbol," where its signifying power is of the crudest and most supplemental kind. (At the same time, and as we shall see in the final essay in this volume, "What Are Red Things?," this level of signifying power can turn out to produce powerful mythological belief.)

Color's subordination to the "scientific" rules of perspective that are crucial to classical painting is thus the primary concern of "Spilt Color/Blur." The essay examines the role color plays in intensifying, so to speak, the process whereby signification is lost in the image. Because of the way it is poised dialectically in the system of determinations between figuration and representation, color is both attached to and resistant to the signifying function. It remains autonomous because it is not expressive (expressivity is the function of the figure itself). Schefer's own lexie *in the demonstration of color's subordination and resistance pulls in a number of germane texts, such as Freud's work on dreams and Mallarmé's notes on theater. Here the proposition is that figuration is the domain, not just of expressivity, but of theater and dance − a notion further developed in other of the essays in this volume.*

"Spilt Color/Blur" is perhaps the least prepossessing of Schefer's work. Certainly, the reader's indulgence will be called upon by the extraordinarily complex syntax and punctuation, not to mention the semiological jargon, deployed here. At the same time, the essay offers theoretical and interpretative justification for much of the work that is to follow.

In what's conventionally called classical painting, color is the object of a characteristic sort of neglect (and we'll see later that the "convention" relies on particular denomination only because it also relies on a particular statute, a characteristic rule for what one might under-

4

stand as a representational system). This neglect and lack of consideration are practiced by both the painter and the art historian and have always been explicitly rationalized or implicitly forced into figurative equations by one or the other of them. As this is the case, color becomes something that still remains to be explained: first, in relation to representational systems; and second, because both formal and material determinations preexist it, and these arise from the representational structure that systematizes them and composes the (system) from them.

To put it another way, this lack of consideration for color – manifest in the limited and discrete application set aside for it – finds its theoretical justification in the actual denomination of the painting we so precisely call "classical." The exact character of such painting is, moreover, at the very moment we define it, to see itself actually finding a definition to absorb it: it is not theoretically constituted and is practiced only in the subordination of all the elements of such painting to a single defining class (first noting the area to which they belong formally. We know that figurative systems make their rules of constraint bear upon typological characterizations rather than upon any signifying determination. We also know, and must demonstrate once more, that the level of signifying determination originates from the representational structure that is overshadowed in all figurative systems). The immediate efficacy of this sort of painting lies, then, in its only ever approaching an object under the auspices of that object's own class, continually rejecting any notion of its species: repudiation of color is, appropriately, an act of aspection, since color is an effect that cannot be integrated into any economy (of a system) that is based upon the principle of substitution.

In the history of Western painting (the painting for which Europe has formulated all systems of representation into a definition of historical classes, beginning with events or *produced* objects – which is how painting has been conceived of since the Renaissance) color is the object of symbolic codification; starting with Byzantine art, and then at the start of this century becoming the object of a theory for Chevreul; in between those two moments codification shifts from color toward figure in such a way that, although the two terms remain in opposition, we see a decodification of figure (of perspective) in favor of color, and the culminating point of this was, clearly, the eighteenth century.

This has meant that, under the constitution of a body of formal definitions, all that has been produced (in the practice of perceptual discernment) is the repression of color by the characteristic *outline* of such practice: that is both the necessary effect and the subsidiary aim of the practice.

So we must recognize that this marks the Renaissance as the limit outside of which (and exactly "outside," if the Renaissance may be

characterized as the time of a categorical obliteration of all practice)[2] painting can become a practice of modernity. For in fact, as we shall see in Leonardo, at that time color could only be thought of as a predicate because: (1) color theory was subordinate to perspectival thought; (2) perspectival thought is bound up with causality (by the intermediary of optical rays, all images are of their own source); and, finally (3) in this system perspective (optical causality), with its explicit empirical foundation, is in fact nothing less than the image of some final cause, or part of an equation (eye–sun–god) whose terms may be combined in pairs (where in fact the binary relations that hold will exhaust all the relations, because any third term is excluded as being either product or condition: thus Leonardo's induction of material cause is both limited and enabled by the deduction of a divine cause which can circumscribe the whole field). From this third condition, the foundation of the Copernican landscape, Leonardo forges the opening declaration of his work; an image is always just the third part of an analogical equation that lays bare the path of a cause (right up to the sketchwork) whose figure is at once its distinguishing mark and its most radical loss. Here it is understood that all causality is reversible, so that the eye rebounding and returning (that is, in accordance with a specular definition) reassembles all those lost causes for the sake of the subject, itself: this is done by the delegation of a cause (god) of which the eye is furthermore the image.

So there is an absolute necessity in the subordination of color to figure (the form of a repression). We see once more that the infinity of a code for color (susceptible of giving account of pictorial productivity without resorting to systematic reduction) becomes conceivable only when Leonardo's theory (in which color is never a proper object but just one part of the system of definition) is integrally inverted. Color's function in Leonardo is purely auxiliary, a distinguishing function that helps the representational structure in its implicitness; it's both the overdetermining and complementary structure of the figurative system (and never manages to free itself of it); it's the depression beyond which signification cannot happen – indeed, it's the structure within which an *operation* is produced as a formal and material system of foregrounding (of the picture, of course) and the production of a signifier takes place (as far as that can happen) and the articulation and production of such can take place inside a representational system (this happens analogically: insofar as a denotated plan is not precisely known in advance of the structure that will determine it (1) in a categorical way or (2) in the terms that are never those of its species. There's never any specificity given to the signifier, or in a representational system the specificity of a given particular cannot spring straight from its signifier – that's a fundamental rule of representational systems – because anything that could constitute the object of some sort of phonematic analysis pre-

cisely cannot be articulated (1) in painting and (2) figuratively in a representational system, or cannot be its categorical product).

It is important, then, to see first that figurative painting is incapable of identifying its own production with the production of the signifier, since the signifier is entirely predetermined – indeed, overdetermined – by the implicitness of a system of reading which excludes the production of specificity from its product, and this exclusion is then the payee for the object of representation; and second, that painting in the quattrocento and cinquecento thus eliminates what might at first appear to be no more than a surplus of the signifier (matter, color, gesture). All this, elaborated to try to establish a pure condition for representation, sets out all the possible transgressions of the principles of figuration, and in so doing determines infractions against representation that always employs another aspect of the signifier. In this context the signifying *function* is first of all a property of figure.

Nonetheless, color – and this is the fundamental level of its resistance to definition, in that it is never the proper subject, never accedes to the signifier, and is thus continuously repressed so that it becomes a mere attribute – color escapes definition and doubles back under the species of the subject itself, painting. It is important to see that this change, too, is marked in Leonardo: color is what is attributed to things, but things are distinguished by means of color: this double distinguishing function can be applied only to color because it's primarily a function of a way of seeing whose terms are reversible: that is, in a formulation of the world which is specular. Due to this very disregard of color's specificity, the history of painting has included this productive paradox: that color has retained an absolute autonomy because, once again, it's not included in Renaissance definitions (because it never constitutes the object to be defined) except as a distinctive quality; color's *effect* is not expressive except in that it expresses what it is not (precisely because it is caught inside a system of essential definitions): color, then, is a variable in the figurative equation.

Consequently, due to [color's] subordination in this type of painting wherein we have seen the role played by the term "classical" (the founding return, the retroactive effect of a predicate, the effect of total delimitation in this sort of painting whose theoretical formulations assume – with Alberti and Leonardo – that its definition does not transgress the laws that the painting imposes upon itself: it has no frames, its only limit being its reverse side), consequently what's classical about it is that, treated under the heading of its class (Ripa: "an image is a definition," so that a well-made image is a well-made definition), it is the means by which the painted picture can inscribe itself in the taxonomic picture; and, inversely: figure, Ripa says, is governed by the order of predicables, and so is susceptible of analysis

7

in terms which are the terms of its categorical borrowings. Similarly, Leonardo da Vinci: "Perspective comes to our aid where judgment fails in things that diminish" (2:372).[3] In this equation, too, where judgment has perception as its petitioner in the same way as the image petitions for definition (where we can show that judgment always ends up relating to figure because perception is itself, according to the equation, a definition), we can grasp that the principal prohibition in classical painting relates to something that is not an element of definition in representation nor a constitutive term of representational structure; rather, it relates to the thing that is treated as a distinctive element: that is, to color – not figure, because figure, where art theory and art history have focused their problematic over the signifier, is still a definable term in the characteristic substitutional movement of the loss of the signifier in representational systems.

If color for its part *resists* (that is to say, if it can't be formalized in the figurative equation except as a variable that *cannot represent*) and if the linguistic formalization of a representational system takes it merely for what it is in the figurative system (a distinctive level which has autonomy only when opposing, or superimposing upon, figure), that is precisely because it's repressed there: if it's present as such, color becomes the waste product in any transformatory operation based upon the figurative structure (in order to realize what representation *clings to,* since all representation works on the actual consistency of the elements it displaces). In other words, color can resist this substitutive movement so long as it is seen as an attribute of figure: figure is charged with reducing color to a principally distinguishing function (such a delimitation occurred in the Renaissance under the influence of Aristotle's *Poetics:* as *subject* is to drama [the subject *of* the drama], so *drawing* is to painting); so the predication of color is thus the very form of its repression.

And when Leonardo da Vinci insists on the necessity of finding colors that are real or natural, it is out of a concern for the truth of perception or the fidelity of images (an image is only ever faithful to its cause, never to its own appearance: thus it can be referred back to a better construction): color is then an auxiliary for perceptual judgment – "Darkness steeps everything with its hue, and the more an object is divided from darkness the more it shows its true and natural color" (2:379). This means that real or natural color exists only as a property of the object, that the "hue" of darkness, insofar as it can "steep" things, is not a pertinent element in (perceptual) judgment; and so it is neither real nor natural, because it inverts the order of subject and predicate which is the very formula of the naturalistic convention, and remains, in the Aristotle reference, the very formula of the *subject;* what's *unthinkable* in all this is that objects could be seen as attributes or accidents of pure color (which Leonardo only ever refers to as a *fog*): that is, it's unthinkable that these

8

things could be produced within the picture. Here again, the same may be said of color as has always been said elsewhere of nature (in that a picture never understands it except as a term of opposition in the rhetorical system upon which it is constructed and in which all articulations are merely references back to the system that is both the origin and the product of the pairs of oppositions that implicitly refer back to it): the problem of Renaissance definition is absorbed by the perspectival problem corresponding to an imperative on the predicability of figure: compare again "Perspective *comes to our aid* where judgment fails. . . ." When, from being the subject of an utterance, a term becomes the predicate, then there is repression, or it is present only as a repressed term.

This goes beyond the problem of natural and conventional color (and generally beyond Lessing's whole problematic about the motivation of pictorial "signs"); Leonardo's realist alibi: displacement (from the apparent to the natural) only ever operates, within convention, from the moment when color is turned into an attribute; or else, the problem of real and natural color doesn't present itself and *cannot be formulated* except from within its distinguishing function, that is, from inside a space governed by the imperative problem of definition (or in other words, within a single aspect of perspectival figuration). Color is absolutely efficacious in this its distinguishing role, which characteristically eliminates it from the representational structure, and, conjointly, from the problem of the signifier insofar as it can even be formulated here; color – by virtue of its repression (without which, once again, representation is impossible) – makes this clear: that the unthinkable (as described above) animating Renaissance definition (and which might be called its ideological space) is not its complement but its contrary: historically we can only add to the equation by suppressing it. This is also what we can read in Leonardo and what color itself can reveal insofar as it is only ever the exponent of a system, its petitioner; and in this system its most efficacious function – the result of the reduction we have examined – is an expressive one.

So there is another reason for the preeminence of figure in the question of the signifier: here, *space is entirely subsumed by the fiction of whatever is being represented,* and every time there is a resistance from color there is also a resistance, thus marked, to representation (in the sense that we've given that term: the total structure wherein figuration is rationalized; as the sum of the series in which the signifier of S_1 is determined). One might, moreover, note that the same applies to gesture, something that doesn't really appear in *painting* (in that a "picture" doesn't include it) except as its own productivity, never as representation; in classical space a picture exists only by virtue of the fact that there is no movement; or, more exactly, the movement figured in the painting is present only as an articulation that has

strayed from its own system: there are, literally, "figures": "signa" = statues (cf. "Reading Poussin" by Philippe Sollers, where the Poussin character is a statue, a "signum" within the rhetoric of the picture in which it is determined, and which it helps constitute).[4] So with Giotto, or Uccello's *Flood* – the rule might be as follows: *each figuration of movement is reabsorbed into what it is a priori constructed upon – a construction figure.*

So we can say that, because of the fundamentally predicative and analogically distinct function in which it is held (by the fact that it's only ever *one* of the variables within a system),[5] color – and this, I think, is its *calculated effect* – retroactively illuminates what a representational structure might exist as. Insofar as – and inasmuch as – figurative painting allows itself to be enclosed by the definition of a system of figures, color has the calculated effect of becoming its limit; or rather, in escaping it color points out the type of reduction and/or substitution that characterizes representational systems: it points out *by default* (the very default by which figurative painting holds perceptual judgment) that only commutative operations (which Hjelmslev reserves for paradigmatic relationships), or substitutional ones, are susceptible of working on representational structure where the problem of the signifier is posed only by means of an implicit logical (grammatical or linguistic) structure that might be the object of an inverse shift in its semantic and phonological levels (literally, then, each system [S_1] is absorbed by the fiction of what it is representing).[6] So we need to recall the following definition: "representation consists in the borrowing of signifiers. It is the economy of such a borrowing (and, by way of the signifiers, it is the entire body of the implicit system whose retroactive and *implied effect* is representation itself), giving off figures that are proposed as (pretended to be) analogical signifiers."[7]

In this pre-tension of the analogical sign (Lessing), a blurring of the signifier occurs under a given representational meaning: we know, too, that in the seventeenth century, in court usage, representation meant a "funerary simulacrum"; a year afterward – or at least in a ceremony not involving the dead man,[8] so that he can attend his own funeral – an empty coffin is used for absolution, and the funeral oration is delivered over it, while the signifier is really what the verse is actively concerned with. Thus, representing is not a matter of recalling *what has already been present* in flesh and blood, as a person, but of producing a displaced figure (that installs its prototype/hypostasis *elsewhere*) from something that has never been present as such, so that, preferably, it can never be there, that is to say, anywhere, except in the place where it's *said* to be: "the imaginary." This representational illusion obtains by a false repetition (the illusion is also a chain of substitutions: what is figured = what is represented =

the signified). Such a theatrical conception of representation entirely *assumes* this funerary conception and its juridical correlative.

Pertinent here is the Napoleonic statute book, section 739, which talks of "the making of the law" (law's actual fiction, but a *fiction* that makes the *law*) whose *effect* (against which painting can in fact be measured – it's the nearest thing to painting's own efficacity) is to make the representative enter court in place of, and in the same name and with the same rights as, the representee; and we might emphasize, "in the same name," since the representative takes on the "title" of the deceased only in order to assume the latter's value (to *renew* him in his value, but at the same time to take it away from him in the form of his rank and his legacy). So the legal world, too, deploys the fiction of instituting the present in the name of the past (and that renewal, authorized and announced by death itself, is by no means an assumption on the part of the representee): the past, the one who has passed away – whose representative institutes the signifying function by announcing the fact of the decease (as a substitutive term), an announcement made precisely in the form of a "predecease," that is, of an anteriority that is abolished by death and that pretends to be the very hypostasis of what it is displacing – it doesn't abolish the representee except by *in effect* instituting him in his name, by means of his decease. The pre-*deceasor* is the one who, before the representee or *anyone else* that the law tries to pass off as the signifier so as to leave his place free, has already gone, *decessus*. In light of all this we can finally see and understand (as we wouldn't be able to outside of that light) this "making of the law" whose *effect* (and this "effect" will be the cause of a further effect in the figuration of the representative) is to make the representative *enter* court in place of the representee (which implies, en bloc in this displacement, the renewal of his rights and his rank); and to understand – in the need to install an heir, to pass someone off as heir, *to pass on* a title from the dead to the living – that *the representee is not the referent but the signifier* (implicitly), that it is his own title, station, and rights that are being played with in representation – as the stake, in fact.

With regard to the function assigned to color by Renaissance theory,[9] it is possible to distinguish three functions it has, or three instances of its usage.

A Game of Chess by Paris Bordone presents us with a radically reduced case: in this picture color is a purely redundant code (and thus superfluous in both the economy of the system and of the [system]), without autonomy and, in short, a nondistinctive level of the signifier, so that we can even construct its economy without altering the *S1* system. Consequently, this is a particularly characteristic case of usage in a figurative system (in a representational structure – it is also a fortunate case, because it is entirely at the behest of our model:

so it's a borderline case as well). Nonetheless, the application of a borderline case doesn't prohibit other possible cases because, in the very act of systematizing itself, the representational structure makes all cases borderline ones by jointly implicating into the figurative system both perspective and the Aristotelian definition. The interest of this particular picture is that the characterizing function of color, at the level of typological constraint where the functions of the picture's elements may be read, should have already been completely suppressed by the metonymic import of the chessboard, the synecdoche of black and white which rules the sequences and functions of the picture and which, for that reason, occupies the entire pictorial surface (also defining it as a purely tactile surface by balancing the picture around the chessboard). This, strangely enough, means that the black and the white are not colors in the Leonardian sense.

> Since white is not a color but is capable of becoming the recipient of every color,[10] when *a white object* is seen in the open air all *its shadows* are blue; and this comes about in accordance with the fourth proposition, which says that the surface of every opaque body partakes of the color of surrounding objects. . . .

(If we think of it in itself as whiteness, white positions the opacity of a body, as it were, as an insight into its own essence; it is defined by its contours, and is both a white object and the shadow of a white object; if its only properties are accidental ones, then its definition will be always accidental).

> As therefore this white object is deprived of the light of the sun by the interposition of some object which comes between the sun and it, all that portion of it which is exposed to the sun and the atmosphere continues to partake of the color of the sun and the atmosphere, and that part which is not exposed to the sun remains in shadow and partakes only of the color of the atmosphere. And if this white object should neither reflect the green of the fields which stretch out to the horizon nor yet face the brightness of the horizon itself, it would undoubtedly appear of such simple color as the atmosphere showed itself to be. (2:296–7)

In the theater of definition, black and white are the *villains,* because they steal; and they aren't natural colors because they're pure fictions of nature – in the same way as the fog which hinders judgment is a fiction of nature. And as for black: "the color which *least* resembles black will be the one which at a great distance will *most* retain its natural color" (2:297); finally, and above all:

> An object which is represented in white and black will appear in more pronounced relief than any other: and therefore I would remind you, O painter, that you should *clothe* your figures in *as bright colors as you can* [that is, without *reaching* white], for if you make them *dark in color* [that

is, without naming black, which would make them disappear], they will be only in slight relief and be very little visible at a distance. (2:258)

So these are not colors, by virtue of the fact that they are not attributes; in the picture we're looking at they are indices of functions, that is, with reference to the chessboard, the *anticipated result of possible operations within the picture*. And, from another point of view, they're not colors because their double grid of squares (functional and perspectival) demands the suppression of color, but across *that* suppression (this time in a very Leonardian way) demands the suppression of what color is the attribute of – that is, of things which will not enter into the picture as functions. That is why the collusion between what is not, by its very nature, either perspectival or functional (that is, the probable object of a transformation) consigns the periphery of the picture to the figuration of a landscape. So it is possible, starting with this picture and the preceding definitions, to sum up their product in the following schema:

1. color $(-)$
2. $(+)$ color
3. $(-)$ color

1. What is proposed as the exponent of color is the possibility of excluding figure from the S_1 system – obviously, the destruction of the whole /system/ S_x – that presupposes (so that the operation makes sense/can have semiotic efficacity, or can turn to elucidating what the signifier is) the preliminary abandonment or the nonverifiability of a perspectival system (which is unambiguously the case starting with Cézanne, impressionism, fauvism). The operation is then negative or tautological and produces what's supposed to be confirmed about the status of the object, namely, that a suppression of the conditions of representation is staked on color. (Which is then only a necessary condition, because it's a sufficient condition only in the Renaissance system. Beyond this entrenched "conditional" opposition, it's possible to say that the eighteenth century can be characterized by its having disinvested in figure in favor of color, or rather in a radical transformation of the general economy of the whole system, insofar as the quantum invested in color displaces and tends continually to annul the quantum in implicitness, the system of figures. The eighteenth century, with both Goya and Watteau, defines, one might say, ever more pertinent degrees of approximation to this formula.)

2. and 3. These two formulae denote a complementarity of figure and color. They place themselves simultaneously in a textual space formalized during the Renaissance, which has only ever been treated as being characterized within itself by the possibility of making text

and image – because of their complementarity – enter one equation together, and, wherever it's still needed (as it doesn't *have to* alter form), of integrating color, thus articulating an entire system of subordination, as follows: "text (figure [color]), or (text) (figure [color])." (Color is always tied to figure and so is never able to determine a text, contrary to what happens with the first formula.) It remains understood (but also presupposed by the dominant logic of the representational model) that color here is something from which we can construct an economy, since the figurative system is articulated only *toward* the terms of representational structure (and it's finally to these terms that commentary relegates it, as in Panofsky: in Panofsky, where everything is interpretation, it's a question of *reading substitutable terms* as being at once both the system of the image, the apparatus, and the "lure" of its representation – it's a *description* of substitution which is unaware of the system or the structure that it is (re)producing. And for the reason, Hjelmslev says, that the substitution that it would be necessary to formulate as a semiotic operation is always present, endlessly caught up as a term – that is, as a result – of the operation. And this comes directly out of Panofsky's production of a miraged structure: any description by substitution is one of a representation in the language that formulates the supposed *descriptum*; it is in the describing element that this miraged structure is constituted, which is to say – and I'm weighing my words – it is an effect of refraction in the describing element where an illusion (*repraesentamen*) is produced of the *descriptum* thus produced *within* the describing element by postulating a structural identity.

Yet a parity of structure seems impossible to reach – and the same can also be said of the determination of a structure, except in the displacement of the most obviously structural terms, in that such terms are never given outside the space where reading produces them. So structure is not the point of convergence and resistance for a series of readings that could produce it as *their own aporia;* indeed, it's more a question of something that's endlessly displaced, not the alternative between variable and invariable (or else, between consistent and inconsistent) as in Merleau-Ponty's arithmetic, but the *variability* (and the diagram of that variability) in any object produced within the general economy of the system. This is for the opposite reason, in which Panofsky's supposed structuralism meets others, that is to say, meets all those systems which are instituted – legally – upon the *utopia* of the object they produce (see Lévi-Strauss: "the history [of structuralism] *consists in* its method" – its only object is what its method can produce).[11]

We have yet to point out that this epoch of representation supposing the conditioning of color is the one in which Panofsky's method is located and justified; here we see a classic case of the collusion between a field of study and the structure of the objects in its field:

Panofsky's method (summed up in his four levels of interpretation)[12] is characterized by the possibility of commutating objects that are interior to the very field they define. This implies: (1) no object can be properly susceptible of being a product inside this same field since it defines the field; (2) what is overshadowed in the field of history is its subject; (3) it can then have no signifier other than figures; (4) all the figures of the general system are referred to symbolic universals; (5) Panofsky's interpretative levels are the "spilt" structure of his history – this is the only possible type of historical formalization in his system, produced by default; so this very method is situated within a representational structure *which defines it* because it is taken for a figurative structure: "speculum rerum" = a magnet for the genitive that renews only the conditions of textual closure, but never – in its linear historic conception – poses the problem of the signifier (except by analogizing meaning, sign, and language) as something which can only be formulated if we start from overdetermination; and the latter, we must point out again, is what determines the signifier. And the insistence of the signifier is thus marked insofar as it's never given in a representational system but is marked by displacement (which is Freud's *Verschiebung*) and by such obliteration that it has to be constructed out of the signifieds in which it is represented.

Verschiebung provokes the following parenthetical remarks.

Displacement, Freud's lateral sliding; lateral displacement in the system of volte-face on the Mallarméan stage: displacement names the *Verschiebung:* permitting us to read, in order to construct a model of it, the structure of representation, S_1 in S x-determination. There is a scenography in this: from where I see the stage in all its perspective, the empty side where theater is written – the writing of a scene. We can join together the texts of Mallarmé and Freud.

Mallarmé: *Theater Sketches: en tè skèné gegrammaton* – toward a scenography.[13]

"A spiritual acrobatics, demanding the pursuit of the least scriptural intention, exists – but invisibly – in pure *movement* and in silence *displaced* by the trapeze. . . .

The theater alters those arts that it takes up into a special or literary point of view . . . if one could not recognize in Ballet the name Dance, which is, if you like, *hieroglyphic*."[14]

Freud: *The Interpretation of Dreams,* in the chapter translated into French as "Prise en considération de la figurabilité"[15] (a rendering that doesn't precisely explain what representability, "Darstellbarkeit," by this movement, might actually be; it doesn't translate "Rucksicht" – retrospective, retrospection with retroactive effect, determining – and considers figurability only under the aspect of an effect in which it measures its derivation [never primary, never a given]: measures its *own* derivation). Freud, when taking account of displacement in effect: "The direction taken by the displacement usu-

ally results in a colorless and abstract expression in the dream-thought. . . ."[16]

> [In German, *farblose* – without color, never having had color. So it is *Sx* that's discolored, and *S1* is colored, but this is also in relation to the *S1/ Sx* presupposition that color only appears as a memory of the discolored, never as *color:* for the very reason that the West, with no cosmogonies of its own, is ignorant of the cosmic function of color – the West can perceive color but (contrary to India, China, Africa, South America, etc.) cannot *think in color;* and for another reason, that because of its closed economy the figurative system can *never introduce elements that it's not capable of engendering by itself.* Plato, Aristotle, Malebranche . . . all engender color for perception, that is to say, in the general economy of a "reasonable" cost to the subject – which guarantees the subject/the world/ philosophy.]

Freud again: ". . . an abstract and colorless expression in the dream-thought being exchanged for a pictorial and concrete one." For, "A thing that is pictorial [*das Bildliche*] is, from the point of view of a dream, a thing that is capable of being represented: it can be introduced into a *situation*"[17] (or onto a scene, which is then, as a situation, already no different from a stage, scenic). "A dream-thought is unusable so long as it is expressed in an abstract form; but when once it has been transformed into pictorial language [*in eine bildliche Sprache umgeformt:* is transformed into the image that its language *actually means*], contrasts and identifications of the kind which the dream-work requires, and which it creates if they are not already present, can be established more easily than before between the new form of expression and the remainder of the material underlying the dream . . . it is fair to say that the productions of the dream-work, which, it must be remembered, are not made with the intention of being understood, present no greater difficulties to their translators than do *the ancient hieroglyphic scripts* to those who seek to read them."

Mallarmé and Freud relying on the theatrical stage, the dream stage (figuration, which for Freud has recourse to *ancient* hieroglyphs, borrows from the past the character which marks it), both relying on the sybilline *character* of what cannot be written – sybilline – unless it's because it's only, by these displacements, the writing of the theater. "A lady of my acquaintance had the following dream: She was at the Opera. A Wagner opera was being performed. . . . High up at the top was the conductor. . . . He kept running round the railing. . . ."

Theater-writing, that is to say a scenography that includes in its text its own choreography, the sum of displacements that writing makes of it (the theater). Vitruvius:

> The kinds of the arrangement [which in Greek are called *ideae*] are these: ichnography (plan); orthography (elevation); scenography (perspective).

Ichnography demands the competent use of compass [*circinus*] and rule; by these, plans are laid out upon the sites provided. Orthography, however, is the vertical image [*erecta imago*] of the front, and a figure slightly tinted to show the lines of the future work [*rationibus operis futuri*].[18]

So, in this picture (*picta figura*), nothing other than the execution of the elevated image (*erecta*) in its projected proportions. "Scenography[19] also is the shading (*adumbratio*) of the front and the retreating sides, and the correspondence of all lines to the vanishing point, which is the center of a circle [*ad circini centrum*])." The total design is the system of these three "graphies" (ichno–ortho–sceno): the reduced model, the erection of the future work in its image, their common theater in the play of the compass – *circinus*.

Traced out by the compass: "ad circinum" – from the Greek *kirkinos*, compass; *kirkos*, the wheeling falcon; *Kirke*, Circe the enchantress. *Circellé:* adj., decorated with small colored circles; *circellus*, dim. of circus; *circiné*, adj., rounded on its own axis in the manner of a cross; *circinus*, circle; circus, the theatrical stage; the compass – *the circus*.

Literally: writing of the stage; but "divested of all the scribe's apparatus" (Mallarmé), on stage, by a lateral sliding (*Verschiebung*), onto Freud's "other scene" (*Traumdeutung*), the *hieroglyphic*. Mallarmé read into Freud (at least . . .), but it's also found in Freud: and who would doubt it? *Anyone* who, not saying it, in doubt, would make us doubt.

Verschiebung (this is the end of the parenthetical remarks): the effects of it can be measured by the fact that the signifier is always the response to its own death, thus marking its *effect* on the *other scene*.

So let's say this: *in a figurative system or in a representational structure the signifier is the displacement (understood as the index of a greater displacement) of what must be constructed in order for the system to find its specificity by recourse to what it had already expelled and which is the generality of the /system/ (and closes it).*

So we can see that the rearticulation of figurative systems onto a representational structure (which determines them so that they can exist according to how they are read), having as its corollary (its obligatory exit) and also as its condition (the opening) the constitution of a signifier from the structural conditions of its displacement, supposes a history that's not, whatever else it might be called, a history of art (linear, discursive in its suppositions about the transformability of its elements), but rather a history whose matrices can think the representational system in terms of signifying overdetermination – where the specificity of the matrices is tightly bound to the displacement of the signifier as we have characterized it (in other words, more exactly: a history from which we can construct the matrices of systems but which is not in itself representable).

To return now to the last two formulae which allow color to be

put into an equation – and which are specifically from the Renaissance: they now present us with an alternative.

What is set up as the exponent of the system of figures this time is color, charged with a positive and a negative function: color's deployment is fictionally situated between those two poles: they act here, marked as they are, as two modes of attribution or two values of readability. It must be noted that the attribution of a zero function, which is a distinct tendency in a system that subordinates color, is a return to simple material suppression: this level, which is never effectively realized, remains pertinent for a moment and is necessary to the reading of a figurative system if – and insofar as – we map its articulation onto a representational structure; in other words, it must be noted that the formula (color O) corresponds to a moment in our semiotic operation without being, in this precise case, an index of reduction. Therein lies the semiotic justification of a type of painting theoretically constituted upon a system of utterance: that moment – when the figurative structure is *recognized* – is predetermined by the total representational structure inasmuch as it is situated inside the structure of a displacement (its system, its "economy") that color, very ambiguously, resists.

So, our three formulae:

1. color $(-)$;
2. $(+)$ color;
3. $(-)$ color.

In the first, color is able to saturate the system; in the second (Giorgione or Pontormo), it can saturate any other system but that of figure, and so it chops up sequences that cannot be substituted for those of figure; the third presents the (theoretical) case of a *purely* distinctive utilization of color, as exhibited at certain points in Leonardo's manifesto.

The manifesto for a scientific utilization of color that Leonardo offers poses several questions that will need to be reexamined. *Empirical* knowledge ("Leonardo Vinci, disciple of experience" [2:365]) of color's properties: because it is empirical, this knowledge can extend only to properties, colors, forms, distinguishability . . . which is to say that the final *subject* of the properties in Leonardian theory can never be the object since the object is still a type of property, which means a type of the predicable inside the perspectival system; this *subject* to which all the properties are related – being both what they are most concerned with and at the same time their author – is finally the general system which permits their representation, perspectival construction itself, and it is because of this that a "fiction" of nature can be retained. The fact is that perspectival construction in its generality is a priori an axiomatization of the world, and is complete only because it is constructed on an axis, a specular pivot *between* cause

and effect: "The image imprinted in a mirror partakes of the color of the said mirror" (2:298); the empirical knowledge of color's properties allows linear perspective to be double, and allows the construction of a perspective of colors: in short, it is a scale of the volumetric *effects* proper to chromatic gradation, thus helping figuration in the third dimension according to both empirical knowledge and purely analogical reasoning; so the chromatic scale is a scale of effect, and effect is always linked, to a greater or lesser extent of distinguishability, to its own excessive production in the body of figuration (the play of surface over volume): so it is susceptible of being related *on the principle* of its measurement – which is also the principle of its regulation – to all gradations of effect; *thus,* distance is a discoloration . . .

[and, parenthetically, we are witness only to the production of the "thus," as follows.

In effect, "Perspective is of such a nature that it makes what is flat appear in relief, and what is in relief appear flat" (2:371).

For, "There are three divisions of perspective as employed in painting. Of these the first relates to the diminution in the volume of opaque bodies; the second treats of the diminution and disappearance of the outlines of these opaque bodies; the third is their diminution and loss of color when at a great distance" (2:374).

Or indeed, "Perspective as it concerns Painting is divided into three chief parts, of which the first treats of the diminution in the size of bodies at different distances. The second is that which treats of the diminution in the color of these bodies. The third is the gradual loss of distinctness of the forms and outlines of these bodies at various distances" (2:376).

Thus, "Make the perspective of the colors so that it is not at variance with the size of any object, that is, that the colors lose part of their nature in proportion as the bodies at different distances suffer loss of their natural quantity" (2:380).]

. . . a discoloration related thus, by the principle of mensuration (our scale, perspectival foreshortening) to all gradations of effect which suppose the same mensuration (which makes empirical knowledge, experience's disciple, all about analogy); distance becomes discoloration: "colors los[ing] part of their nature *in proportion as* the bodies at different distances suffer loss of their natural quantity," quantities that reside in the very proportioning of the analogy of natural properties – itself no more than a gradation, a regulating of effect. Compared with all the properties of bodies (that is, compared to bodies themselves), distance generally means loss of quality, the very loss of the object. The far end of the scale, the moment of diminution and discoloration (when even the passion for line can no longer see anything "at a great distance" except the very unreason of its madness in the malignant blur that nature *breathes* – in the picture's background – as the resistance of the subject being constructed there) is

the point at which nature is produced in all her fiction, the fog that threatens form and erases colors with the whole weight of the painting itself yet to come: color, with which Chinese painters, before starting to paint, used to fill their mouths and then spit out, is *entirely* inside this very fog – the fog into which Leonardo sees line, contour, volume, color, objects, the world itself disappear – with his own analogical passion last of all – the spittle that washes away all the mouth's evil spirits, voice, utterance, breath, the storm of reason, and in this case it all goes onto the paper.

For Vitruvius the effect of depth is determined only by a system of lines corresponding among themselves according to an optical principle, color having no part in the matter except in that "what appears as ground seems to advance and recede," and so color is something different, ornamental, ochre that is worth more than silver, the silver used for dyeing in the first great clothing industry – "and therefore I would remind you, O painter, that you should clothe your figures in as bright colors as you can" (Leonardo) – to make the obligatory coloring in clothes, their paleness (*ochros*); in the gesture of putting on, taking off clothes, dressing up in or taking off color: *ochra,* yellow earth, red earth. ("What used to be the best [ochre], the Attic, is not available now, for the following reason. When the silver mines at Athens were worked, shafts were dug underground to find silver; but when a vein of ochre happened to be found, they worked it no less than silver" – Vitruvius.)[20]

For Leonardo color is no longer a resource to be found in the earth; it's a property of things;[21] it's enjoined in the service of their vision/visibility and so is subordinate to the imperative of proportional distinction in figures; it's also the change in a thing's color according to distance, which constantly renews the specular effect of perspective. So color has an essential role in this distinguishing function in which it is caught up: "at a certain distance" [where "certain" is then what can be measured by the effect of distance] what is dark becomes blue." A scientific knowledge of the "natural" properties of color (which, once again, means to Leonardo a knowledge of color itself) is thus entirely reabsorbed into the constitution of a code auxiliary to the code of figure where those properties are related to each other by the same analogy (of scale and degree) *from* science – which it allows – *to* representation. In this connection it becomes obvious that a manifesto for the scientific utilization of color is not the right one for suppressing the use of symbolic residues (as, historically, perspective is brought into a single symbolic space that's entirely codified in the ground and is thus perverted, as, for example, in the introduction of perspective into Cimabue's *Madonna della Santa Trinità,* where the symbolic codification of color – its attribution as a property of what is symbolized – plays upon the "*forced* articulation" of two spaces), because in both cases we are concerned with the same

predicative function, reabsorbing almost totally its distinctive function precisely because it *also situates it inside of the figurative system.*

So this is how problem of color has been presented historically (under the aspect we know, since the cubist and impressionist upsets) from the Renaissance onward.

With our three formulae, moreover, it's possible for /1/ to change to /2/ and /2/ to /3/, since /3/can become /2/; but it's not within the logic of the system for /1/ to become /3/. Besides, since in this transformation it's a matter of reducing the code's constituents, a transformation is possible if its inverse transformation is also possible. Unless color is valorized, it remains clear that /3/ alone can be the *equivalent* of /1/ in the general economy of the system if color animates certain elements of the picture and constitutes an autonomous code within them: in such a case we get two different systems, two texts that cannot absorb each other.

So it is necessary to subordinate color to figure, for if it "loses" the signifier (under certain conditions) it can become one by ceasing to be the object of a predication. So this is the definition of that normality (as the construction of a representational *machine* in which the signifier is only ever the factor that slides, the object of the greater displacement), a normality that for the most part is *retrospectively* posited: at the end of the Renaissance so that it can fall back upon the *whole* of the Renaissance and act as an apologia for the "perspectival science" to which all science is subordinated in both practice and theory; that is, in a specular spilling, the level of practice (painting) is the level of theory because perspective (to which all science is subordinated) is a science that has as its object only what it permits itself: namely, representation through perspectival figuration. It is a science that doesn't permit knowledge because it always *supposes* some already acquired knowledge, and any science appropriated in advance thus necessarily becomes empirical: "Those who are enamored of practice without science are like a pilot who goes into a ship without rudder or compass and never has any certainty where he is going. Practice should always be based on a sound knowledge of theory, of which perspective is the guide and gateway, and without it nothing can be done well in any kind of painting" (2:283) – this being written by "Leonardo da Vinci, experience's disciple."

So perspective is its own object: it has no application; indeed, all its objects allow us to know, *by means of the fiction of what they represent,* the structural conditions for its principles: it is not a science of things because things are never more than a term for reading this science's conditions (its displacements, by virtue of which the principle can in fact be constituted): so we can see that its interest is not in speculation about space (and Leonardo's total equation should make this clear, once again). The definition of normality starting from the representational machine is paramount insofar as color has the prop-

erty (this is a postulate that cannot be axiomatized into the system) of not representing: that is to say, it doesn't lend itself to *the same deduction as defines the status of figure:* "The reason why we enjoy seeing likenesses is that, as we look, we learn and infer what each is, for instance, 'that is so and so' " – Aristotle.[22]

Besides, we know that it is because of his transgression of this norm that Pontormo earned himself a reputation for madness: such unreason, in the restrained economy of the structure of representation, is the introduction of its inverse, its outside, in the *species* of color which is figured there in order not to represent. But Uccello and Pontormo, both stigmatized by Vasari for their characteristic excesses, are excluded from an ideological space that can only think its own norm:

> For, although these studies [of perspective] are meritorious and good in their way, yet he who is addicted to them beyond measure, wastes his time, exhausts his intellect, and weakens the force of his conceptions, insomuch that he frequently diminishes the fertility and readiness of his resources, which he renders ineffectual and sterile. . . . one so disposed will become unsocial, melancholy, and poor, as did Paolo Uccello. . . .[23]

The prison of this perspective is indefinitely substituted for production itself, from gesture, color, body, even to sex, color, *sperm:* "[His] wife, who was wont to relate that Paolo would stand the whole night through, beside his writing-table; and when entreated by herself to take rest and sleep, he would reply, 'Oh, what a delightful thing is this perspective.' "[24]

And Artaud says, in "Uccello the Hair":

> The ideal line of the hairs, inexpressibly fine and twice repeated. . . . Apart from these lines that sprout from your head like a foliation of messages, nothing remains of you but the silence and the secrecy of your fastened robe. Two or three signs in the air, where is the man who pretends to be more alive than these three signs and from whom, throughout the hours that cover him, one would think of asking more than the silence that precedes or follows them? They form the words of a black syllable in the pastures of my brain. You, Uccello, are learning to be only a line and the heightened level of a secret.[25]

We can add: perspective and color, in themselves, in their madness. Like all excess in the system ([S_1] S x-determination), as the system is made only to reabsorb them and as its coercive force relies on (derives from) the fragility of a single definition (and this is the pivot that supports the whole ideological construct), a definition caught up in Aristotle's *Poetics:* "the subject is to drama as the design is to painting," a definition that we must also understand in all its retort(ion)s: the drama in painting is the subject of the design; it is the design as well as the subject; it is the subject; it is the drama; it is the design.

And to continue: perspective, retracing the path (the trajectory of

the optical ray) from image to cause (*alla sua cosa* – to its own object), being founded only on the existence and demonstration of a prime cause: perspective is organized space in the absence of a god to motivate it; cause of an absence of god which allows it to exist under the major effect of that absence. And this perhaps irreverent text: "inscribe in any place the name of God and set opposite to it His image, you will see which will be held in greater reverence! Since painting embraces within itself all the forms of nature, you have omitted nothing except the names, and these are not universal like the forms. If you have the results of her processes we have the processes of her results" (2:227).

According, that is, with this perspective that has to be totally formulated once more:

> Perspectives are of three kinds. The first has to do with the causes of the diminution or, as it is called, the diminishing perspective of objects as they recede from the eye. The second, the manner in which colors are changed as they recede from the eye. The third and last consists in defining in what way objects ought to be less carefully finished as they are farther away. And the names are these:
>
> Linear perspective.
>
> Perspective of color.
>
> Vanishing perspective (2:241).

And so nature is the fictional space wherein representation can be achieved, where it is improbabilized, in fog, in smoke, in the system's seminal loss, in an extravagant spending that it cannot command: "The density of smoke from the horizon downward is white and from the horizon upward it is dark; and, although this smoke is in itself of the same color, this equality shows itself as different, on account of the difference of the space in which it is found" (2:298).

Color *is* the smoke in the loss of the system that locks it up, that for all bodies *snips off* this appendage that is liable to disturb and produce some dangerous supplement. As it plays on the line of the horizon, above and below it, color is *the difference in the field wherever it is*. The field where it is, is the field of definition, of Aristotelian drama – the field of analogy. It is the West in that Renaissance. It is the very same West where color is seen only at its setting. On the horizon and over the land where the sun is shaded by the ray that swings across the farthest fringe of the earth; in itself, in essence, *in the last instance,* color *is* the difference in the field where *it is found.*

ON THE OBJECT OF FIGURATION

The following very general article on figuration, although not published until 1979, both arises from and leads to Schefer's book on Paolo Uccello's The Flood *(1976), as we shall see in Chapter 4. That is, it sketches out an unfinished project – the project of a history of figuration and figurative systems in Western painting – of which the Uccello book would perhaps be a substantial part. The summary given here of such a history is brief, but it nonetheless shows the sweep and the range of Schefer's concerns in terms of figuration, and the conception of the human body. In particular, he focuses upon a shift in figurative practice and its accompanying epistemologies between the classical period and the Middle Ages, or in the transition between pagan religion and Christianity in Europe. The general proposition here is that the suppression of paganism and the ensuing elaboration of the subject for/of Christianity (what Schefer calls the "anthropological subject") involve a simultaneous disavowal of the pagan image and of the pagan body.*

A key actor in this transition for Schefer is Saint Augustine, to whose work he has already devoted the volume Invention du corps chrétien *(Invention of the Christian Body, 1975). That book analyzes the work of Augustine as he is, in effect, the theorist of the disavowal of paganism. That is, Augustine formulates the new anthropological subject by redefining the relations of its body, its libido, and its memory. Among his writings it is* De Trinitate *that performs the theoretical work of filling in, by way of the Christian formula of the Trinity, the experiential aporias that are, for Schefer, the essential topic of* Confessions; *Augustine's own conversion – the repression of his "pagan desires" – is symptomatic here and is consonant with the consolidation of trinitarian thought.*

The effects of the establishment of this anthropological subject and the repression of paganism can be glimpsed in the history both of the image and of writing, but in each case especially in relation to the figuration of the body. Here Uccello, with what Schefer calls his "grand fantasy of the other body," appears as the residual memory of pagan figuration. While

"Sur l'object de la figuration" from *Espèce de chose mélancolie* (Paris: Flammarion, 1979).

much of Uccello's work, including The Flood, *has often been understood
to be primarily concerned with the formal solution of perspectival prob-
lems, or to be merely decorative, Schefer's claim is that Uccello's efforts
in relation to representational unity are secondary to his subversion of how
the developing "classical" systems figure the human body.*

*Like the work exemplified by "Spilt Color/Blur," this essay continues
with Schefer's expressed concern with the process of reading the historical
symptoms that systems of representation exhibit. Here, however, the em-
phasis is much less upon the structural and semiotic constitution of such
systems and more upon the establishment of the appropriate* lexie *for his-
torical interpretation. It is drawn from the book of collected essays that
Schefer published in 1979,* Espèce de chose mélancolie, *and in com-
mon with many of the essays in that volume – including Chapter 3 of
these translations – constitutes an attempt to focus less on the signifier and
its systems and more upon the constitution of the signifieds which make
up the sociohistorical terrain of both the visual text and its readings.*

One day I'd like to begin writing a history of the body in Europe
since the fall of Rome. More exactly, a history of representations of
the body (of the rules of representation and the limits of figuration).
Of course, such a project couldn't work exclusively on the terrain of
art history. Especially since analyses of signification and figuration
need first of all to be pulled away from mechanistic notions of repre-
sentation; analysis needs to redefine the field of any given symptom's
historical reach (and here the notion of the symptom has to replace
that of the sign, if we are to construct a properly historical field,
since that would allow us to ask more openly what signifying pro-
cesses are as they shift ground, as they shift between domains of
signifying work). The idea that signifying practices confirm a divi-
sion of discourses based on the social division of labor is really a
retrospective nineteenth-century idea and is obviously hardly perti-
nent here, as social practice is generally dictated by two particular
pressures: allegorical thought and legal thought (though, to be sure,
in order to be seen as such pressures, these must equally be under-
stood as conventional signifying networks). This project would also
want to say that the beginning of the Christian West is not a legacy
of Greek philosophy: the only Roman philosophy is juridical
thought, based upon a Latin version of stoicism.

It will be necessary, then, to mark the moment of rupture between
Rome and the Middle Ages; to try to understand, for example, what
was the status of the image in fourth- and fifth-century thought; to
ask, in particular, what became of the remains of the mystery that
paganism had attached to the image, a mystery that early Christian-
ity (or Latin monotheism) could no longer comprehend. This imme-
diately brings up one of Augustine's concerns (in *City of God*): the

25

annihilation of polytheism's legal irrationalism. If Varro can no longer be considered correct (when he says that paganism simply became spiritually impotent), and if polytheism doesn't put pressure on the plural libido, on that triple libido that appears with Christianity, then polytheism and what goes with it cannot be the cornerstone of Christianity's new *formula* – an enigmatic formula it is, certainly, but the least "metaphysical" one possible – namely, the Trinity, defined in opposition to the thought of Plotinus or preallegorical thinking.

So what happens to pagan images? The project would demonstrate that a certain mode of the image ceases to be relevant as its historical and ideological background is erased. For example, the image of Janus is no longer used because the persistent division of its faces goes from two to four, so it is too unstable a figure for the problem of numerical disproportion – signifying moments are no longer possible in this mode. So there is already at least a strong *disavowal of the image* in paleo-Christianity or the pre-Scholastic period, insofar as the image's referent becomes, first of all, the object of a displacement; it comes to be textualized (under only one of its aspects). Thence the image is not so much tied to a practice (except in relation to the remains of Roman painting); rather it is caught up in the first attempts to define the anthropological subject. If one tries, from that standpoint, to deal with the figurative production of the Middle Ages, theological and juridical thought (with both their usual conventions and their aporias) become more important than the persistence of Roman figures. Strictly speaking, the image is not forbidden, but rather becomes impossible after this displacement of its system of reference.

On another track, fiction probably had a very long latency period: the symbolic novel arrives only with Prudentius. (One could also reread Tacitus's *Dialogues* here: there is no place for the writing subject in Rome; the choice has to be made between the public realm and historical work. And for a long time it wasn't possible to transform the text of Petronius.) Christianity begins not with the writing of novels or drama, but with biblical commentaries; these meld together language and philosophy to produce the new position of the anthropological subject. That subject is, furthermore, a measure or the moral consequence of the position of the commentator. There also, or there first of all, we see two men in man: the one who interprets and the one who is the moral effect of the interpretation; the latter occupies the privileged place of the image. And all of Augustine's work on the image rests upon the hypothesis of such a body's autonomous existence: the one who writes is constantly effaced or written off by the one who is imminently written.

Such a transformation is probably essential for this discourse which has no fiction (this discourse, from Origen to Dante, is also

the starting point of poetry, and it cannot feign, cannot introduce a fictional subject). The Augustinian (for the sake of dating it) rule for the symbolic: writing will produce two subjects, but will not produce a hero for the text (no fictional actor, but rather someone who acts out the writing process, as with Dante). One might also consider the way in which the Roman novel and theater are obsessed with the question of the identity of their heroes (as in Petronius, Plautus, or Terence) according to juridical formulations, or by what in Ovid becomes the question of the identity of mythological figures.

Who is the hero of the text? He is an allegorical man insofar as he can turn his back upon (he pre-scribes) the one who writes.

The man in question is always double, because he is defined only by his relation to the Scriptures: his identity is split and requires the introduction of a dialectics; the bifurcation of knowledge *(scientia)* and memory indeed works in this way as the generalized extension of the symbolic mode's having divided all other signifying fields; the symbolic mode reinscribes as cause what was in fact only the effect of the extrapolation of signifiers: namely, revelation (the appearance of a contradiction which becomes a paradigm, an anacoluthon for the "history of humanity" that religious historiography has already pre-scribed).

So this is where one would have to start (and it's the starting point of the only historically possible philosophy – the philosophy of law); start with this language that's not novelistic but rather the language of commentary. And scriptural commentary foreshadows the effect of a division in the writing subject (for that subject writes only scriptural readings) across the signifier as signifier of Truth. So from the first this language can only pre-scribe the subject as a particular effect, the result of the moralization of scriptural interpretation.

Guaranteed by the symbolic mode and acting as the clearinghouse for the making of textual rules, such a subject is logically *only an image,* and is certainly just the same thing as a juridical subject – it's not constrained by the real and it becomes a subject only because of this interpolation of Truth.

The *second body,* that of memory, of jouissance, is *reduced* to a static moral entity by allegorical thought; and, in the same way, allegorical thought reduces the question of writing – a question which can only ever be one of giving body to its own paradox (to give it *a* body. In this project, one would have to try to understand, too, what the art of memory might mean after the rupture with an antiquity which, like the Bible for early Christianity, is now a kind of *hallucination* produced by the misrecognition of historical signifiers and by this disavowal of an historical legacy).

By way of these same sorts of claims, it would be possible to bring under the rubric of writing (that grand *fantasy of the other body)* Uccello's *Flood,* because of the legibility and literalness with which

it presents the paradoxical body (by showing figures divided beneath the weight of a material pressure, against the *mazzocchio*).[1]

Uccello seems to me a decisive departure from Dante's text, an exit from allegory and from Christianity's perspective on the minute observation of the body's suffering (to borrow from Nietzsche). The global body, the body in its totality, does not exist for a Christianity which *knows* the body only in its signifying articulations, by its "joints" that represent it as a symptom only, and thereby make a bridge of knowledge of its meaning. Later Christian philosophy intensifies this tendency (most obviously in Condillac's legal fictions or in Hegel's progressive/reflexive fiction – the history of philosophy/ phenomenology) and everywhere, beginning with Kant, *this division around the general principle of the body-as-symptom is taken up by and as philosophy itself.*

There is in Christianity a pressure – albeit surrounded by and working with both allegory and mysticism – the pressure of a necessity: that of the interior body, that – in a way – of *anatomy;* and it's only resolved through the annihilation of the body and of the very symptom that the body represents more than it can figure. (In relation to this, Huizinga has a fine chapter on the *disappearance of images* and mystical writings: chapter 16 of *The Waning of the Middle Ages*).

In Uccello's *Flood,* for instance, the painted body exists as the very limit of the imaginable body; not the limit of a real (anatomical) body, but the limit of a body pre-scribed as to its significations. Its special physical coherence derives from the unfinished plastic space around it (and its production is akin to that of a Sadeian effect).

Uccello's decisive point (his "lesson," if you will), both in the picture's totality and in its *smallest aesthetic effect,* is that the body constitutes the irrational limit of all spatial construction. It is also a limit on irrationalism (a further way in which antique culture comes to an end is in Greek statuary, where space always exerts pressure on the body, and the body is neglected): in Uccello the body is still there – as the locus of a cultural and ideological blindness and of a nonerotic symbolic overinvestment. The body presents a trace of irrationalism and of primitive perspective (thus "composition" and the importance of *mazzocchio* become symptomatic in Uccello). His point is that the body, historically, cannot be reduced to its allegorical and symbolic treatment; it's not *sacred,* it doesn't transcend what surrounds it, it isn't plastic; but rather it's limited to minimal effects of volume and proportion. Uccello's most powerful gesture is to make that body produce an effect of coherence, to lead the misrecognition of the body back to the mythical (to the problem of mythology, which is the division of the species, marked by "creatures" with no identity except the marks of their tracks). Equally, Uccello can discolor the body, making figures vary even if they are substantially undifferentiable.[2]

Similarly, this body can be without color because it has no function, no position, no social name (it is an autonomous body, representing not a hero but exactly no one – as opposed to mannerist mythologies, which are theatrical acts, novelistic fictions. Color also has the function of allowing the body's repetition – that is, of producing a memory trace from it: the memory of color).

Uccello's lesson brings us closer to the possibility of elucidating the status of the body in painting (and what if painting has been used to absorb – to resolve, to free up, to hide, or to annul – something like the problem of the body's inarticulateness in our culture?); brings us closer to the question of the symbolic body's division and of the body's imaginary (simultaneously the figurative body and the very surface of the canvas, which, according to Alberti, is the skin itself).[3]

The question, too, of the body in its allegorical *place*. The body, as an enigma of sexuality (and probably as *the unreduced state of the object of pleasure*), allegorically figures the liberal arts, the sciences – these are all women, with attractive bodies that are pierced, gaping, and split (as, for instance, in Santa Maria Novella, the Spanish Chapel, Andrea di Bonaiuto, *The Triumph of St. Thomas* and *The Allegory of Science*). I mean that allegories, by way of what they do not figure, take over the *mystery of both the object and the organization of pleasure on the body;* they even take over the effects and histories of objects and bodies. The only locus of knowledge constituted as knowledge proper, and that takes account of experience as a symbolic pressure, is henceforth the mystical body: the one that escapes both juridical and figurative regulation, the one that is constituted as the very knowledge of its own transitional function as the caesura of desire. This is what is at stake as well in the execration of God by the mystics and, later, in Campanella's last revolt against the Scholastic motto, *scientia est de singularibus non de universalibus*.

So here, in Uccello, we find at least a profound reinscription of the motif of the image as division (in Augustine, where "man is double because he is an image," he is double also because he is a sexed being, and he is sexed as an effect of the scriptural text from which he receives his circumcision). The image as a kind of failed figurative solution to the dialectics of love.

Perhaps figuration needs to be studied with this in mind: it blindly drains and elaborates a remainder, the remains, of the problem of *the body's coming to represent the very mystery of the object of its own pleasure*. More than a mystery of the body as organism – Descartes's pineal gland, the body and the soul (that is, the pleasure principle), the obsession with the anatomy lesson. Everywhere the question of finding that little particle, that self-pleasuring nexus that could irradiate the whole organism, the principle of the soul's thought: there where it first pleasures, there I emerges.[4]

29

And painting devotes itself to *pre-scribing the invisibility of this place* (the problem of the *nuvola* or of autonomous figurative objects can be approached in this way).[5]

The question broached by Uccello is not of knowing where the visible body is to be found, but of knowing where is the visible in the body. (Compare, too, the anatomical drawings, the penetrating incisions of da Vinci – anything that painting cannot reproduce. What is he looking for? for the place of pleasure in fiction where it's visible but cannot be figured).

Holbein's *The Ambassadors* asks the question again: what is, not the organization of, but the emblematic apparatus of pleasure? Holbein's picture responds with a doubly inscribed apparatus, a catalogue of measuring instruments (those of astronomical procedures *out of proportion* to our species), and with a symbolic apparatus designating the loss of all inscriptions of pleasure even in the very *place* where pleasure irrupts in the form of an autonomous body. This all rests on a unique base: that of a dis-figuration of death (an anamorphosis) that supports the picture's "characters."[6]

Occasionally one does find some evidence of autonomous bodies trying to break through into paintings. Allegory and the division of the body as artefact, as distinct from a body of pleasure that can be isolated: division conceived as a contradiction.

The question posed by *The Flood* is largely the paradoxical question of all painting (religious painting can hide for only so long the fact that there's no progress, no progression in the plastic arts except within the terms of this very paradox) – the idea that the body can be made into a figurable term only by some arbitrariness: the body is a complex irrationalist solution to the very principle of figuration (of its systematic or its logical – not its historical – principle; this is the problem for the Renaissance); and that principle is the projection of space. Space is not supported by bodies (and so what could we make of the gross overcrowding of bodies in this painting?). At this point, what is the object of figuration in terms of a set of logical presuppositions? It is the body represented as the mystery of a pose in any composition, which is why it is repeatable, that is, variable, in its determinations.

(Notice how bodies grow old in painting; how their synecdoche is reduced, how they stop emblazoning themselves in space, cease to have value, stop showing themselves, showing their skin.)

In the history of painting there is a place of madness, of anamorphosis, of mystery, of *mazzocchio*. That place is reserved for changeable objects: they simply figure the fact that death can be credible only when dis-figured (Holbein). Pictures maintain a fiction of a place: a window through which a patch of color watches the enigmatic body floating free, away from painting's geometry.

THANATOGRAPHY/SKIAGRAPHY

"On the Object of Figuration" ended with some remarks on the necessarily anamorphic place of death in figuration, suggesting that the death of the body – like the pleasure or libido of the body – is another problem for figuration within the regimes of post-Augustinian ideology. "Thanatography/Skiagraphy" constitutes a further adumbration of how the figure of death "splits" representation, or of how death can be figured only at the interstices of the body and in the body's articulations with other objects. The essay furthermore links that tenuous figuration with the practice of writing.

Schefer's consideration of the body, death, and writing is in this case followed through a discussion of a canonical art-historical object, Poussin's The Arcadian Shepherds *(c. 1655; Fig. 1).[1] In Schefer's reading, this painting stages what we might understand as the historical onset of the apparent necessity of writing and interpretation due to the loss of the human body. This is the crux of Schefer's concern throughout his writings with the question of figuration. For him the conventions of representation and/or figuration in Western painting (and, indeed, in cinema, as we shall discuss later) rest upon the "disappearance" of the body or, more simply, on the displacement of what is the object of figuration par excellence. It is the paradox of Western representation that its systems are built around a body that disappears as it is represented, and Schefer here tries to establish this impossible or paradoxical condition of the representability of the body as the determining feature in the history of Western figuration.*

The result is what is intimated in "Spilt Color/Blur" – representation produces a construct wherein "space is entirely taken up by the fiction *of whatever it is representing" – for Schefer this is the "funerary" condition of representation. The history of Western art – and, indeed, of Western social institutions – is a history, then, of this "funerary conception and its juridical correlative . . . this fiction of instituting the present in the name of the past," a history which may be emblematized by the tombstone in* Arcadian Shepherds.

Another way of saying all this is to suggest, as in the previous essay's

"Thanatographie/skiagraphie," from *Espèce de chose mélancolie* (1979).

discussion of Uccello, that the paradoxical or "dead" body is continually present as a pressure upon the doxical, juridical body. Thus Schefer sees his task not as the undertaking of endless hermeneutic analyses of his object (which would always be to submit to the doxa), but as the solicitation of the object for what it hides – that part of us which has been disinherited or made to disappear – "the enigmatic body."

Equally as important as this point, however, is Schefer's stress in this essay on the place of writing in both the history of visual systems and in the spectator's possible response to such systems. Apart from showing how Poussin introduces "the anachrony of writing into the theater of the picture," Schefer wants to play out the drama, exactly, of the tension that this produces; that is, as he writes about the image and its theatrical scene, his own writing attempts to register what we might call the intrusion of writing into the pictorial system. Schefer's chosen topic of address always seems to be primarily "a surface upon which Schefer's commentary acts out its own representational drama, writing the crisis that it concomitantly reads in the object it describes."[2] In other words, there is simultaneously a reading and a writing always working dialectically together in Schefer's texts, and this essay provides a good instance of how that works. The reading of a picture brings to the fore the position, function, and effect of the "letter" (of writing, of fiction, interpretation, or the law, and so on) for the spectator.

It is perhaps worth noting at this juncture that Schefer's sense of the nature and place of writing seems almost the inverse of Derrida's view. For Derrida, writing is always the other, or the supplement for the systems of rationality and interpretation with which we are familiar. Schefer, on the other hand, literally sees writing, and sees it as the agent of an alienation – not, as Derrida would have it, as the repressed of a Western logocentrism. The other, for Schefer, is that unattainable body which has died and cannot be replaced by an image or a resemblance but only by writing. What we might call this flaw in figurative rationality is a sort of Achilles' heel for the tradition of Western visual arts, and it is one of the main items of business in this essay and in others of Schefer's works to describe it.

I introduce a certain subterfuge (that of an analysis, a gaze, and a staging) as I allude to a picture by Poussin, *The Arcadian Shepherds* (Figure 1). This picture – in my analysis, at least – is peculiar because it puts on stage a little drama of reading, against a backdrop that rehearses one of the symbolic functions of painting, against the background of a tomb. One of its oblique figures – the one that interests me here – is a crouched body pointing out on a stone one of the letters in the phrase "et in Arcadia ego." The link between this body and the letter – which is the absolute vanishing point – is here a shadow, a projected shadow. In a longer analysis it could be shown

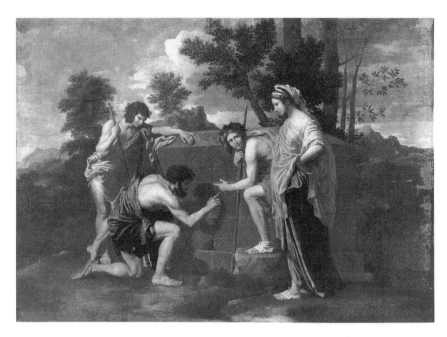

Fig. 1. Nicolas
Poussin, *The Arca-
dian Shepherds,* c.
1655. Paris, Lou-
vre. © Photo
R.M.N.

that this shadow is the result of an incorrect projection, but it is nota-
ble for the way it sketches out three ages, in a kind of fugue that
takes up (in three stages – Poussin's discovery of the fundamental
schema that appears later in Warburton or Vico) the halting history
of writing, scanned in three stages. Three ages: gestural writing, pic-
tography, and the alphabet. Here the intermediate phase – the lit-
eral – in the relation of the reading body to the letter or this Arcadian
formula, is presented as a sort of Egyptian hieroglyph: the one that
would designate the subject. The "I" as it were in Egyptian: a figure
with no phonetic value, placed after the sequence it determines and
casting a retrospective glance across it; this is perhaps the visible
looking at the literal, at a structure of consonants.

But what interests me here is the confirmation that there's a sort
of alphabetical perspective in Western painting, and that this perspec-
tive is both what regulates the status of seeing in classical figuration
and also what makes two-dimensional painting disappear. In fact,
Poussin's gesture here is, in some manner, to introduce the anach-
rony of writing into the theater of the picture. Meanwhile, some-
thing else is at play in the background: that is, the very thing that
cannot be communicated in writing – the fiction of a triple fugue of
the body, the collapsing of reader and writer. So, what we're wit-
nessing is roughly this: there is in the reading body a collapse of its
relation to the letter, and of its future – historical, perspectival – *in*
the letter. The moral of the picture calls upon painting to intervene
as a kind of mongrel stage in the history of writing. It doesn't matter
that this history is mythical: its movement remains. This movement

33

takes in hand, ideologically, the otherwise unengendered specificity
of figuration. Yet this history of writing is in its turn merely a sym-
bolic scansion, or the loss of the body in the constitution of the letter.
The collapse of the reading body is written, in all its phases, upon a
tombstone. What is this tomb here, in painting, in this picture? It is,
no doubt, that which closes, seals, and makes confidential the very
atopia of the symbolic – Arcadia.

There's also another gesture in this picture's little drama – a point-
ing gesture: the moment when the kneeling person holds, at his fin-
gertips, his own shadow and the very disappearance of his body into
the letter. What's the picture doing at this point? It seems to be using
the finger to write a third dimension into the scene: the dimension
of its own absence from figuration – a dimension that is, perhaps,
that of interpretation. This is what we can witness, through the sort
of reading that I'd say is not, at any point, an analysis, but rather
an absolute solicitation of the picture. We can assist, almost in the
etymological sense of "standing nearby," assist at a tearing of tissue;
here the painting is holding at its fingertips its own imaginary semi-
otics – its imaginary *is* "semiotics" or the morality of the letter, the
process at which we assist being nothing other than the *division* of
the reading body: that gesture, this shadow, *skiagraphy* (the writing
of division) as the only real moment that can situate painting here,
the pronoun in the epitaph, *ego in Arcadia,* or in "atopia," in an atopia
sealed by the tombstone – the supporting ground and the place
where figuration itself is inscribed in the picture.

Thus, athwart what it can actually represent, this painting fig-
ures – and never figures anything but – a third dimension, namely,
interpretation itself. Furthermore, in order to find its laws, it de-
mands that this fiction not be dispensed with, so as to become its
support, exactly. In a way it is this fiction which gives painting its
lasting effect; and it is the subject of the fiction who, by *the tips of his
fingers,* speaks *for* figuration in painting. The nearest thing to a sub-
ject, to the alienated commotion of an "I," is this fugue. What it
catches on the end of its fingers in the shape of its own shadow is
just fiction. Novels and mythography become painting's very per-
mit. They constitute the rights of freedom that exempt what has
not yet been given the problematic and unusable name "the pictorial
signifier" from any minimal structure of decision or splitting.

A real structure of oscillation, then, as a result of which figurative
painting explicitly unleashes the third dimension and installs it as the
dimension of interpretation. And yet it can't be argued that language
is the actual foundation of figurative painting: more exactly, it's that
language *sees* figurative painting. Language is the principle that stim-
ulates, by replacing the problem of space with *semantic* space – or,
because painting is painted, already, replacing it with interpretation
(this "already" is the very condition of seeing in figuration) – lan-

guage stimulates the impossibility of detaching the question of space from the question of interpretation. So painting is articulated upon the very thing that is missing in a painting: the overwhelming symbolic conditioning of figuration as interpretation. So it is figuration that painting doesn't include or can't comprehend in this case; which means that the picture has already been interpreted before it even takes place for us, now, as we look at it.

So, the position of reading fiction, staged in this picture, is to see painting at the moment when it oscillates, changes registers, becomes lost to its own space. Now what does this mean here? – what's inscribed here, as the scorchmark of interpretation, is the very possibility of painting losing its specificity in order to be read.

Looking at this old painting again: it is a form that's renegotiated, exchanged, simply because it started out as a movement and not as a place, and because *its material is primarily the figuration of a process of replacement*. The edict of figuration demands such conditions as these – these modes of replacement, these figures, exactly – so that, in this regard, painting can become the game in which every signifying being loses its consistency. And yet interpretation doesn't come to an end at this point – and, what's more, it never will, because any representation of what it requires (that is, a desire to see and the contradiction of seeing as a passion) ties us up in it once more.

As a result of this kind of tourniquet of seeing, which still resists the position of being interpreted, the remains of what can be read in this picture return – as is the case with the person busily deciphering the epitaph only to learn that his "ego" designates both nobody and nowhere, the place of the dead in the symbolic: the remains return over our shoulders and burn us, look at us. And this is the moral of the picture, the moral that frames it: that even for the person who scans the inscription and begins to lose his body – the body is relayed from the index finger, to the deictic gesture, and to the "ego" in the inscription – even for him there still remains some seeing that burns his shoulder; which is to say that, because of this desire to interpret, we are enjoined to that place of repression where "seeing turns back on us"; or rather, it's just that moment when, thinking we're going to the theatre, we find ourselves already on stage with the symbolic undoing itself within us. So what is this particular contradiction and the passion for seeing in this space?

Saint Augustine's question: *Quid autem voluptatis habet videre in laniato cadavere quod exhorreas?* – "What pleasure is to be found in looking at a mangled corpse, an experience which evokes revulsion? Yet, wherever one is lying, people crowd around to be made sad and to turn pale. They even dread seeing this in their dreams, as if someone had compelled them to look at it," and so they go, in the hope of finding some beauty at the very heart of this horror.[3]

That is Augustine's response to the question of seeing. Seeing it-self, its pleasure, that stranded heart of our "libido spectandi," the spectacle of corpses. To go to see in a corpse the very thing that annuls death in the species itself. And it is this, he says, that drives me to see: because the "signifier" is never really the thing that has died, except that it's already caught in the desire to deprive another real of its specificity; that is, "*to expropriate.*"

And if it's true that, in order structurally to live off them, the symbolic locks up some archaeological positions within us (and that's obviously why we're so "complicated"), then painting remains as the thing which dictates that a body today should be tattooed with it whenever it looks; and that's why, Augustine says, he likes it so much.

What's the point, then, in going to *this* corpse?

We go, as if to a source, in our desire to see, to find something contradicted.

THE PLAGUE

As we saw earlier, in the essay "On the Object of Figuration," the painter Paolo Uccello is a special case for Schefer and is used to exemplify the proposition that the character of Western "classical" painting is primarily constituted in a kind of struggle over the body, or over figuration of the body. The following translation is taken from Le Déluge, la peste, Paolo Uccello *(1976), a book dedicated to one of Uccello's frescoes,* The Flood *(c. 1445; Fig. 2), and in which Schefer elaborates more fully on Uccello's resistance to the ideologies of his time. In a related gesture, Schefer's own writing is intended to, as it were, liberate the body from the same constraints: as he says below, "My text wants to . . . loosen a little bit the belt that binds the body," thus joining and subventing the project of Uccello's painting itself.*

The translation is of a section of the book called "The Plague" and has been chosen here because it is an especially effective rendering of the linkages between figuration, the body, and memory.[1] It begins with the observation that Uccello's painting is "obscene" because it doesn't play by the rules of figuration that "classical" painting tries to establish and because it is the body that's primarily the site of this resistance. It's also because of the struggle between these two conceptions of the body that the plague becomes an important topic here. The plague is, in Schefer's sense, the theater for such a struggle – the body is sick in the plague, and its conflicting images are both the cause of that sickness and its historical and social stakes. Schefer plays at length then, not just with the idea of the doxical and paradoxical versions of the body, but also and at the same time with the linkage between plague and theatrical scene (warranted by Augustine's reminder that during times of plague theaters were closed down, only to reappear in another place).

Trying to undo the strictures and constraints on the body entails giving free play to the memory of the paradoxical body – the pagan body that Christianity combats. The figuration of that particular memory – of what we might call either a social or an ideological memory – serves Schefer here in engendering what will become a crucial component and impulse of

From *Le Déluge, la peste: Paolo Uccello*, 1976.

*his writing: namely, the notion that memory as such is always at stake,
or always put into play for the spectator by the visual text. Memory is
indeed structurally bound up with visual experience, and Schefer attempts
here to show how that is so.*

*Later, as we shall see, the place of memory in this sense will warrant
increasingly autobiographical explorations. This progression will in part
be registered by the idea, introduced here, that the interplay of image,
body, and memory provokes (or even invokes) a certain fear in the specta-
tor. That fear is of course related to a certain sense of paranoia, in that
the subject of memory is always necessarily insufficient in relation to the
realm of knowledge, science, or anthropology. And it is always linked,
too, to a sense of childhood or of the childish (it is a primitive and childish
knowledge that stands against the protocols of "knowledge"). For the mo-
ment Schefer seems content with the strategy of allowing this structural
place and role of memory to thicken the historical texture of the interpre-
tation – to expand the lexical field in which the visual object must be
located. Thence the battery of references that Schefer deploys here: from
Michelet's writing on the plague of Marseille, for example, or his remarks
on Watteau, alongside Defoe's fictional account of the plague year and
Artaud's linking of theater with the plague at the beginning of Theater
and Its Double. Even Schefer's gambit of associating the fresco itself
with the plague might seem at first a little out of the way, in that there is
no explicit representation of the plague in the picture. However, what
all these lexical maneuvers produce is an extensively rich and textured
understanding of the painting, the history of figuration into which it inter-
venes, and the social history of its meanings.*

The Gutter

We have to acknowledge the poverty of Uccello's painting.
A painting of great pallor (an arch stretching from Dante to Vico).

THE painting seems to be attached to an enormous gutter.

WE'RE dealing with a painting that's relatively obscene, for the sim-
ple reason that it doesn't perform in the theater of figuration. The
body here is obscene (with all that this supposes or necessarily im-
plies about the history of painting) because it's pre-theatrical, or
more simply nontheatrical. I recall the passage in Augustine, quoted
by Artaud, where Scipio Nasica rather strangely declares that at the
time of the plague the theaters had to be destroyed[2] – it's as if the
body had been seized by some new urgency, literally by some new
fire, that prevented it from making a scene: with such a pressure on
the body, there must be no theatrical unity, no scenographic organi-
zation. But, stranger still, it nonetheless draws a crowd. This is obvi-

ously related to some kind of quality of what we might call the mythological signifier: it is a state of the body – a papillary body, emulsified, and totally indistinguishable from its shell; a body that doesn't yet produce figures, except deeply anonymous ones. There is, in that sense, the work of an evidence that *induces* the painting while bending its fiction and breaking it: the mythological body is crushed beneath the tempest, the first storm – the storm, in Vico's version, when the opera of history begins with the clash of cymbals. A homology or a sort of porous passage between the work of fiction and figures and colors. It is indeed the sign of a kind of dramatic quality, of a stupor that's totally powerful. It is Vico's thunder.

THE Flood? because it awakens in me something that's deaf. Or rather it wakes me up in the presence of an adult astonishment: seeing a kind of enormous bric-a-brac of memory, drowned, caught on a line, and tossed around. A rain of bodies. A catafalque of graying flesh.

That the beginning of history should return by way of this buoyant, urethral memory. The entanglement, the skewering of drowned bodies, corked up, looking like hefty horses roughly rubbed down.

That the painting should begin here, with the fable of a second humanity, its ground fixed by way of this watery fresco. Not to capsize, drift, land high and dry. Where the painting begins (a monstrous opera of the anatomy). The first not to give a damn about the morality of painting: painted in lumps, detaching the drowning of fabled bodies from their earthy background, engulfed.

Uccello doesn't give a damn, gets cheated by some chubby monk, shits on his face, resorts to violence.

There's a peculiar strength in all this (a painting that, alongside its contemporaries, isn't very pretty, not well researched, careless, done in broad strokes). It has the desperate strength of a Ulysses: all in a bundle, arriving in an overheated space, in a baker's oven.

A haughty painting that delivers flows of shit, slithery space (a rebuke to all the cute Botticellis), the bodies in the painting fall back into the shell.

No affectation. Painting's first theater, the subject of its own delay; it sends out onto the stage the body's very *separation,* rowing through this bog. A body, having had once upon a time to begin with its gills, turned onto its tip, a vibrating string, a body trembling, stretched out beneath space. And now it paints its own swill.

We have to acknowledge the poverty of Uccello's painting. It is this poverty that moves us because it's just right – the eyes in the water, the head submerged – and it makes other painting seem useless and wrong; it makes any richer signification, any exuberance, seem immoral.

The feeling several times in Uccello (*Flood, Profanation, Battle*) that he wants to get rid of painting and retain only its shock, its impact, the boldness of the signification it achieves through a deferred brutality: it's up to us to prepare ourselves especially for this bloated body of memory. The subject here? – Uccello's memory.

Piss, corpse, sponge, specks of milk, a stalk of a head beating its closed eyes against the night. A memory populated by fabulous bodies.

In broad strokes, the classical theater, the Christian theater.

By the handful, outstretched arms, catching at the torso, a pagan memory crosses the body of Christianity, inverting its meaning, abhorrence of the body.

The inside of the boat is an eel-trap, a mass of body – drowned, capsized, mashed, edges splattered with white.

Paestum? A city destroyed in the time of the plague? The City of God, decadent and sunken. An anonymous mythological body, thronging, a body of talcum powder.

Scipio

Scipion Nasica. Black nose, *paper* nose:

"the gods, in order to put an end to physical pestilence, commanded stage plays to be exhibited in their honor."[3]

Dii propter sedandam corporem pestilentiam ludos sibi – so that the plagued body would be calmed by taking a seat – *scaenicos exiberi iubebant* – the gods commanded stage plays to be exhibited in their honor, exhibited, thrown before them, on those burning boards.

Pontifex autem (but he who made a bridge for them) *propter animorum cauendam pestilentiam* to ward off a pestilence affecting the mind *ipsam scaenam constitui prohibebat* forbade the stage itself to be constructed.

And so from the start the image was split.

So that the costumed bodies in this burning theater couldn't set up a stage where the soul might take on the gods, the plague.

And so that it wouldn't be in this theater seized by division that the image would inhabit the body.

FISTS to the ears, mouths in charcoal: that the body leaving the stage should be deafened, on the soul that represents it.

If by the light of any reason (*si aliqua luce mentis animum corporis praeponitis*) you might prefer the mind to the body, if you put this movement in front of the body, then let the body spill its ink!

This plague "so blinded the minds of the poor unfortunates with thick darkness, so polluted them with a foul deformity, that even now – this will quite possibly be incredible to our descendants –

when the city of Rome was sacked, those who were so possessed by
the disease and were able to reach Carthage, after fleeing thence,
were daily in the theaters, indulging the craze of partisan support for
favorite actors": burned with their charcoal, in front of those bodies,
exactly, they lost their heads, spinning-tops.

AND this sickness, this plague that *leads to the theater* ("the dainty
frenzy for stage plays" – *insania delicata ludorum scaenorum* – of "a
warlike people, hitherto accustomed only to the games of the cir-
cus," the blades of swords, pockets of noise, the arena marked out,
bloodied rumps, smashed shoes, torn haunches, armor, backs
clubbed: the brutes!).

WHY look at the painting here? And at what within the painting?
What theater? Already on the corpse, a desire of the sleeping body,
the sleep of the signifier.

Defoe: *Journal of a Plague Year* (a Bataillesque procession, with a
way of proposing the "I" that holds that entity, that someone, cheap,
and by its hint of writing, asleep near this desire, unsettled).

"I resolved to go in the night and see some of [the bodies]
thrown in.

"There was a strict order to prevent people coming to those pits,
and that was only to prevent infection. But after some time that or-
der was more necessary, for people that were infected and near their
end, and delirious also, would run to those pits, wrapt in blankets
and rugs,"

> (the desire to see the slaughterhouse spectator pass by like the phantom
> of death; in sum who is driven there, runs to it, already draped in a
> shroud, the statue walking toward the corpse. What does it amount to?
> this covering, a tangled-up comedian running in a sack-race!)

"and throw themselves in, and, as they said, bury themselves." (I
pause over this sort of breach, this wonderful use of tense in Defoe's
fiction: these wrapt bodies throwing themselves into the pits, and
they said . . .).[4]

Medea

Plague, theater. In this decomposition of the body, in its terrible
erosion, writes Augustine, resides the chance for the execrated body
to be displayed, that body which leaves a sort of pus on the spirit
like an open wound: those who escaped, taking refuge in Carthage
(thrown together like a crazy bunch of grapes on this bridge, cut off
from their Roman memory), piled up like vultures *pro histrionibus
insanirent,* "indulging the craze of partisan support for favorite

41

actors," that is, for the body that acts as their proxy in these theaters of execration.

WHAT is this imminence of the body on its painting, this hanging body?

Something that thus has a frontal impact – here and there we find the same opening up of an angle onto the witness or onto the body that is dislocated but that appears like a hand in the slippage between the scene's panels and takes hold of this abruptly suspended spectacle; it is halted by the monologue of Medea, anchored in the foreground by her sword, and by the cube (the one on which the angel of Mileseva is seated) where two children are posed like chickens on a slab. This Medea (she's already facing us: with a hollow look, turning her back on the picture, she sees the playing out of the contract) "meditates" upon the death of her children. What's the meaning of this poultry-yard drama, this feeble solemnity? Is it for their own dismemberment that the two children are playing dice on the sacrificial slab?

That's an image with the power – as I know all too well – to move me deeply (an oblique image, frontal, pale ochre, a section of more washed wall, like the mauve dress of Medea belted in yellow, a framing that opens out onto whiteness: the stupid image of Egea, the door of Hera's temple). The signifier here is simply what leads totally beyond itself. There is a signified being referred to here (it's that which gazes violently: there's no proper reversion to meaning, but a chopper, something that modesty forbids. The rare feeling of the frozen brutality of this place, of this word to which the body suddenly finds itself addressed, in Latin, *palpantibus:* to other bodies that are groping around; for me all of a sudden the fright of signification, its underside, and its invented memory: paganism [the Medea in the Naples museum].

Medea? One of the most "unstable" of all mythological bodies, here along with the dagger of Euripides like a menhir from Filitosa).

My text wants to relieve the painting of its fiction, to deduct it, to hand the painting a suspension that it cannot tolerate. To loosen a little bit the belt that binds the body.

MEMORY coming alive upon the withdrawal of one facet of the real; it's also in the wooden boat that Uccello's *Flood* holds back, one moment before the rain or the indefinitely suspended breeze. We'll come to see how there's something here that's desperately halted, caught in a net, ready to sink, like a swarm of wasps, a sort of jelly that melts, two wooden jaws that bite into the cranium, split the head, then globulate.

Painting (on this fresco) is isolated or ceases to transmit a knowledge that would be both vague and more free.

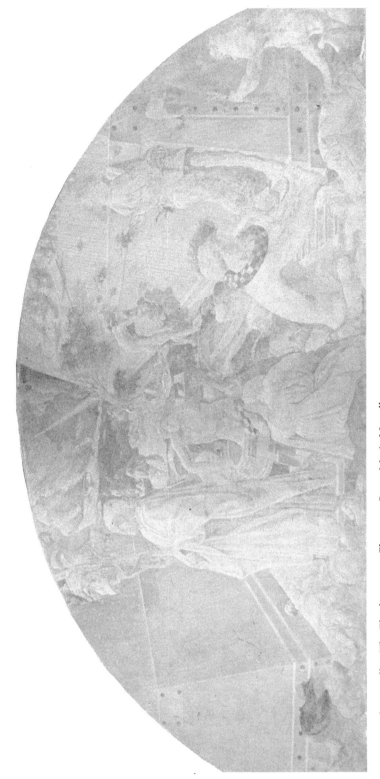

Fig. 2. Paolo Uccello, *The Flood*, c. 1445. Florence, Santa Maria Novella.

(To speak of painting, or more exactly of the strangeness of signi-
fication, at an angle that can no longer be varied.)

The painting here catches an indefinite memory in its net. There
is, then, a minimal differentiation of the signifier overseen by the
possibility of being awoken to a sort of biographical stress. It leads a
drowned body far beyond itself: the body of another jouissance, a
jouissance always lost to this body, and which throbs.

WHY Uccello's *Flood?* (it's still a matter of grasping the signifier,
the grain that drags signification, its wheel, and that which precisely
worries us toward knowledge, but leads to its refusal, burns it), be-
cause this brutal theater (sends, throws, capsizes, and propels right in
front of you), sumptuously infected with leprosy, awakens another
commotion, disturbs the consciousness of another body that comes
adrift and yet remains the prisoner of a minimal bond; no air, but a
sort of clamminess.

No hand, no finger can touch this body: it's not a matter of the
abortive return, precipitous and confused, of some real body that's
not figured here. Where has it gone? Its sudden rise ensues from the
upturning of the head. But again: the painting sets afloat the arch of
a forgotten body, immense, bloated, and latent.

A blind body, invaded; it stretches out, transparent over the stress
of a fractured image that doesn't resemble it. This: a stupor that
transmits a body of memory (but allows it to endure) that is articu-
lated by the strangest denial of resemblance.

Heaps of whole bodies, turned pale, fungosities rewashed in an
intensely shaken memory, a memory traversed by a kind of star-
tlement of its own bestiality.

To the right of this fresco, an incredible tangle of contamination,
of dishrags, peelings, dirty shavings, grease. Such a weight inhibits
the body's flight, its oneiricization (the mystical step of Dante's
chalky statue, advancing toward the edge, fist clenched, one hand
lifting the toga's train, crosses untouched; ignores the shit): a body
lifted from memory, bloated too by the leprosy of recollection, and
it cannot get up; it cracks, fissures, reheated, greasy spot: capsizes
again.

PRESSURE of the memory upon a fainting body, its stomach shaded
yet perfectly white.

THIS fresco: a new putrid odor (Venetian) is here gently disturbed,
and what's dislodged from it is this irrepressible and yet unexpected
memory. That this minimal but invasive suggestion should link up
(by means of an extremely fragile bridge) with the greatest commo-
tion of the signifier (that's used to replace all other commotion, and
the signifier has nothing to tell us but that). Or else the commotion

of something savagely awoken by dreams or by memory (the place of memory in the classical science of *ars memorativa* tried to stake out the real in a certain relief, in its fiction of a fully conscious body scanning the very footstep that was recording it).

THIS space is overwoven for the imminent destruction of its referent: so the painting inspires the writing of just that (a sort of Latin text), the reserve of the body that is invested here, or its admission (its madness that makes a bridge [*pontifex*], without for all that being able to help us cross anything at all); it's bent on a course of destruction. The painting also induces a movement of knowledge as a motif of resistance but whose analyzable element is always nearby – nearby, in the sense that the painting in some way makes the signifier *dissemble,* attaching the signifier to the painting in the register of what I call a *duction* of the signifier, which is then only ever given over to the ability to deal with a certain residue.

To discover the history of figuration through this fresco of Uccello's – this edge: the fold of the toga, nude bodies, cramped walls, liquid background, a flame about to go out, granulations of a sort of hypersensitive skin, a watery and emulsified hornstone memory: an immense memory, in puddles, weeded over and that catches alight on its fissure; returning inflamed. A tiny, faraway fire that doesn't spread to the mythological body floating in its folds, on its water, encrusted milk, pus that crosses the whole arc of color on a raft. Crosses with dead eyes the eye of its color. Putrid, regurgitates.

SUBJECT of the painting, subject at least of this loosening of the moldiness of milk in the mythological eye: the painting surveys this bridge.

WHAT is this *body* of color? Boarding the boat in Dante (Hell. The signifier, having passed this way, is a voyage on the paradoxical waters of memory; there it's the only lifeline, on its entire arc, for the material that rises up as nothing but a sort of coagulation of water, mud, milk, and wood. Swollen body and swollen memory, emerging from this pus of matter, of water, scenically set in the belly of the boat, refrozen).

(REMBRANDT's *Jewish Couple:* "while the fiancée was waiting, in the flesh, she sat down on a pile of dung.")[5]

IT's a matter (no less) of putting to shore, wherever possible, and swimming quite brutally through layers of space.

TO unblock its pipes. Blow down its tubes. The drops of its milk, cracks, scales, fingered eyelashes.

45

Boccaccio's Plague

This pestilence was so powerful that it was transmitted to the healthy by
contact with the sick, the way a fire close to dry or oily things will set
them aflame. And the evil of the plague went even further: not only did
talking to or being around the sick bring infection and a common death,
but also touching the clothes of the sick or anything touched or used by
them seemed to communicate this very disease to the person involved.
What I am about to say is incredible to hear, and if I and others had not
witnessed it with our own eyes, I should not dare believe it (let alone
write about it), no matter how trustworthy a person I might have heard
it from. Let me say, then, the plague described here was of such virulence
in spreading from one person to another that not only did it pass from
one man to the next, but, what's more, it was often transmitted from
the garments of a sick or dead man to animals that not only became
contaminated by the disease but also died within a brief period of time.
My own eyes, as I said earlier, were witness to such a thing one day:
when the rags of a poor man who died of this disease were thrown into
the public street, two pigs came upon them, and, as they are wont to do,
first with their snouts and then with their teeth they took the rags and
shook them around; and within a short time, after a number of convul-
sions, both pigs fell dead upon the ill-fated rags, as if they had been
poisoned. From these and many similar or worse occurrences there came
about such fear and such fantastic notions among those who remained
alive that almost all of them took a very cruel attitude in the matter; that
is, they completely avoided the sick and their things, and in so doing,
each one believed that he was protecting his own good health. There
were some people who thought that living moderately and avoiding
excess might help a great deal in resisting this disease, and so they gath-
ered in small groups and lived entirely apart from everyone else. They
shut themselves up in those houses where there were no sick people
and where one could live well by eating the most delicate foods and
drinking the finest of wines (doing so always in moderation) . . . these
people lived, entertaining themselves with music and other pleasures that
they could arrange. Others thought the opposite: they believed that
drinking excessively, enjoying life, going about singing and celebrating,
satisfying in every way the appetites as best one could, laughing, and
making light of everything that happened was the best medicine for such
a disease.[6]

(What about the "things" of a man who had been ill or had died;
nothing here to demonstrate the monstrous: the demonstrative is in
the text's vague, flowing, cloudy body − limit of the sex, ill as sex −
the passage of this thing, syntactically out of control: appendage,
attribute, vehicle.)

What is peculiar about this plague, Boccaccio says, is that it
crosses the boundaries between species (it will affect the other ani-
mals in man's circle); an anticlassificatory plague, terrifying and na-

ive synecdoche of pig-men; the rags thrown into the street are seized and shaken by the pigs about their jowls. Humanity is surrendered to the stream and will fall in after just a few twists of these infected linens.

And the pressure, like a necessity, that this plague should be such that those who remained alive would then begin to live differently than they had in the past (the plague is what separates history into two parts: the contagion crosses species, it is passed on a rag, on this sort of bridge: that which sketches out the arc of a symptom for every living creature). It is, ultimately, a new paradigm: the historical body cannot get through this sickness unless it changes its habits, changes its social costume (indeed, the only history of the body as social body has been written as a history of costume).

Michelet's *History of France,* in Book 6 (the Black Death followed by a current of mysticism in northern Europe – Michelet cites Ruysbroek).

And Quicherat's *History of French Costume.* Ways of dressing changed after the plague: "gowns short, so short as to show their buttocks."[7] The crossroads of sickness; everywhere it means a change of scene and a change of costume. The plague in everyone's head is a theatrical sickness; a sickness in which the body returns to its social disinheritance, returns to the crowd. Defoe tells of the processions of migrants, of the parades wending their way across the map.

An elevated aspect of bodies (the thoracic cage during inspiration): a scene on the painting – asking what the theatrically painted body is; so I've been asking what sickness it was that painting painted in order to capture the body in it, what skin, what limbs, how many lepers? – a skin that doesn't hesitate but that soon buckles under or rises up. Painting's body on an *immersed* skin.

Lucretius: the plague is internal to the body. Boccaccio: the plague is passed through the skin, from skin to skin (the cloths and sheets spread this plague into the stream). The image arises with a body (the body, henceforth, of memory. That body has, then, finally found its feet).

THE Flood: an enormously knotty body. Large lateral movements, sliding with a cry over knots in the planks. Ovid: this boarded body is the one that thus attempts to escape being captured by the monster in mythology. Ovid's affection for painting: what is *Metamorphoses?* – metamorphosis is a moment of censorship in the text; it intervenes (as a figurative, hysterical supplement) in order to defer or annul the interpenetration of two bodies, like a censorship of the real (the case with all Pan's nymphs, the centaurs, Polyphemus, the sileni). Metamorphosis is the production of this dislocated body, of

47

this excessive thing, by means of a story to which painting is then
attached (Poussin): the ideal solution of Alberti's *istoria.*

BUT between Ovid and the Renaissance there is still room for the
development of allegory as a historical moment in representation
and – probably – in a fantasmatics of the body. The problem of the
division of the body according to its objects of desire, according to
the enticement to classify this "body" as matter that is reflected (lit)
by the object-libido: there are two men in a man. This divisional
protocol can be attained only through an unclassifiable question
whose allegory is exactly its *deferral* – which of these two bodies will
be the first to *come?* It's difficult to understand in any other way how
we get from the Greek and Roman body to a Christian body that is
ligatured throughout the Middle Ages (one factor is the way the body
is disinherited both in law and in scholastic theology). Allegory and
the law – the problem of an obsession with the symbolic body's
anatomy.

SO: what is *the plague?* the plague is also *the fiction of an infection in the
social body that allegory cannot conceive* (and primarily because allegory
cannot conceive the division of the interior body through the divi-
sion of the social body. Allegory is one form of the theatrical body's
unification). Thus the function of the plague is to produce some
other division of the body. (So it's here, still, that it relates to the
Flood: therefore it's carried less by a fiction than by the need to pro-
duce the pertinent division on some new representation of the histor-
ical body – it's *tied* to mythology, that is, to Greece; even Vico's
Greece.)

Fear

Artaud: the effect of the signifier dispersed across the body of hu-
manity is to inflict fear, plague, paint: the body of writing, the sym-
bolizing body.

In Vico, the history of civilization, of writing, that continual scan-
sion, is represented by the thunder that transfixes humanity in fear.
This fear, manifested dramatically as a *fear of storms,* stresses the his-
torical impossibility of humanity's body collapsing whole into lan-
guage, or of its actually becoming a signifying body (language, he
says, is the nonsynthesizing *intermediary* between spirit and body: it's
almost what makes the animal body float within humanity).

To organize this body for a painting that can't properly discern it.
Painting and the prefigurative division: division of what material?

Project for a science, that of modes of dividing (skiagraphy): *how
to divide pictorial material?*

What is the body that's divided and divides itself as image? – a symptom. The body is produced on a bedrock that's not figure, image, copy, etc., but rather the preconstitution of the figurative field as the field of the symptom.

THE Flood (the painting too) is a sequence taken up into a history that remains to be written (it still has no terrain, if not historically at least *ideologically*): the history of the body, of its symbolization, the body and the signifier etc.; its symptomatic stages might then be: Origen, Augustine, Saint John of the Cross, Vico, Freud's Schreber.

How to make the body speak in such a history about its excessiveness, or perhaps just about its historical symptom – the plague; this would constitute the very return of its social and moral disinheritance. Or else the body that can't speak makes a scene instead; it explains also what, on the fiction of its sickness, of a sickness that sheathes it in a crowd, what a division *as* image might be.

The Reign of the Slaves[8]

The cart of the dead, a body stirs the slime with a pole.

"All mixed up at random, in one big soft mass, putrefying together"; "the people themselves, besides, deplored their misfortune in not being buried separately."[9]

Tintoretto's plague: "Whole groups of women, friends and sisters, clutching and clinging to each other, in the indistinct darkness, in the chaos of the gray shadows, are already anticipating the community of the grave. Everything is fleeting, becomes dull, and dissolves. And yet certain of these poor little figures display a strange grace, already otherworldly with languors and indolence, wonderful morbidity. Even as they decompose some of them are horrifyingly pretty."[10]

There's nothing of any of that in this painting, in close detail, but, on the other hand, this is all there too, the possibility of this immiserated gaze, of this emphatic literature that designates a color, an imprisonment, a smell. In Michelet the plague is also a kind of coagulation of the body in the System of Law that's ruining the North; this system ruins credit, immiserates, divides, produces beggars. Among the people of Marseille, who are disproportionately actors, the system is the expiatory procession, the clamor to be punished: bodies throw themselves out of windows and off roofs, jumping out of their rags: here, there, and everywhere (we rediscover in Artaud this vision of the imbecile doctors, wax dolls with canvas noses who cross the city on sandals that help them avoid contact with bandages).

Michelet: "Over the poisonous, thick, bloody streams . . . which

gush out of the corpses, strange personages pass, dressed in wax, with noses long as sausages and eyes of glass, mounted on a kind of Japanese sandal made of double wooden tablets, one horizontal, in the form of a sole, the other vertical, to keep them from the contaminated fluids, chanting absurd litanies that cannot prevent them from sinking into the furnace in their turn. These ignorant doctors betray only their own fear and childishness."[11]

The body taking refuge from the plague manages only to become a puppet, a mummy, a fur-clad corpse, mounted on a spring. The very picture of fear.

In Lucretius it is the body marked by death like a blotter that the statue stains. That fears the faux pas (the portrait, statue of Uccello/ Dante: whom fear paints and understands in the picture).

THE plague engendered by the fear of shadows: "a little black boy," says Savaresi, "who one evening, on a stairway in Cairo, had been frightened by a shadow and was upset by this shock, got the plague the very next day."[12]

In Marseille they moved the dead with iron hooks. In Toulon, they threw them headfirst into graves from the upper-storey windows.

The plague, says Michelet, inflames the imagination, and in his text it is immediately linked to painting.

In this particular painting, the one I'm looking at (which pushes me in the back toward this half-drawn cadaver, imprisoned by perspective), it's a sickness. The effect of an acute and contagious leprosy that is transmitted through clothes (*dei panni*), writes Boccaccio (the two pigs fighting over the rags of a corpse in the street), and transported in bails of cotton. This painting in *terra verde* retains this: the source of the enigmatic body and of the uninhabitable body (taking the place of the execrated body). This painting arrives at a *stricken* body. The skirting of a double floating (what floats is caught, hauled in, and thrown back).

The plague – Lucretius, Augustine, Boccaccio, Michelet, and Artaud all agree – contradictorily leads to the theater. It leads to a picture of the blind body – it is retrieved from the film, the body of a rivalry (driven crazy, paraded, beating the air), from a change in its substance; the doctor then is disguised, puts his nose in waxed canvas, crosses the pustulence on clogs that make his gait look ridiculous – in all the narratives of this sickness.

SO there is this thread running through the history of the plague: the statue that crosses the arch of the fresco; it is the step of the doctors on those wooden sandals, wrapped in wax.

In the background of the fresco, like a map, a whole continent goes sailing by.

"It is the very soul of the plague. In Florence, in Venice, Marseille,

such it was, bitterly amorous. . . . No pity at all for the dying.
Death itself scarcely secure."[13]

"The gravediggers are overwhelmed, going crazy. It's necessary to take violent measures, make reductions. Churches are forced open, their catacombs breached and loaded up with bodies and lime. Then hermetically sealed. All the rest go to common graves. But these were soon full and gorged. They began to putrefy and, a horrible thing, they were throwing up! The ditchdiggers fled."[14]

Something scintillates, brushes past? – broad stroke, of arrow feathers, on the raised floor, striated planks, body, on its backside, unlathed.

Detail, under the magnifying glass, of the body: this body (the figures with clubs) is treated like a wall. Skin? – these scratches are made on the material of a wall; the painting holds little, when it gets old, and doesn't retain this skin but only its quite fissured memory. I remember from this fresco its lacunae, the panels that have dropped out of the story. As Stendhal might say: the missing painting is what subsists in these "little memories," these little islands, still quite close together, that float upon blackness.[15] Or, in reverse, these black scales, mounted, tossed, are like "eyes" floating upon a kind of soup.

Watteau's Death

(Watteau is sad: "why sad? Sad about art above all. He thought he couldn't understand it, not knowing anatomy and being ignorant of the principles that allow movement, allow the surface to be transformed in all directions").[16]

THE man with the club: the wall, the back, skin peeling off, like one wall of the painting. Scratched painting: the body is a subcontraction of these little wounds, the anatomy – that is to say, whatever remains of the figurable body at bottom would almost be a slow and bulky subtraction, rolling across this character, in a scribble. (What might we hope to find at the heart of this most improbable horror, not very pertinent here and yet so carefully displayed? – simply the pleasure of seeing. The peeling off that causes writing; an absurd and gratuitous excess, brings back with a pole, or a hook, the underlying fear in the painting).

Shadow that contaminates, excess of petrified fear (Michelet's text is all about theatrical fear: a shadow falling on a stairway in Cairo).

I know few paintings of the period that go so thoroughly to the heart of things: perspective, wall of color (that is, a walled and graffiti-ed color). These striations (there is, then, a kind of madness, *insania delicata*), they can't cart the picture off, but they begin writing – that

is, begin then on this cracked surface, take over from there, and with a scratch of the nail make its date of birth appear.

Behind that man with the club? – a black pig (a hyena) (a female hyena).

What is beautiful in the fresco is to some extent its puzzle: we can't isolate one detail, one figure, etc., except in order to carry away at the same time the enigmatic and disproportionate fragment of another body; think of this as a chain of bodies, troubled, blind, harried – an extraction, consequently, of who knows what body. But this is no less striking: the epiphenomenal detail, the little annexed body (such a character, surprised on the field of another body, relinquishing a still more violent body that poses, shows its muscles, bandages its made-up face), and so, this little bit of body is there just the same (the dogs, the rower with the hook, a foot, the head of a beast, etc.), desperate to signify, to insist upon what it can no longer understand: the lenticular magnification, the network that overweaves the skin (if you get close, it's a painting with a canine naughtiness).

I get too close, to the point of myopia, where I can understand only the complete dullness of the signifier; a body looked at from this close, giant (under the magnifying glass, the skin is no longer anything but the wall, the *opus reticulatum* of Hadrian's villa, with craters like animal markings).

EXPLAIN this, something that stands out like the ring in the nose of a bull: bodies transfuse. . . . Into what thickness do these stinking bodies, washed, inundated, idiotic, pass and dissolve? – the painting at least films such warped memories: Diderot, the skin looks at colors, and most surely touches them.[17] And this is why. An extremely stretched painting (not a speck of blue).

THE cap of Dante/Uccello (it would suit a housekeeper).

Photographic details (some of them are much enlarged, and the fresco is entirely cut up) at work on the detritus of the painting. Enough to fill another book, to show exactly how this fresco is in tatters and that it attracts, like iron filings, peeled skin and all sorts of moltings that will fit nowhere else but here.

I understand very well in fact that in this fresco what is figured is not the plague. Or rather this sickness. A memory, incessantly struck in jolts, of another history on the body of humanity. The history, too, of the doctor-actors who act out their own alienation, completely making up the scene from which they disappear, rigged out in their bird's noses full of scent, musk, spices. The history of the alienation of the medical body: these dolls at the edge; a history of culture – they're there with their crow's beaks so as not to breathe in the pus, so that it doesn't go to their heads, and theirs are the only bodies removed from the agglutination.

Thenceforth the painting would be the effect of this fear, led very precisely to the point of its own collapse. Like the child who leads me by the hand into the dark corridor in order to show me, in a sort of maternal deprivation, what he's scared of – *there it is.*

The painting thus impels me to write something that writing *sees:* the gaze of writing is in that sense the knowledge of a fear. I have said it's a childhood fear, because it's so much easier to remember succumbing to it since these days a child's fear is the only thing that's comparable. And which collapses. It's as if Vico were saying: children are afraid of the dark, not of ghosts; it's the only way they can say that they're mortal, absolutely, without a bit of this edge, plunged into this terrible test tube with a pair of forceps.

So if a child leads me by the hand into a dark passage to tell me, there it is, *that's* what he's afraid of, immediately a sort of rhombus trembles, round-chested, its head somehow making its wings flap.

A deprivation torn from this admission, from this secret. How to make this darkness recede? by what bridge?

So the painting leads to the heart of its own darkness, leading by the same hand.

SOMEONE WRITING

The essay translated here, "Someone Writing," and the one translated as Chapter 6, "Roland Barthes," both express Schefer's peculiar concern for the difficult place and indeed the difficult experience of the practice of writing. Writing is understood here as a privileged operation of the tension between the doxical and paradoxical bodies – between the registration, that is, of science and knowledge on the one hand and the practice of memory on the other. The subject of memory is always posed in a relation of difficulty in terms of the operations and protocols of all doxical knowledge. Knowledge, understood in that sense, always insisting upon what Schefer calls the anthropological subject, can do no more than "throw a bridge" between the two bodies (we have seen in Chapter 4 Schefer's fascination with the priestly role of the pontifex *– the one who makes a bridge); on the other hand, it is the function of writing to register the* actual *experience of the paradoxical body, to experiment upon it and be experimented upon by it.*

"Someone Writing" takes a moment from André Gide's diaries which records his dream of Paul Valéry's dying. The deathbed scenario is given over to the difficulties of Gide's oneiric transcribing of Valéry's last words. Schefer takes the tripartite structure of the scenario – there is in his reading someone talking, someone listening, and someone writing – and offers it as a moment that exhibits the unstable relation of memory and the body, as well as the peculiar tasks given to writing in that relation. What is important here is not so much the recovery of the paradoxical body but rather the laying out of those unstable relations. Thus Schefer turns Gide's dream into a kind of hidden figure of those relations – an anamorphosis indeed – or an attempt to register, in excess of the scene's actual figuration, the presence of the enigmatic body and its relation to death.

One point of reference along the way here is Freud's account of the dream and of the "situation" of the dream (see Chapter 1). While Schefer's disagreement with Freud and with his metapsychology is often hinted at, it has never been developed into a thoroughgoing critique. Nonetheless, the presence of this disagreement in much of Schefer's work

"Celui qui écrit," *Espèce de chose mélancolie* (1979).

can perhaps point up some of the essentials of Schefer's own thinking. One fundamental objection to the Freudian account is that it does not go beyond the allegorical; the dream is the discourse of Freud's "other scene," attempting like all allegory to throw a bridge between the experiential body and its paradoxical body, but succeeding finally only in marking the "laceration" of the human species. Another and related objection is the "scenic" presumption of Freud's account that the dream is a "scene"; this Schefer dismisses, reckoning that the scenic is always cut through by the Christian ideology we have mentioned, and in the ways we have seen. Indeed, when Freud offers a triplex libido (ego, id, super-ego), Schefer considers this as a theoretical form filling the same experiential gaps and aporias as Augustine's Trinity – it is a theoretical formula that stands in allegorically for the paradoxical body and for memory by constructing a scene *for them in the theater of figuration.*

What Schefer is looking for instead is more exactly what he has called a skiagraphy – etymologically, a *writing of the split* or *the division of the subject between the living body and the body of memory. In a sense, Schefer is on the track of something we might see as unsophisticated, something primitive or even primal – the kind of "childish" knowledge that in Chapter 6 he says he finds at certain moments in Barthes's writing. For him, Barthes produces a writing that recognizes itself as the necessary place for the registration of a distance from the lure of the anthropological subject or the subject of knowledge. This is the lesson of Barthes's last work, which, suitably enough for Schefer's purposes, happens to have been on the subject of the image – on photography. Schefer's obituary here for his friend and teacher, who died in 1980, has seemed ungenerous to some readers, but it might just as easily be understood as a kind of alternative rendering of the anamorphosis that "Someone Writing" constitutes: rather than a death that is dreamed, it movingly registers Roland Barthes's real death in terms of his lifelong practice of writing.*

The Scriptures tell us that there are two men in any man: "For in as much as the external man is destroyed, the internal man renews himself every day"; and "I delight in God's law after the internal man." . . . Some believe that it is simply by way of repetition that in Genesis, after the account of the creation of man, we learn: "God took a clod of earth and fashioned man." Such an interpretation would suggest that man's being *after His image* is his body, and that God has human form, or that His form is something of that sort. For our part, we are not so foolish as to suppose that God is composed of an inferior and a superior element, to one of which our being after His image corresponds; nor to suppose that so far as the image of God is concerned our being *after His image* is entirely constituted in the inferior rather than in the superior element." (Origen)[1]

Or rather – in what can this "being after His image" consist for someone writing? Origen's passage comes down to this: quite apart

from what it says, it remains horribly attached to one of the strangest moments of my own life, something that even distance can't help me express. Something, equally, that can't be taken up into a drama.

But akin to that is the following bizarre antecedence of death that André Gide described (September 17, 1936) in the form of a body indefeasibly given over to someone else's writing or to someone else's voice. The curtain opens onto an uncharted stage: in Gide, Paul Valéry can subsist only through the agency of someone else's writing. This is the opening of what could only be an allegorical scene, extremely difficult in its content:

> I had a strange dream from which I awakened just as it was turning into a nightmare, and this is what allows me to recall it. I was in a room in which Paul Valéry, in bed, was dictating as Milton used to dictate. It was clear that he was very ill, too ill to write for himself. In a corner of the room someone, who might well have been Claude Valéry, was taking dictation; or at least, he was supposed to be writing; but when I looked at him he was busy nonchalantly sharpening his pencil, while Valéry continued to utter sentences the importance of which came partly from the fact that they would perhaps be his last. And I felt fall upon me, like a command, the urgent obligation to make up for the secretary's default. I took out my fountain pen and on a sheet of notebook paper that happened to be in my hand I began to write. But there begins the nightmare. Valéry's pronunciation was more indistinct than ever; there were words that I heard, or understood, badly; and that I did not dare ask him to repeat, in view of his great weakness.
>
> I had already covered half a page as best I could, and if I had awakened earlier, I should have remembered other sentences; each one in turn seemed to me of great importance, sublime. I recall only the last one, which, having awakened, as I say, I felt the need of noting at once. Here it is: "Just an Ah! ago, we were literary clocks." I had interrupted him, not understanding very well and not daring to ask him what that meant. I found it more expedient to ask him how Ah! should be written. He replied at once, and with some impatience, "It doesn't matter – a or Ah! . . ."; and I then understand that he was expressing a period of time. That meant: the time required to say a or Ah! As for the rest, I wrote it on trust, but wondered whether he had said clock (*pendule*), or hung (*pendu*), or lost (*perdu*). It was, in any case, admirable.[2]

This opening could also be the opening of a sudden or anticipated memory of the dictation; or a dream incessantly begun by the wakening of a muffled dictation. Gide waking up within his own dream, a whole to-and-fro movement on that paradoxical filmy surface – and also waking up within someone else's sleep, someone who is dictating in a muffled voice: dictating his last words, totally at the mercy of an uncertainty in the spelling, and thence in the meaning. So he's trapped in a kind of vacillation: he doesn't know the ultimate essence of what he's writing. Here the dream is not quite a stage: more like a drop of oil dripping from the uncertainty of the object,

of its *moment,* of the incalculable weight of something suggested by this sort of bedside stenography. Ever-increasing circles; the reservoir of writing, this hurried inscription no longer holds anything, always nothing, not even a monster. The bulk of the recumbent figure lies back, supported on an elbow, annoyed, with a voice that becomes more and more hollow, more and more inaudible, attached simply to the gravity of his imminent death. Invents nothing; reaches beyond that distress which has always eluded expression (and was always the great task of his writing, its most pressing business), beyond the final threshold of a sort of indifference between whatever it is that can be written straight from the mouth, at the bedside, and far from the head, and whatever it is that can be spoken or written as a counterbalance to the muffled and weighty death of the speaking body; he reaches then, in the form of a dream (the only representation permitted outside of the social body's day), reaches the threshold of difference between this chain of heavy words (improbable and undecidable) and the consistent nothing at which they arrive after their transcription.

The stirring, inside the dream, of an act of writing in the shape of its own inability to understand the sigh as anything but an unfamiliar word. Valéry's last sigh. He doesn't understand death except as a clock that just records innumerable quantities of time, themselves in a taut oscillation. The dream presents or writes something that's not approachable, the imagining of time as a shadow beating against a weakened body – tensing itself to restate or invent just this pendulum and in the most uncertain terms.

The tension of an entire life in this almost final *a,* or Ah!

What music is written by the hand, by the heart, by the head?

Something insists – and heavily – that it be written, but only through the death of music.

This scene – a mixing together of all the disproportions between writing, hearing, dictation, muffled speaking – adds the quantity of a dream to this place where it has never been, this scene that cannot be figured. Only half-spoken in a new place, and not in an imagined space. Da Vinci's dream:

> *del sognare:* men shall walk without moving, they shall speak with those who are absent, they shall hear those who do not speak.

> *del ombra che si muova coll'uomo:* There shall be seen shapes and figures of men and animals which shall pursue these men wheresoever they flee; and the movement of the one shall be as those of the other, but it shall seem a thing to wonder at because of the different dimensions which they assume.[3]

The body lives and subsists only in a paradox. A motor going backward in time, a motor unhindered by space.

So no stage. The function (but not the figuration) of dreams is to

empty the present from every possible – that is, every repeatable – figuration. This is not the opening of a theatrical scene. Here everything is exactly this – an instability *which is our species,* a slipperiness (but not a sliding away of content); here it's the future that works on the impossibility of any "situation" like a past that hasn't yet come about (the present of this dream, propped up but without a discourse, is thus the future of some past that hasn't yet come about). The Freudian scene, like any visionary dream, is contradicted every night. The rationality of the "other scene" is denied by its own reality.

Knowledge remains allegorical – speaking allegorically of time, and of the era preceding the construction of dogmas. The allegorical body is attached, not to a place, nor to the imagination of a place, but to a language and to this reversal of time that occurs, as language, within a tension of meaning. Meaning prior to any scenic imaginary. Science (or the first anthropology) has always tried to construct a bridge between these two bodies that are neither ever contemporaneous nor ever mutually indefeasible. The allegorical experience isn't an experience of their union but of the laceration that constitutes the very *sign* of our species.

With these three representatives, these three pressures scattered around the room – the one who dreams, the one speaking, and the one telling the story (who plays the role of the one who had been supposed to do the transcribing) – it is a question of different positions being gathered up into the body of an anamorphosis; the three can have no possible unity. If there's something in Gide that can write them all down, it's the opening of this totally impossible theater, a theater that has no stage, as its only aim is to place a sign over the time that has to be given only to be discharged; or it must be given in order to provoke the arrival in similar dreamlike quantity, in a measureless quantity (unaccountable by its own insistence and by the obstinacy that's proper to dreams as they wear down figuration), provoke the arrival of latent man.

Cold, dark bedside, an invisible elbow, unaided by light or shade, supporting a voice that's beyond its own words. The throat's emission passes onto a murky pad that writes down just a strangled sigh or a mathematical sign that carries it all away – and the figureless duration of this body is set in motion once more while it pronounces upon the constant hesitation in which (according to Gide) death *must* be inscribed. Back again to the movement of a clock. Insubstantial shadow, spindle that cannot write; striking in between the duration of a muffled cry and a letter detached from the alphabet, an algebraic curve. So the dream writes down the irritation of the shapeless hesitation that nonetheless shapes our species through time, and transcribes it with an impotent hand. A sigh that has fallen from the alphabet, since it is no longer a shape nor – even so insubstantial as

it might be – the duration of a body that is future, but only latent in a recumbent letter. The clock that we might have been strikes only on the face of two disjunct languages for an *a* of time. Two languages, both of which it weakens, capturing the impossible body in their uncertain echo so as to articulate that body, put it together, all at the same time.

A barely distorted anamorphosis: the backward movement (the metronomic moment) within the impossible or indefeasible body of Monsieur Teste (someone who only survived in quarter-hours of incalculable writing, Valéry said). Someone who composed these three characters together on a face that was written without a shape: voice, hearing, and deafness.

So there subsists here, as a striated or crosshatched face, the very thing that Leonardo allowed to hang outside of every imagination of time – a third aspect of a character, of a scene, of theater, of figuration. Shadow.

Imagination of the furthest body (or residence), but also its opposite – a body without a home that would just *gravitate* without chiming, without moving in phases, perhaps without moving at all. It's this – the weight of a body removed *from its own imagination*. Black, shadowy – at any rate the weight of what cuts it off – the face on which it must turn to be born and to escape from its image. Up or down? more like an anatomy of limbs that's of uncertain cut and that's only ever an *intermediary*. An intermediary to its own future (its own arrival) – I stress, the effect of the absence of light.

We might say, "latent to its own sun."

A whole, terrible blindfold placed lovingly upon the unknown species that wakes me each night. To witness its dream or its death. Cut off or endless.

A mass that's released before it can be reached by the death of a pale body.

(I cannot stay with you for very long, nor, I'm sure, for very far. I'm on watch. For what, I don't know. Or I know only too well. A sort of promontory. Sentry to a language that doesn't exist but that causes moments of terror and passion to last within me.) The fear that a hand might come and touch or feel, traverse an anatomy so imprecise as this one, turned toward a face, darkly, and jealous of a future. Of a future that doesn't threaten it. Not so secure as that. Remains far from where this hand can carry. A face at first unhidden but turned away toward the prospect of its birth. Separated thus from a death that's inadequate; hoping for an intermediary: it's a constitutional gap that can never be joined again.

Begins to know this fateful, black metal in the credit balance of the entire species, and of which only a small sum would be negotiable: piles up at precisely the point where an animal would unwillingly be cut in two for the sake of a stage spectacle. A kind of lami-

nated soul that subsists anterior to any movement that would cut a
body in two.

SO it is that, in Leonardo, a *dreamlike quantity* of something *invincible*
is attached to the work of shadow. There are three people locked in
a room where a voice is dictating: a clock, a little bit of time, the sigh
connected to that bit of time, and the further sigh of noting it down
in the form of an italic *a*. Pent-up pressures, each unable to write,
speak, or hear. And their union isn't the working of pressures upon
a single being. They're not embodied. In this desire of time there's a
triplex libido within a single room, always locked up there because
this impossible time, this time impossibly discharged from the pres-
ent, is busy making monsters that are linked to a spelling problem:
monsters who, for this duration of time that cannot find its inscrip-
tion, struggle with time itself as its triple consciousness.

The shadows in this room, displaced onto the banks of a river,
made da Vinci write the following little scenario in which bodies
don't add up ("Of the shadow cast by the sun and of the reflection in
the water seen at one and the same time"). In da Vinci there's a writ-
ten man – a novelistic body, unraveled by the sight and the experi-
ence of its own paradox, and now entertained only because of the
rupture that it causes in the fiction of perspective: "Many times one
man shall be seen to change into three and all shall proceed together,
and often the one that is most real abandons him" – *Vedrassi molte
volte l'uno uomo diuentare 3, e tutti lo seguono, e spesso l'uno, il piu certo,
l'abandona*.

ROLAND BARTHES

The recent pages about a photograph of his mother, about his "little girl,"[1] constituted perhaps for the first time the words of a man no longer driven by anything except the mystery of profundity and the origin of an enigma, the words of a man no longer *made up* to please anyone. Is death the beginning of such a secret?

I retain an undespairing affection for this man, no doubt because of that calm voice behind which the very young mastery of a child could be heard, like an object carried in the voice. This man had, and his speech had, a child's knowledge about all knowledge. That's at the origin of his science, and it's precisely something that's incapable of manufacturing power (a subjectivity forced into making its origin a possibility through the objects of our human world), and something that kept the slightest vulgarity at bay.

His final writings are, for me, a miracle of the simplest thought, and in them there is an art keeping up what must be described as *proper appearances*. That is to say, the unique content that used to give us forms as lovable objects. This was always just the possibility of discussing the most immediate objects of our culture and what it is about them that opens up (or, strictly speaking, invents) the emotional body.

So I learned something from this man; it is to him that I owe the decision to write (to publish). When I was twenty he showed me that work is a technique, and that in this "philosophical" age we should break it down into the simplest of gestures and objects, since they're what guard, as it were, the mystery of that particular annulment of time during which our whole written language ceases to be obviously destined for anyone (this is the only way I can summarize what wasn't really a teaching: paradoxically, it was by another route that I learnt how to work, choose paper, pens and pencils, and to respect that time which chains itself to objects and around which the essential part of my life began to revolve).

Speaking with this man, I learnt no philosophy or literary history,

"Roland Barthes," *Cahiers du Cinéma* 311 (1980).

etc. – as to those, in my way I knew more than he did. But I did learn how all of that could live within me, belong to me, and that somehow a second center of gravity had already been born, awaiting the body (being able to coincide with the origin of the written word) which would never surround it, reify it, or make it up. Already it was a matter of writing as the condition of living under the double commandment of a floating truth and a mysterious urgency; a matter of vainly fulfilling the mad program of such a writing body, like a mass of ideograms that could never be born and whose first point of appearance, floating outside of everything, would only ever be *remains*.

I learnt that there's no master, that solitude is perhaps the very *milieu* of work, not its end, nor its destiny, nor its truth.

And that there exists something like a *true perspective* on everything we do – that perspective is perhaps just the hope of reaching a still unimaginable human being, that is, something that really lives outside us or outside our passions.

I probably don't know the content of my friend's books (books haven't had content for me for a while now), but their particular ideational matter still strikes me. I didn't learn from them any technique, a look, or a manner, but they did send me back to the urgency of writing my own work – that is, back to the real disinheritance of any subjectivity, and to something that can't be delivered up to anyone else by way of the very object which exceeds all of its givens. Even in its very poverty, in its tawdry results, this isn't solitary work: it's situated at the very heart of the species, but right where there's no eye to see either this point where the written is born or whatever still resembles a human being there. And yet it's there in this mysterious shelter, in this interior open to the most violent of winds (open to the tail of the wind blowing from paradise which causes a tragic storm, according to Benjamin),[2] it's only there in the very matter of language and history that men *speak to each other*.

It's only there, primally, that we find the drama of our time because even that *can disappear*.

From talking to this man when I was young I owe the fact that I was able to understand and nurture an anxiety about the historical fragility of our language, of what constitutes our species. And the thing whose sublimity I wanted to reach when I was young was a gesture that is human – that is to say, necessitating more and more the utmost humility. It's true that I didn't know there was something there that would lead me to a certain poverty.

So this friend has died; there's something inadmissible about this fact that I once dreaded for a long time when, once no longer a young man, the weight of the friendship disappeared without changing, or when I felt a doubt about the truth of what I'd learned (mistrusting, for example, the truth that resided for me in that talent

which, certainly, always insisted, but without teaching me anything and without being able to transport the simplest things to where they aren't banal thoughts). I don't know how to admit that his death is a relief in some way. This is certainly tied to a dimension added to an event whose consequence is *interior*; and yet that body is from then on attached to a sort of interiority of time so that such an event can no longer represent anything for me. Because in the end I can only and unfortunately say this: that presence and that talent had become very heavy . . . and yet I owe him a lot, having had to understand, for example, that I must, in writing, give my life over to a time that has no measure.

And yet (and this is what's so distressing) death once more adds something to that time we can only imagine – that is to say, to a sort of impossible virtuality.

Yet the death of this dear friend inexplicably relieves something, like the threat of his death. Just like those unidentifiable people in family photos that fall from the family genealogy, solidifying strongly and measurelessly into an image of time, attaching quite feebly to the external edges of our time, retaining but not engendering the mystery of having been able to live within us. No death can belong to us; what belongs to us is something like one more ghost, a few moments when we're absent from the world because we're thinking about someone who's no longer here and to whom (whether by convention, tact, or fear of death's contagion) we can never again, so long as we have a body, speak in a normal voice – or, I fear, probably even in a whisper. The dead produce a certain harshness in us which is nonetheless the accompaniment to our tenderness or to our melancholy at their departure.

I can't summarize here a teaching that has remained improbable – I don't believe in words spoken from on high. I feel a certain pain when I think of the quiet weakness of this man (of what constituted his culture, his manner of holding himself aloof). And doubtless I can say nothing about his writing – that long ago removed itself from me. I don't like thinking of this man or of his fear of something essential that he never took the time to see. I suffer because of this close friend (like everyone who knew him well and had genuine affection for him) and because he turned away, with all his talent, from what is *most mortal*. I can't refrain from *speaking ill* of him, because it's not true to say of this friend that he was all charm and sensitivity. He was unfair, neglectful, frivolous – so he had that calm passion for the living and so probably took the measure of something in all his readers.

It is our duty to be unjust to the dead because they make us demand much more of ourselves, and because with the death of our dearest friends vulgarity ineluctably grows up around us (attaching, to a great extent, to our own desire to remain alive).

We've long focused on death. My feelings and sentiments don't grow in proportion to the celebrity of this dead friend. But they do cling to the importance of his unfinished task: it was a work of civilization that Barthes carried out among us. In seeing that work I think of the endless distress of humanity. Today, it's simply for the immediate emptiness of our art that I shudder.

Thinking of the increase in anthropological distance which was the most special talent of his work (all objects of knowledge, all practices have changed their distance in relation to our bodies and language because of that work – indeed, the work revealed to us that those distances *could* be changed), something in the shape of our existence has indeed had its proportions altered.

LIGHT AND ITS PREY

"Light and Its Prey" is a complete translation of a 1980 book originally conceived and commissioned in 1979 as the commentary for a film by Thierry Kunzel's workshop. The film was to have been directed by Philippe Grandrieux but was in fact never made. However, Schefer's commentary on one of Correggio's paintings, The Mystical Union *(c. 1526; Fig. 3), remains a powerful instance of his mode of analysis or reading. The painting, which hangs in the Louvre, consists of a central grouping in which the Virgin and the Infant Jesus are visually joined with Saint Sebastian and Saint Catherine; in the background are indistinct renderings of the martyrdoms of these latter two figures.*

"Light and Its Prey" begins with a usefully overt discussion of Schefer's particular mode of approaching and writing about painting. In a sense, the problem Schefer sets out to solve revolves exactly around the title of the painting. That is, Schefer's work will question both the putative unity *not only of the picture's topic and structure, but also of any analysis. In that sense this text enacts in writing Schefer's understanding of the process of spectatorship, which in his view always registers a certain tension between spectator and painting. Here the tension is not only topical (to do with the painting's proposition of a unity in its meaning and figuration), nor simply structural (to do with the painting's organization and representation), but also procedural (to do with the painting's interpretation or the process of its being viewed and read). The analysis therefore proceeds, not according to any of its supposed or desired unities, but by "anatomizing" the picture to the time of what Schefer calls a "diastolic rhythm that provokes the arrival of wisps of words, scraps of reasoning or memories." These "arrivals" are in a sense the experience which the picture's union or unity cannot control.*

So Schefer sets himself the task, as spectator, of as it were entering the picture and finding the gaps in the overarching proposition of unity that the picture would proffer. The gambit is to pay attention first of all to the picture's periphery – the somewhat indistinct bodies and objects in the background which constitute what Schefer calls a first approach to the

La Lumière et la proie: Anatomies d'une figure religieuse, Le Corrège 1526.

visible. These will constitute in Schefer's reading points of entry into the picture for the spectator. More specifically and as the text progresses, these "openings" come to be understood as the unstable figuration of the obscene (etymologically, that which is "off-scene"); that is, these are the registration of the animal and paradoxical body that cannot quite accede to the shining and sacred scene *occupied by the central grouping. The painting is construed for Schefer, then, around such tensions as those between the obscene and the sublime, pagan and Christian mysticism, the primitive body and the divine body, the scene and its borders.*

A central question in all this concerns the place of the spectator in the picture and the spectator's experience in and of the picture. The proposition whose validity the book tries to demonstrate is that the painting opens up onto a world which depends upon it but which it cannot control. That world is the world of the spectator's experience as subject of both memory and the painting's ideological solicitation, and the paradoxical experience of it is what this book attempts to render by reading the picture's multifarious "anatomies."

Such a brief summary of how Schefer approaches this picture can, of course, neither do justice to the complexity and texture of his writing about that experience nor take stock of the often surprising conclusions to which he comes. Suffice it to say that Light and Its Prey *has been chosen to be translated in its entirety because it provides a powerful instance of what it might mean for the reader to experience the experience that Schefer is indicating.*

introduction

A painting in a museum is reduced to a few minutes of writing. In that way it is described, commented upon, or indifferently looked at against the grain.

Yet a text isn't the master of its object – nor can any object in the world constitute a pretext; a text is organized primarily by imaginary durations (that is, by an invention of time) from which the signification of objects consequently arises.

The text is ultimately constituted only by inventing the duration of a world that we call imaginary because it can act as the model and the sounding board for every universe still possible.

So the present text doesn't exactly describe a picture. This picture (Correggio's *Mystical Union*), isn't my text's pretext, and it won't be able either to guarantee or to annul my text in the long run – the only possibility is that the picture might be able to *invent the text.*

A text isn't a system of lines and points. Although it's materially composed of figures, it can't be essentially reduced to geometric forms: so, by its nature or its destiny, it is to be heard but not seen.

So the text's vocation (or its nature? its function?) is to make heard

what's not seen: or else, because it's a hidden thing or a thing constructed in such a way that it remains constantly invisible.

But if it makes heard something that cannot be seen, it replaces that invisible body by ephemeral constructions that constitute our imagination (they're ephemeral because nothing, no surface, holds them down, and no geometry allows them all to survive together).

Or else it's because the text is indefeasibly attached to making invisible what it designates, and to contaminating it with an entirely other space (I'd even say, contaminating the whole world with the results of a theoretical physics that hasn't as yet been formulated).

THIS text isn't written in fragments but rather is written to the time of openings – the openings of an eye, of a camera, or, more accurately, of a ring that has no apparatus, a sort of isolated ring beating alone, dilating and closing upon the parts of a picture, as if this were an organ without lids and living without a body, an eye that effects writing and upon which writing presses with an unseen hand.

So each of these openings, each passage of light onto figures, marks a tiny experimental night, and in their turn such nocturnal fictions take on different durations only by dint of writing.

I know only this, however: this organ, this eye, is subject to a diastolic rhythm which provokes the arrival of wisps of words, scraps of reasoning or memories. It's constituted in that alone, and it regularly closes up as if to expel something that it would be fatal to be filled with, and as if it were constantly necessary to regurgitate something that makes every vista impossible. All I know, then, is this succession and this accelerated alternation of nights in between these movements of the eye – so I know that the creatures in the painting are just asleep, they're cohabiting there, stretching out to their fullest extent, unconstrained, like a maiden spending the night in her chambers.

golden legend

Correggio's painting represents the mystical union of Saint Catherine with Christ, who is represented as an infant, under the gaze of Saint Sebastian and celebrated by the Virgin Mary.

In Saint Catherine we recognize Catherine of Alexandria, whose life is reported by Jacobus de Voragine in *The Golden Legend*. Her exemplary life – which is inimitable because its every event, miraculously, constitutes an encounter between the poor girl and the sacred or something that's already bigger than she is. This legendary life is divided into tableaux.

Saint Sebastian, the Roman archer who lived elsewhere and at another time, doesn't appear in this particular story.

Catherine:

Catherine comes from *catha,* total, and *ruina,* ruin; for the edifice of the Devil was wholly destroyed in her. The edifice of pride was destroyed by her humility, the edifice of carnal lust by her virginity, and the edifice of worldly greed by her contempt of worldly goods. Or Catherine is the same as *catenula,* a chain; for of her good works she fashioned a chain, whereby she ascended to Heaven. . . .

Fig. 3. Correggio, *The Mystical Union of Saint Catherine,* c. 1526. Paris, Louvre. © Photo R.M.N.

sterling examples

"I am Catherine, the only daughter of King Costus. But, albeit born to the purple and not ill instructed in the liberal learning, I have spurned all these things, and taken refuge in Our Lord Jesus Christ. Now the gods whom you adore can aid neither you nor others. . . ."

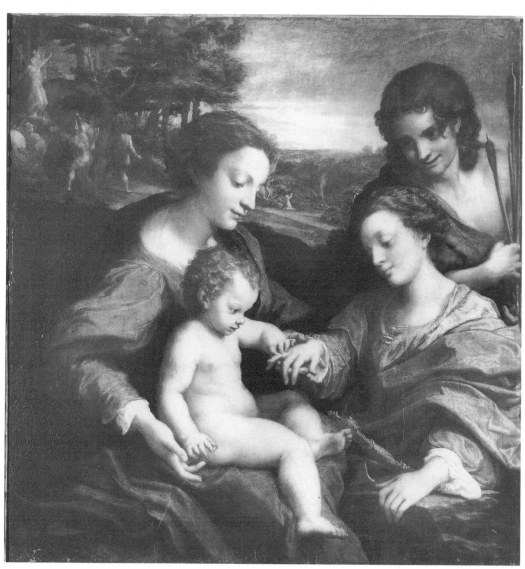

"I see," said the king, "that thou disposest to ensnare us with thy pestilential cunning. . . ."

Then, seeing that he was no match for her wisdom, the Caesar secretly sent letters. . . . Hence fifty orators gathered together from the various provinces; and these surpassed all mortal men in every earthly wisdom. . . . [Caesar said to them]: "There is among us a maiden of incomparable sense and prudence, who refutes all our wise men, and affirms that all our gods are demons. If you master her arguments, you will return to your lands laden with honors! . . ."

When therefore she stood in the presence of the orators, she said to the emperor: "By what justice didst thou set fifty orators against one maiden, promising them rewards, while thou compellest me to fight without hope of guerdon? But my reward shall be my Lord Jesus Christ, Who is the hope and the crown of those who fight for Him!" Then, when the orators asserted that it was impossible that God should become man or should suffer, the virgin showed that this had been predicted even by the Gentiles. For Plato had spoken of a god who is a circle but wounded, and the Sibyl had said: "Happy that God Who will hang from a high tree! . . ."

Then the king was called to another part of the province to deal with certain impending cases, and the queen, inflamed with love, hastened at midnight to the virgin's prison, with Porphyrius the captain of the soldiers. When she entered, she saw the cell filled with indescribable brightness, and the angels salving the virgin's wounds. . . ."

[Later, Catherine speaks to the Emperor]: "Whatever torments thou canst devise," she said, "delay them not, for I desire to offer my flesh and blood to Christ, as He also offered Himself for me. He in sooth is my God, my Lover, my Shepherd, and my only Spouse."

Thereupon a certain prefect commended the following plan to the furious king: in three days four wheels, studded with iron saws and sharp nails, should be made ready, and by this horrible device the virgin should be cut to pieces, that the sight of so dreadful a death might deter the other Christians. It was further ordered that two of the wheels should revolve in one direction, and two be driven in the opposite direction, so that grinding and drawing her at once, they might crush and devour her. But when the engine was completed, the virgin prayed the Lord that for the praise of His name and for the conversion of the people who stood by, the machine might fall to pieces. And instantly an angel of the Lord struck the monstrous mill, and broke it apart with such violence that four thousand pagans were killed by its collapse. . . .

She was therefore sentenced to be beheaded. And when she was led out to the place of execution, she raised her eyes to Heaven, and prayed, saying: "O hope and salvation of them that believe, O honor and glory of virgins! Jesus, good King, I implore Thee. . . ."

And a voice answered her: "Come, My beloved, My spouse, behold the door of Heaven is opened to thee. . . ." And when her head was cut off, milk gushed forth from her body instead of blood. . . . And from her bones an oil issues continually, which strengthens the limbs of the weak. Catherine suffered under the tyrant Maxentius, or Maximinus, who began to reign in the year of the Lord 310.

It is said that a certain monk of Rouen betook himself to Mount Sinai, and there abode for seven years, devoting himself to the service of Saint Catherine. When this monk prayed earnestly that he might be made worthy to possess a relic of her body, suddenly one of the fingers broke off from her hand. . . .

She had the mathematical in her contempt of earthly things; for, according to Boethius, this science speculates upon abstract forms without matter. This Saint Catherine had. . . .[1]

Now, if "Plato had spoken of a god who is a fractured circle," is that a matter of geometry or of melancholy?

At any rate, that's what one tradition tells us, the testimony of an unknown witness. We can suppose the witness to be imaginary or to have been, by some trick, Saint Sebastian himself: the torments of this maiden on the wheel would have compensated him for his own long torture or for the infection of his body by innumerable arrows, or for his being hit by the miraculous shrapnel from the angel's breaking the wheel in the course of the first failed and bloody attempt to execute Catherine: four thousand shards of iron and wood. According to Sebastian's testimony, Catherine of Alexandria would have lost her head after such goings on. . . .

prologue

Someone other than the one who looks is doing the writing, or is describing this picture to him, ceaselessly and inexactly. So this is the scene: someone is looking and someone else is speaking in his ear or using his back as a support for writing.

It's not a matter of knowing what the picture is, but what the duration of looking implies. For example, passing into mobile points that are not precisely figured in the picture; passing, therefore, into an imagination of those points. And it's a question again of knowing, if he turns away after every page, what color the spectator's back is.

Perhaps he can see something else here, without doubt, insofar as he's writing this entertainment in capricious moods. And yet, insofar as it exists, I don't like this painting.

All I retain from it is the part that points toward another world, its hardened milk, or its quantities of dust.

Its huge bent figures and this curdled milk, that ignoble pink child.

AND this scribe on my back is maybe not the *most* improbable denizen of the picture: the one who's speaking has perhaps not even seen the picture, nor imagined it – perhaps he drew it himself, quickly, in a quarter of an hour, in a single night.

So it's rather – and because of this double spectator – the anima-

tion of a generalized anatomy or its scenario: how long, for example, does a visit to the museum last?

We always speak to someone as we look at paintings; meaning what? – that we simply make someone a witness to our safeguarded look. But between the spectator and the scribe the fiction of a blind dictation is maintained; so we're not so sure of keeping our look safe from sleep. So then, what does the pedagogue do with all that?

I didn't choose this picture (this piece of writing was commissioned); besides, it's sublime. There is – I don't know how to say it – a whole internal periphery of objects floating around in it, bringing about indistinct, enigmatic, and misshapen edges almost everywhere in the picture: a sort of proof of the view or of the distance at which, alongside the painted characters, the visible subsists for us in its quantity and in the latent or expended force of the figures. The larger figures in the picture – those that play like the light – are bordered by unfinished or indistinct bodies. Bordered by a primitive blurring of (the first effort at) the whole species of the visible which, if the space were turned around, would replace the world with monsters, or with the hell that the sublime hides.

Sublime or decidedly obscene. Those sketches placed in the picture, like a world turning itself inside out, like thoughts in the back of the painter's mind, are like animals trying to participate in the same figurative space, intent on contradiction or upon removing the ridiculous from the shadows (a shadow is an inimitable body) and depositing it in the sacred.

So there's this continual assault on the larger forms, on the miracle of their light, on their world that's illuminated by two stars, two moons, two suns simultaneously – an assault that's all the more consistent if in the shadow a demon appears attached to each figure; and the result of this assault is the constant whispering of all the remains of the visible that the picture gazes at in us. And incites us to regard the monster there where it improbably resides. Meaning where? – the place that we ourselves would occupy in the painting. As if the return of our abhorrence at what we love were imperiously leading us here.

THE obscene – in the instance of our gaze that's realized here – is added to the sublime by way of our presence. The sublime of this painting, or of this scene which abducts the painting, like the rape of Ganymede, suppresses the entire object that a desire encumbers, and is thus infinitely aggravated by the weight of invisible things or of the not altogether painted things that we add to it.

So we add our probable enigma here; that is to say, the invisible quantity, in all its irony, that attaches to us and that always interrupts the ascent or arrests the very flight of an arrow that might carry us somewhere else. Exactly there where in our constancy and imperti-

71

nent laughter we can't reach, there where death doesn't exist (there where, because of death's absence, the lineaments of faces are stellar orbs).

The shuddering of the painting leads us, on the contrary, to where the genius of Correggio contrives both to figure and to weigh those inverted faces that will come to disfigure the saintliness of every scene in its suspended light, in its duration, in its desire for limpidity.

Those unfinished figures fill in all the gaps of this mystical scene. They immediately signal the place where we live, the species that we can't leave: the very certain mud of all light. So it is that all our active life passes by in the application of this darkness, in these holes, alongside the most sublime desires, that is to say, alongside a sanctification of death.

Now such a face, or its light, such a vanquished hand: something in me turns me away, therefore, from what I can't always be.

Alluding to this gravity and to this unhappiness without which we would already be shooting stars or extinguished spheres in eternity, out of fear.

THE effect of the picture is to produce something that our gaze or normally active sight could never give birth to within us. Casting our eyes around us, it's not invisible objects that we encounter (this is the mysterious default of transparent bodies – that is, of bodies beneath bodies and which impart continuity to the world – that classical optics corrected with its theoretical hypotheses). So the picture dries up the possibility of a visible that is finally, "after all," empirical. These flat universes of color, of figures, zones without movement in which the autonomy of the world is primarily the simultaneity of all its parts, are thus not quite laid out for a human gaze.

This is still a new experience, that of seeing in our ways of looking a slow growth in the quantity of objects or indistinct zones that constitute the edges of every figure. This growth of indiscernible things doesn't bring back the idea of a moving flow, I don't know what it figures, yet it unleashes an inopportune consciousness of death. So it is, too, that the picture is a paradoxical mirror, that it organizes for us the consumption of a visible that it nonetheless doesn't reflect. So it is that, turned toward it, we're already the whole, momentary consciousness of a universe mutilated by the inexactitude of visible proportions. . . .

Those proportions aren't measurable by compass, nor indeed by our gaze (as if a world reduced to flat figures presupposed optical operations alone, and more elementary ones than in our universe); in these masses of light and darkness that don't reflect any sun, and of which we have no experiential memory except the memory of an impermeably invisible world inside us, these are new emotions sur-

veying these unmeasured faces: a laugh, the lightest anxiety, the sentiment of the sublime, the despair of such an impossible reflection of time; these take the new measure, so to speak, of the emotional distances and of the sentiments not destined for our world, but which touch off a second picture within us.

This upside-down head and this gaze don't move us with their truth, that is, through our memory of having seen them reach daylight, but they do sink down within us as inimitable gestures and immediately lock up this sublime in a world that's determined to remain invisible within us.

And because at the center of ourselves, by way of a spot that cannot be demonstrated, this world is not *of* the world, and because the inimitable gesture, the virgin's tears, the grimaces of a Bacchus, are all proof that we ourselves have been made secret: another time in this closed-up pocket within us – and which only confuses their mass – composes an uninhabited world; it's in this world, in crossing the heaven or hell of a memory without experience, that the desire for the sublime, for the obscene, or for the ridiculous, already locates the memory of an inimitable world.

the world of hair

On a horizon or a blue crepe sky, or a sky of feathers. With Correggio the wind has thus forged this division in the open sky and this invention of mixing fibers in the wind but making them push the limits and release a wad of cotton as if from a tree, or from a head. That is to say, taking hold of the sky, that is thicker here and already engages this fringed material, and pulling it apart with both hands like the edges of a wound.

This is how the wind causes the beginning of the universe: upon the quantity amassed here, which is ever more transparent, and by pulling apart these fibers that are porous to the light.

So, as if through a reflection thrown into the sky and this obscure image and this hair, from a head turned upside down in the trees, and leaves trembling and head and clouds made of skin, almost there in these trees, planted root and branch in reverse into the head of the Virgin, her own head in reverse in Saint Sebastian's forest – through these first nebulous remains of the smoke of the world, and the breeze, and the sky in the place of the water that cuts these stretched fibres in two, it's through all this that Correggio finally casts his eye upon the skin touched by the wind, upon the hair, the trees, the water and mother-of-pearl and the milk of the women's skin. And those mad desires caught like birds, like little branches, like bits of straw in the hair.

Then from the hill an equal mass of leaves becomes thickly de-

73

tached, the head of the Virgin gets turned around. Thus the sky marks the distance between these two images and further divides these two similar forms, and the red hair in the branches and on the tree trunks strings out the body of Sebastian, catching his arrows.

A quantity of trees and leaves separates the whole incipient universe here by pulling away the caulking of hell, this wool, this powder.

It's a strangely back-to-front image, the image of equal quantities without a site, the oldest or lowest form of those colloids, dusts, and fibres that the painter's eye releases. The world of Correggio begins in this way, it begins then by opening up exactly the wrong way round.

YET these primitive states don't exist anywhere, their place here is unpredictable, their strange transfer to the sky — as if it were just being branded onto the reflection of this tree, this hair. It's here that the painting begins, with this indistinct distancing. It's the pursuit of this paradoxical body — look at it — that finishes painting this whole picture on its skin.

affirmations

Correggio: "If we consider the wind and the clouds as a world, this world already simulates or manifests the forgetfulness of bodies, and yet it is in this world that all bodies must move."[2]

Heraclitus: "A person in [the] night kindles a light for himself, since his vision has been extinguished. In his sleep he touches that which is dead, though [himself] alive, [and] when awake touches that which sleeps."[3]

THIS weight on the eyelids is a world of women. In the incipient landscape, or in these first remains of landscape, made of trees, hair, and prayers, there's a dream that hasn't yet been worked through, persisting on the retina and turning its back on the initial puzzle of a childhood dream.

A blind child disseminates the stuff of his contradictory dreams. This sibylline monster, this hermaphrodite is then a god who immediately comes to reign over the confusion of his dreams where women's bodies become enlarged. Sebastian, standing up, is distracted by the dream: it's the real (and its irony) gazing on the accident that the figures guess at, or that they grope at with their eyes closed.

But we cleave to this painted world of figures and colors by way of a single point that subsists in us in this spectacle — not with our whole body, but by way of a single point that beats, that crosses over, that's entirely turned toward this other world.

two objects and two points

A preliminary sacrilegious hypothesis might suggest that the Infant Jesus here is an object of exchange, a homosexual transitional object, a sort of currency between these two women.

But could Saint Sebastian, as delegate for a perforated body, take the place of some other body detached from the real (from the mystical body)?

And why, as with metaphor or crime, assassination, in ancient texts, is nothing perpetrated on these seeming bodies except displaced parts, simulacra not of whole objects but of living parts? And so a character in a mystical scene could ask that question of this object in transition, or more exactly in crime, quite innocently. . . .

So Sebastian is there like an actor backstage watching the union being performed and witnessing the ever-so-tiny murder in the course of which, unlike in any act of love, the body and the figure (the figure that follows the disappearance of the body by proximity or distancing) *nonetheless subsist together* (both the lost body and its new face in one figure); but they subsist neither in a gesture, nor in an object, nor (even when it's this to begin with) in a figure ideally reducible to the point where three dimensions meet and cancel themselves out in one figure.

So do we have to find a point that engenders, equally ideally, the entire space of the picture's figures, since one point could annihilate them?

It's a question of the extreme irreducible point where gesture becomes a body, a space, a figure. The extreme irreducibility of such a point is its obscenity: it's a point that is neither physical nor geometric; it's the memory of what constitutes movement in any body. But bodies are just as much effected by the reverse memory: the body is a limit to movement. This reversal is infinite.

If the observer steps back far enough, the picture will be reduced to a single point containing all other possible points, etc. . . . This point is immediately the one through which we disappear from the painting.

disproportions

Linked to the martyrdom of Saint Sebastian and with their backs toward him, the people in the picture here are giants; these characters thus compose a kind of Olympus, they are gods; yet approximately in the middle of all their stomachs they're hiding or holding a god who is smaller than they are.

This god is singularly badly drawn; among their thighs that he's still touching he has even smaller thighs: he's transported by a revela-

tion and by a desire (or curiosity) that's even smaller than he is; the god–child is haunted by the future of a still smaller god, still more of a child, by this hint of a god, or of an adult woman still more minuscule than the child-god, than this dwarf.

This desire has no object to fit it; or no object can measure or contain the very body of the desirer. It closes up this troubled object not as a measure of its power but as a failure of imagination.

So is there a scale here that would invariably have to be gone down? The biggest body holds a smaller object, one that it can make enter itself, this bit of a world that it consumes in its desire, but on condition that the smaller body can look, that is, can pull into itself a lower body, that is, an even more naked and blind bit of the world.

The squalid doll, caught in the gaze of the little god, no longer sees anything. This is a vanquished desire – the final state of a coveted body. The skin of the universe spilling onto a hand.

Thus the Virgin, Catherine, the Infant Jesus, the ageless doll: where, then, in this chain and this scale does endless desire reside? where is it extinguished, that is, where is its ecstasy and its fulfillment? what is Saint Sebastian doing here unless he's obliquely enjoying all the innocence of such a crime?

The last child in the picture, appearing as such only because he is the ultimate object of a disproportionate appetite, of an appetite that is nonetheless only that of an object finally residing in a look; this infant without a face is no god, and moreover he's forever vanishing.

BUT isn't it the case that, beneath this ultimate figure, by way of this body beyond all bodies and yet more naked than any other, a figure begins within the picture?

And isn't that the case because the hand of a painter (in Correggio's time) approaches a mirror like this one and deposits upon its simple image a pose, a gesture, a hint of a resemblance, because some other body will have to emerge from the captive desire of this figure, monstrous only because it's beginning and thus taking shape in body and face, will have to emerge and surround its first reflection and its image of the very gods who annihilate it, hold it, desire it, and then in their turn lose themselves in it?

the picture's division

Is the picture divided as a scene of the different actions that it figures? Alongside the very slow movement of the mystical union (very slow or else constituted by halts at the different stages of movement which deliver or invent bodies), there is this lively and piercing gaze, and also the whole pointed figure of Saint Sebastian. In a single moment he precipitates – like some kind of witness to an endless, tension-free

orgasm – this slowed-down action that constitutes the center of the picture. But even more, caught up in those clouds of branches, leaves, and hair, its speed forever slowed, the martyrdom of Sebastian delivers a lightning bolt, a glow of sulphur, to the back of the picture.

So beneath the Virgin's lowered gaze, at exactly that moment, is the martyrdom of Catherine solidifying something like a cone and this pyramid, and the sheaf of arrows, thrown in the wink of an eye?

BEYOND this division of time, what is it that's initially divided in the picture? Is it figures, forms more primitive than figures, colors? What, then, is the most fundamental body here (the one from which the whole picture could be engendered)?

The existence or the hypothesis of such a body (primary, elemental) is almost confirmed by the presence in the middle of the picture (and at the center of the manipulation of the visible, of all the tokens of the visible, by the different characters) of a figure that seems to attain a final state, an almost vanquished state of figuration – or if you prefer, a paradoxical state of resemblance construed upon these forms.

The hand, indeed, the hand onto which alien fingers are grafted, responds to two different scales: as soon as it's broken down, in the sum of its parts this hand is bigger than a single hand; a body is hidden within it – at rest or abandoned; this body is therefore smaller than the figure of the hand that contains it; but if, in addition to its stomach, its thighs, its swinging legs, this body had a head and some hands, those hands would in turn be the smallest detail of the picture. So as soon as one sees this body, it has to be able to grow bigger than the hand upon which it rests; for the child looking at it, then, it must immediately be the most complete body, or the most naked, decapitated, and amputated body, or a body simply sketched out in a look; and nonetheless, this unfinished figure must be a finished animal and a complete monster.

So an uncertain body of this kind recalls all the other bodies; thus an unfinished or monstrous figure recalls the definition of all the other figures. But if this little image, if this doll of an image holds all the figures, then in some strange way is it still the biggest? – or maybe the most absolute: this strange doll and obscene simulacrum is, then, the most naked body; it is the only object floating in the characters' view, and this constant anamorphosis (located at the point where three bodies join, where the space also construes this knot of fleshes and skins) is the whole object and is wholly disproportionate to these desires, to these looks. Desires that are unified in one form, that trouble it, while at the same time detaching any verifiable form from it. So something moves, awakens, dies, rolls over, and ceaselessly inflates and lifts itself up – within this form that is

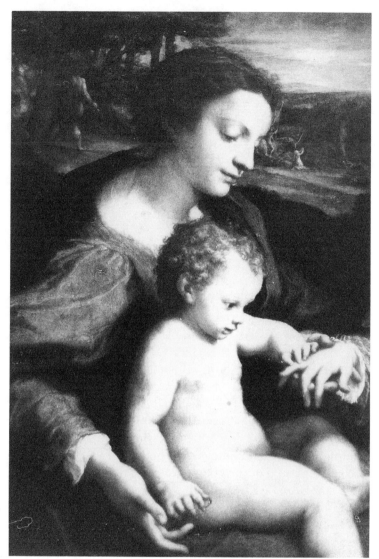

Fig. 3a. Correggio,
*The Mystical Union
of Saint Catherine,* c.
1526. Paris, Lou-
vre. © Photo
R.M.N.

disengaged and sketched onto another form, like the momentary truth of what a gaze and the weight of a gaze attaches to an object.

But how can the smallest of bodies be the biggest, if it's still only a shred of skin?

Berkeley: "I say you never saw one Body touch. or rather I say I never saw one Body that I could say touch'd this or that other," or this figure alone is immediately a touching; a small violence. And is it not equally a way of painting, within the painting, so that what's painted can in turn paint what will emerge from the shadows of the picture, and do so indefinitely?

"IF you want to know what depth of shadow is best for flesh, project

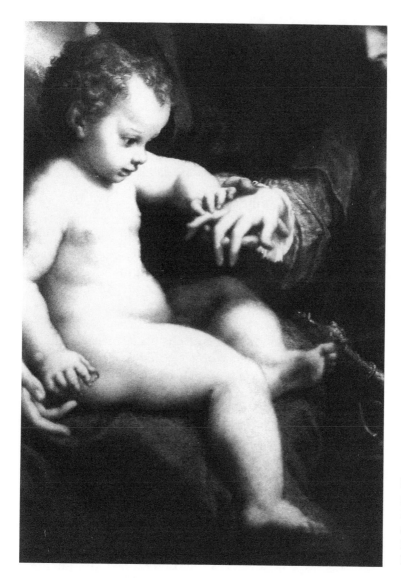

Fig. 3b. Correggio, *The Mystical Union of Saint Catherine,* c. 1526. Paris, Louvre. © Photo R.M.N.

above it the shadow of your finger, and according to whether you want it lighter or darker, bring your finger closer or farther away from the painting, then copy this shadow."[4]

But that's still not it: this body, however small it may be, still isn't the size of a dot. So nothing can come of it.

And is the picture divided because something – less than a figure and not yet a form – continues to be divided within it?

fascination

Let's start again: what fascinates us in the picture is nothing other than the enigma that it puts on scene. What fascinates us in the pic-

ture, fascinates its characters. Our gaze is therefore led, and all the looks in the picture finish, stop, and are annulled in the same enigma. This enigma ("why does one indistinct body give account of all the other bodies?") turns us into characters in the picture. So if we're to see this body, do we have to become other characters in the picture? And is that what we call a *mise en abyme*?

Or rather, why is it that we can only look at the picture like one of its characters? But a character who's supplementary to the scene in the way that Sebastian is.

Or again, why is it that we can open up this space (interrogate it, live in it) only by complementing it, that is, by closing it up behind us and thence participating in the secret (in the illusion of the secret) that it organizes, the secret that would thus be everything that figuration hides? The painting doesn't exactly explain that; it makes us watch our own enigma. This is the enigma: the visible is what we don't understand, or what constantly agitates a blind spot within us, this blind ray that instantly mortifies all perception. This picture finally paints us, then; it makes us live on the edge of its scene, precariously balanced, our backs entirely up against a shadow that still hasn't been painted. We won't be able to grasp the whole picture unless we lose it entirely.

The characters (and we ourselves) thus look at the picture in different ways: they're not doing anything else (in fact they're looking at Correggio's ultimate trick, the smallest of skins, situated among them). The picture is made in such a way that as soon as we discover such a secret we can no longer be anything but one of its characters (the one, precisely, whose turned back hides the painting). One of the characters – does that mean, strictly speaking, another body?

Or that one more hand joins these already crossed hands? Berkeley: "Qu: wt do men mean when they talk of one Body's touching another. I say you never saw one Body touch. or rather I say I never saw one Body that I could say touch'd this or that other. for that if my optiques were improv'd I should see intervals & *other bodies betwixt those wch now seem to touch.*"[5]

HOW to have done with all these extra bodies, these intervals between movements, these bodies among themselves, the monster and the weak god who has collapsed on the scene? And how to leave the body through which all the bodies touch each other?

the wrinkles

Let's pretend that this picture is a face: immediately (with the horses at the top and their world, that is, the imagination of the states and

bodies that they recall) it offers smoother and better illuminated sur-
faces, declivities, shadow, a multitude of looks (internally, but im-
posed upon it from the outside as well).

It also presents some wrinkles, zones that are more indistinct, very
fine grains (or as if such a face had just been constructed from several
different ages whose combination endowed it with an expression –
as if again the whole picture were a blemish on the skin . . .). For
example, if the painter fills in or illuminates those lines, they become
objects or figures. But does this make the picture unstable? Is there
something in it then that remains unfinished, not quite fixed, and is
the picture then internally drawn toward one particular color that
would efface all other colors? And how, if it's a face (a huge animated
face), can it contain so much *body?* Are the picture's folds thus the
only insignificant detail that had to be introduced?

IMAGINE immediately that one could make an inventory of these
folds, these spots, these fibers or these hybrid figures that gravitate
in the picture. Or else try to suppress them. What would remain? –
perhaps exactly the same picture, that is to say, the same effects. So
must the picture remain intact after the subtraction of such a quantity
of painting?

Is it again made so as not to change if another painter (if, for exam-
ple, I myself, who already belong to the division of these visible
masses) then started to organize the painted matter in another way?

But in order to see all that, in the shadow of this scene, in the limit
of the red and bordering on these folds of red fabric, you'd have to
touch what you guess is there – look, that is, at what wasn't made
to be seen, look at what's not in the light and that retains not the
slightest particle of whiteness.

A black surface, embossed at the Virgin's elbow, is wrinkled or
loaded with all the folds of the matter of the picture. Black is nothing
but the color of the most invisible body.

And why is it that, alongside these slick faces, these faces stretched
with light, the picture's ageing, its grimace, its usury, its hell, are all
collected together into one corner of the picture? There's no expres-
sion here and this isn't the effect of a fold in the breeze; it's a wrinkle
that's dried out, so it's a sinuosity and a relief that reflects nothing.
Like the silent work, rotting in the shade, of bodies that have no
color, that are, strictly speaking, invisible.

A crust of painting that nothing pushes or lifts from the inside? a
corner of the portrait of Dorian Gray, abandoned to time? or of the
unmanageable model who wouldn't stop moving, or of someone
who just had to be *the first to look?*

Is it possible to imagine lighting this shadow so as to make an
object emerge from it? You have to cross immediately to the other
edge of the picture – passing across bodies, dresses, knees – to where

a hand is resting upon a broken and indistinct wheel that seems to be made of breadcrumbs.

What animates this whole scene, the pearly or transparent flesh, if not the transfer onto those angles of an invisible weight, of what subsists as a pure quantity of painting, entirely impregnated or loaded with the invisible body's color?

Yet if you make those uncertain traits disappear, the two women in the picture continue to play; they send light to each other, from one face to another, and one of them collapses.

Correggio's two tricks

Vasari: Correggio's trick is in his way of painting hair (that is, painting the very matter of painting, and painting a body without the support of a body).

Berenson: Correggio's trick is his lack of depth. He discovered how to paint surfaces; and, painting the surface of the picture's characters, he obviously painted their skin, giving it life, that's to say, color, and iridescence – breath. The sensuality of the women in Correggio's religious paintings allows for a Jesuit marriage: "I then understood why his sacred subjects could not please, for he had no interest in the male figures, and as to the female figures, the charm of femininity, mixing with the expression imposed by the religious motive, resulted in that insincerity which closely anticipates, if it be not already an embodiment of what in painting we call Jesuitism – and quite rightly, for the Jesuits always traded upon human weakness, and ended by marrying sensuality to Faith."[6]

THAT hand is still the ultimate character in this painted world (the index of an additional charm, thus: hair, skin, hands, and clouds – these are what apparently constitute the whole anatomy for Correggio. But this hand is equally the first character in the picture.

A hand could touch all those "signs" in Correggio (it is also his only imaginative trick): lift up, wave the hair, brush the skin: so the picture is the unification and the ideal animation of the elements of a body that touches itself through those parts.

So the hand isn't yet a figure, but it's already a character; it's a covering; it's a fetish for the painter. But if a hybrid figure like this were seen in isolation, wouldn't it appear completely monstrous?

It is, first of all, detached from any body to which it could have been related. We've seen that a figure is founded here on these fingers (and this new form is the result of the contact of several bodies – Berkeley: "I say you never saw one Body touch. or rather I say I never saw one Body that I could say touch'd this or that other," unless you can see, perceiving the spaces in this contact, the body

that emerges from among bodies that seem to be touching). Or that forms pass into one another according to the cinematographic technique of the dissolve.

But if this hand were in some way independent and took on a life of its own, crawling, moving, grabbing at other prehensile and tactile members that stop it from getting away quickly or directly, wouldn't it look like a spider, a hairless one, or perhaps some sort of crab without a shell?

We've been imagining a union between Saint Catherine and the infant-god. But what's this crab doing there between them?

omens of death

Bit by bit, a second picture begins to appear, almost imperceptibly, like a star, within the first (and looks at it from the inside), and it is made by punctuating the space or the scene with signs of death.

That, for example, is what seems to survive from the mystical spectacle of Saint Sebastian, or it's the consequence of his contemplating those fingers, his burning gaze (and his mutilation is offered as a discreet sign of his renunciation) – and perhaps it's what is present too where the picture produces this enormous efflorescence, where this flattened body is wounded by displacing itself: distractedly playing with his arrows and anesthetized by what he's looking at over Catherine's shoulder – at the same time as his tunic places the figure of a lion on the Virgin's neck, he pricks his finger and bleeds, and his bloodied finger, this blood that flows, intensifies the picture's unsteadiness from his tight angle. And those signs intensify his expiatory destiny, over which the Virgin rules.

The flesh tones also mark a passage toward a dead body: the child-god's pink flesh (framed by the red of his mother's dress); Catherine's yellow waxiness (in her cloak and her dress, the approximate result of these two colors), as if she were anemic, and imperceptibly approaching the green of her cloak; the celluloid pinkish-yellow of the doll (the other fingers sticking to this figure are almost a bloody pink); a balance among the flesh color on the Virgin (*frozen* flesh), the red in the martyrdom of Saint Sebastian, and the white (albumen) in the martyrdom of Catherine (treated thus in glair or egg white). And then Sebastian's pinched ear, his whole face inflamed.

The Virgin's profile, on her hair, is drawn by a crest or a light garland, leaves or weeds, a crest, very pale. Almost invisible.

THE fleshes or skin tones are captured in that way, as soon as some whiteness is added to them or the light falls upon them, as soon as a *luster* appears in the skin's humidity, in the tension with which a body, otherwise controlled by its muscles, can endow them, the ex-

treme tautness to which it can continue to stretch them; in a *force of
extenuation*. At the end of a finger, then, the skin changes from the
milkiness at the edges of the corpse and the bleeding meat to the
greasy yellow of the hem. Rome used to imagine likewise that in
pallor there was a god and a plague that brought only whiteness and
killed the last living being – that is, the inimitable body – with dark-
ness. The body that the desire for light continually extenuates here –
the body that, as Saint Catherine dies, is astounded by the consis-
tency of her paleness and by her cries beneath the blows of the living
and the dead ("because his unhappy memory causes memory to kill
him"); because the machine's annihilation, when a wheel crushes her
flesh against iron teeth, persists in her as the annihilation of the price
put upon her torment, and because this broken wheel formidably
produces in her the desire for this cruelly extinguished passion; so
she endlessly succumbs only to the remnant of a life devoted to the
memory of dying, only to this broken wheel that bends her over
backward; and, falling beneath the redoubled blows of the continu-
ing massacre, she collapses into this deeper or more yellowish white-
ness, and consequently her hand can no longer point to anyone.

The machine or the disk that, as it turns, pales or discolors faces,
for example, is driving the mill, grain by grain, that bites into the
saint's back and throws her into a perpetual swoon.

eyes closed

So the upper parts of the picture represent the Virgin's double con-
sciousness: the martyrdom of Sebastian is attached to her hair, the
martyrdom of Catherine to her closed eyelids.

Her hands join other hands, or close up the distance between bod-
ies, annul that distance by way of an added sign, a sign that all the
characters inhabit, desire, and through which they are all extenuated
in their turn (the mystical union). The Virgin transforms the whole
countryside into a destiny of sacrifices.

She is, then, the principal character, not because her face is the
smoothest but mainly because all the other bodies pass through her
for their annihilation. So is this Sibyl, this Circe, a torturer? She's
seated and manipulates, changes, helps the dying Catherine on to her
death, helps the androgynous baby on to becoming a dwarf. She
doesn't put a stop to their suffering.

The meditation on time that doesn't affect her face allows this
blind manipulation to shine in her: time as suffering is the imagina-
tion that she endows to all the bodies. (What we have here, just the
same, is a confrontation of the two virgins around a dwarf, uniting
them in a double portrait.) And in the empty invocation of this *stella*

suppliciorum the original meaning of *supplicium* is genuflection. Sebastian's finger is bloodied by his arrow.

THE only scientific explanation to be offered for this physiognomy and this comportment is indeed that the model who sat for the Virgin was a woman afflicted by deafness; thus, deaf before being virginal?

SEBASTIAN, for his double torment (his place as witness, his pricked finger, his martyrdom), and Catherine, for her annihilation, return to that silent meditation or to that deaf graft of a history of the bodies of characters united by the Virgin. The church used to say of the Virgin (by the invocation of the *virgo crudelis*) that through her virginity she had placed in herself, like a fruit of stone, a limit and a kind of milestone, like the fulcrum in the Roman circus, the stone which, stopping generations, simply stops succession in death. So this figure who has placed in herself the stone of sleep for her centuries of dormition is basically deaf to the most elementary supplication. The supplication, releasing the hand of a character who is destined and marked by this abandonment, that she should put an end to their torment.

But this death, stopped in the connected effect of generation, is simply radiant: in this figure made up of ecstasy, transport, wounds, and miniaturized massacres – and, doubtless, like a nimbus around man's halting or decelerated disappearance, the disappearance of the race of giants, under the ecstatic gaze of the androgynous dwarf.

time

The background upon which the characters turn their backs can only be imagined as the past rather than the future (the destination) of two of them.

The center of the picture, the equidistance between the figures or the whole bodily zone framed by this multiple hand, is the point or the pivot around which figures or scenic functions are exchanged and equalized; beneath the gaze of the fingers they become, strictly speaking, indifferent, equidistant from the figure that seals their future.

So this presumes only one action – that is, a sort of perpetual present. The hand that's suspended among all the stomachs, casting a shadow on the picture, is less than the sketch of a figure, then. It is a rose of breezes, a rose of action; in this hand made from several different hands – none of which points to anything – a star (of wax, of flesh or nacre) revolves indefinitely in the same suspension of time

for all the characters (who are thus condemned to be able to swap places). As soon as it falls, assuming that it does, it enters the sketch of a child's backside, or slaps it.

The light of the scene corresponds to this circular or null eternity; this light simply revolves, focusing on a ring.

SUPPOSE your fingers are dangling, and are lifted up by other fingers from beneath, and another hand immobilizes this greasy flower, if stumpy fingers are then attached to your palm, you'll not be pointing to any object, any place, any point, even any name. You'll just have to decipher this enigma: how much time did it take to make this composition of nails and skin? All you'll see then will be time, and if it could move, this new hand would show only the time from which all the bodies are equidistant.

attribution

Who is the infant-god's mother?
"God has made me with child."
From that point onward movement begins to decompose: "thus I give my child to God."

A calculation: if Catherine dies or remains hanging near death, then some part of her probably becomes the child of god-Jesus.

This connected reproduction reaches the limit of its possibilities in miniaturized bodies.

We've shown that, in a play of lenses, the body of the infant Jesus could diminish – and, equally, paradoxically grow – to the size of a doll. Proposition: an androgynous being thus has no fixed size, it receives one only by contiguity, by annexation, and in proportion to the object it desires. Thus, this object defines the androgyne as both human and monster, that is, in any case, endows it with some sort of proportion, from which. . . .

SO all this lands up *in miniature!*

metamorphoses

Ovid crosses the picture, that is, the sequence of the states of painting in these successive determinations of forms:

The hill, the hair, the trees (the grove and the archers), the suppression of the trees and the hair; the dwarf and the doll: single beardless body.

Metamorphosis enters and works both background and foreground, the depth, as a story (that is, as a sequence of avatars) about

86

the figuration of bodies. A few signs taken from the mystical scene organize a history of figuration in this picture; it's also just a whirl-wind of details, like a wind, pilgrims trapped in sand, a light fog or dust in their eyes alongside these Olympian giants, inordinately busy, inordinately seated, majestically perpetrating the extenuation of the smallest one among them. Yet, from that first vibration of heat in a body located among a hair, a tree, and its shattering on a star of skin and transfixing those gods, it's like a diagonal ray that finally transpierces the whole picture and, like a trunk or an arrow, even crosses the flesh of the seated bodies.

That hand is only a body (I mean that hand as it's supported beneath the eyes by an invisible stalk), and a body that's simply lost in all these differences of size (so every character is painted according to a scale and with the size proper to it). So is this body *taken out of limbo?*

In Plutarch, following Ovid, the bodies of the dead are submitted to the work of cutting and weaving for metempsychosis: every anatomy has to be remade for its destiny in eternity, beyond its punishment.

According to its strict scale, the foreground (where we find this hand moving in opposite ways – it clenches, moves away from itself, escapes, holds itself back – this hand finally bringing a shadow, and immediately dominating that shadow with its own small mass, becoming a unified figure by way of this simple projection), the foreground ought to be the very background of the picture – if such an encumbered character is indeed the farthest away. If it's not over there, then it's the miniature of the picture.

And what if the head of which it's deprived had, for example, already been transferred in effigy to the medallion pinned to Catherine's corsage, in the sketch (ivory- or bone-colored) of a death's head, or a moth, a hawkmoth?

forgotten scene

So the picture has been composed of geometric relations between paired terms: the virgin and child, the child and the dwarf, Saint Sebastian and the dwarf, Saint Sebastian and Saint Catherine, and so on. . . .

The picture has further been composed of mathematical points and chromatic points, colloid or powdery. So we've seen how a body is doubly engendered starting from a single point, and how in turn such a point is reversible within a body, or in fragments of undrawn material which, as they are added, can become anatomical parts. It plays, then, among a point, a body, and bits of dust (smoke, clouds, or the imagination of a Brownian motion, of a swarm of

colored grains in the canvas – where we've acted as the hint of *one fly too many* surveying some of the detail of the figures); it plays, then, as a double hypothesis, both geometric and plastic, somewhere between Ovid and Berkeley.

All these relations, between points or between opposed pairs of characters, come to be figured at an angle to the painted world's center of gravity: in the middle of the universe, in the middle of the assembly that presides over the ruling of this universe (not over its fate, but over its imminence and over the suspension of its annihilation in the light), the transitional object of all the relations composes a flower of flesh, a blister, a single, smooth finger fixed in fifteen successive positions. This multiple index of time, the hand of supplication, the ignoble body which alone can reside as a complement to the whole apparatus of torment, that is, the way the same SACRED figure, passing constantly from crime to innocence, returns to the eyes of all the larger figures, the return of the only figure that's on bended knee.

But that figure, as you see, has managed to relax the tension (of lust, abandon, hardness, softness, and obscenity – but again, of color, or light, or shadow), relax the tension that brought all these characters together. So these characters have assembled to produce among themselves the very object that unites them, and to see that object deformed and pulled in all directions, pulled toward all sorts of forms by their individual desires (so each of them might be coupled to this image that's drawn according to each of their points of view, that is, drawn at an angle). So this body, in a unified way and on all sides, derives from the broken wheel (the wheel that's always cut off from the quarter of our desire because of the imprescriptible condition that such desire can only be wholly conducted upon this sight), and exists only by virtue of those angles. Fleshing itself out beyond limbo, it can only suppress all those who join with it.

So it's the mystery of a second incarnation that's being played out here, alongside this transfixed infant-god: so the incomplete body incarnates the finality of every figure, that is, its look (or to put it another way, its obverse). So, are all the characters looking at their own naked backs? – they are all contemplating in deep despair the only body that suppresses all of *their* bodies, the only object that's needed for them to be annihilated: and if that object turns away, and if it turns away without showing anything, then everything has finally to disappear.

But have we forgotten something? some other point among the points? another body, that is, another relation? – every relation, Correggio tells us, is a new body, and that's why the picture, written down in both Berkeley and Ovid, is multiplied in several ways, that is, according to proportions that are *extreme opposites*.

Have we forgotten to unite this saint to God? have we actually

forgotten to talk about the picture's subject? – almost, although this union passes through all the characters, except through the union of the saint and the infant-god. It can't get beyond the Virgin's mediation. Nonetheless, it also can't avoid contact (that is, the body in the extreme interval of a movement). This contact is Saint Catherine's coma. This contact and this body suppress the object of all the bodies. But this figure suppresses all the figures except the one that becomes scenery: so it effaces the whole picture.

so the question is just a rhetorical one.

IF there's no body to resist the duration of the luminous emission of the anamorphosis that prolongs it, that is, no body to resist its contact with the visible, if the picture undoes the picture, if a single one of the figures (and the least clear, the only one that has no iconography) effaces it and eats all the figures because they are in their turn unfinished forms or shams (for example, dressed up), the saint and the god unite only because of this recourse to a form that destroys all forms. In short, because a star or a monster, an incomplete metamorphosis (Ovid corrected by Berkeley or Descartes), is corrupting all the light.

Your question about how to unite a virgin with God has no answer. It gets its response here, rather, in the dormition of the Virgin and in the stone of sleep that the saint in her turn tries to push into her body. It gets the reply that she must die even as she stays awake; she must die because what He loves in her is the very surrender of her death. So, close to indecency, her sin and her banner must survive her as the abandoned body; in this perpetual swoon what must survive is her unrecognized desire to be the absolute other loved only by God. So she keeps on swaying into this future of albumen, ivory, mashed bread, white linen, yellow, moth, hawkmoth, swinging by a finger that has come unlaced from her body.

Your question has no answer, your question effaces the whole picture.

It is a rhetorical question that ought to be phrased as follows. . . .

measurements

Why unite a virgin with God? and in this picture, unite her to which even smaller god that might be figured? to the one that's precisely the smallest, the little finger? to the point, to the dust? or perhaps to the one that's not figured, as if the mystic union might take place once more somewhere behind the picture, on its reverse side? But what if one figure represents within itself the turned and naked back of all the characters? You still can't make anything out on so concen-

trated a surface, it hides in turn the only – and smallest – picture of a world that you'll ever see, placed at the tip of an inverted cone, an indiscernible point whose perspective is still obstructed by this very confused, concentrated, welded union of naked backs bent over the orifice of that world. . . .

So ask me only this – and the reply is written in books: why and when, perhaps, was it possible to imagine – and for the sake of what addition of an otherwise unavailable blessedness – this union of a virgin with God? And the word "mystic" here: does it mean "mythic," from the word *muthos* (a fable), or mystery (from *musterion:* silent history), or is it explained by the offices of the *mystes,* priests of the perpetual initiation into the hidden things?

LET'S try to add more, all the same, one last time, just for the pleasure of the experience.

Leonardo da Vinci's anatomical schemas of the human body are hypothetical combinations: there, anatomically unknown human organs are replaced by animal parts, and thence the physiological world is crawling with grafts, permutations, hypotheses, pigs' snouts grafted onto men; and so in this torture of our species the universe gives off an endless din of bleating and baying. Similarly, the entire organism is a puzzle made of a woman's body, a human foetus in the uterus of a cow, a dog's larynx. . . . But what has this to do with our picture?

It is that here, in the same way, the unknown (that is, the unexperienced) anatomy of this coupling is *dealt with by guesswork* across variations of size. What, for example, is the result – not the act itself, but the result – of this mystical union? If you mathematically express the relation between two anatomical parts as that between two distinct bodies – for example, between Catherine's body and her hand turned into a dwarf (and immobilized to that effect) – then a simple proportion results from the difference; so, mathematically, the infant-god is the androgynous issue possible from such a union.

And what a frightful secret has thus been unleashed, step by step, upon the world of babies.

ANOTHER hypothesis still remains.

The coupling of saint Catherine and her hand – or her kind of proportional subtraction – might produce a little woman's body (a term anatomically absent from the picture) facing the Infant Jesus and having the same size: a prepubescent girl, or a female dwarf indeed.

But this anatomical conversion is quite obviously a physiological impossibility; consequently, we can expect nothing from the world of babies.

And so your question has led to completely absurd answers!

spiral

(rapid movement)

Like a dog that won't give suck, the Virgin inflames desires in some unknown (that is, unexperienced) bodies for the pleasure of a spectator. That spectator wounds his finger – like the two cupids of Danaë who tease arrows.

The most unexperienced body is both beardless and blind: so it's not offered any kind of spectacle; it's tried out, manipulated, and made to mate with itself.

In the middle of the unfinished circle, this copulation is done by this kind of snail whose spiral shell uncoils in such a way as to describe, as it turns, the place of each character.

This is how Saint Sebastian gets his revenge.

Correggio dies in 1534, having been born in 1489; his whole life is written on a scroll. He dies of a sudden illness. He would have painted this picture around 1526, and that year he was blessed with a daughter, Caterina Lucrezia: so he would have given the name of the picture to his daughter, the name of his daughter to the picture, and put his daughter in the picture. His daughter was born blind, dumb, and tiny, and she died; that's all written on a scroll.

(transition)

Consequently the subject of the picture doesn't exist. So if that's the case, how can the picture come into existence through the destruction of its subject and its own internal exhaustion? The painted figures look – that's the whole fiction of painting, their definitional visibility. Like bars of soap in Dutch paintings, they can only look indefinitely – if every gaze recenters the imagination of an active visibility surrounding it – or they can sustain the consciousness of a visible residue left by the sudden retreat of their bodies from the field (and the visible grows around you only in an undefined moment of the latency of your whole body); the painted characters would evaluate the extent of this catchment of images, allowing only premature ghosts to run to its surface. That is to say, a new cohabitation of time in the corruption of images.

miracle

This is no majesty ruling over this scene, but a sovereign deafness.

The mother of God doesn't hear the cries that accompany the metamorphosis – the suffering of fishes tortured in aquariums.

A hook silently lodging in their flesh, no cry, trapped in the water,

impossible to breathe, a cloud of blood in which this tormented body
lands up suspended, that is, giving a few spasms.

Thus the silent reign, in this light that's so exactly placed, no
dazzle.

the closed eye

Yet the Virgin's closed eye, or her eyelid lowered over the eyeball,
the mirage that it locks and holds in, allows another picture to escape
or collapse in the grass – a minuscule picture at an angle beneath the
moon, seen by closed eyes:

> he had executed admirable paintings that one would almost not call
> mythological so particular were they to him, painted in fidelity to a uni-
> verse that he carried inside, or that he perhaps saw before him where we
> would see something quite different whose consciousness had dimin-
> ished to the point of making it something quite as passive as nature . . .
> clouds bleeding in a foretelling of death, mysteriously dark valleys smil-
> ingly consecrated and which knew the mystery that they locked away,
> the sea happy to transport the *Argo* . . . a promontory dedicated as a
> marble temple and finished as a temple, a bird that realizes that it stands
> for death or inspiration, the serpent/monster conscious of the struggle it
> engages with the hero, a Muse looking like a traveler, a courtesan as
> serious as a saint carrying her sin like a badge almost separate from her
> and as serious as a saint, the hero calm and as extremely gentle as a young
> girl, his head bare, his body calm, his limpid eyes directing a sword into
> the flesh of a monster that seems conscious of the struggle in which it
> engaged against those eyes, his steed a horse with eyes half-closed like a
> courtesan lazily training her eyeballs beneath her eyelids to admire his
> trappings, furious horses grinding their teeth and rolling their eyes.
>
> Why his inspiration always made him cultivate, as if he were filled
> with something more precious than the rest of the world, a certain look,
> that of a serious woman, with the purity of antique features and with an
> almost childish expression. . . ."[7]

(As if this page from Proust, down to the last detail, had been
destined for Correggio.)

Ovid's Ovidiana

Descending from his whistling forest, Sebastian – a hedgehog of
arrows, or an aged cupid – surveys the massacre from which he has
escaped.

With Correggio the wind has thus forged this division in the open
sky and this invention of mixing fibers in the wind but making them
push the limits and release a wad of cotton as if from a tree, or from

a head. That is to say, taking hold of the sky, that is thicker here and already engages this fringed material, and pulling it apart with both hands like the edges of a wound. Leaves trembling and head and clouds made of skin, almost there in these trees, planted root and branch in reverse into the head of the Virgin, like birds, like little branches, like bits of straw in the hair.

And the god Apollo said, "*arbor eris*":
'My bride,' he said, 'since you can never be,
At least, sweet laurel, you shall be my tree.'
. . . On the trunk
He placed his hand and felt beneath the bark
Her heart still beating, held in his embrace
Her branches, pressed his kisses on the wood;
Yet from his kisses still the wood recoiled.
'My lyre, my locks, my quiver you shall wreathe . . .
So keep your leaves' proud glory ever green.'
Thus spoke the god; the laurel in assent
Inclined her new-made branches and bent down,
Or seemed to bend, her head, her leafy crown.[8]

The stag lay down upon the grass to rest . . .
There, unaware, with his sharp javelin,
Young Cyparissus pierced him in the heart.
And as he saw him dying of the wound,
So cruel, he resolved to die himself.
What words of comfort did not Phoebus give!
What warnings not to yield to grief so sore,
So ill-proportioned! Still he groaned and begged
A last boon from the gods, that he might mourn
For evermore. And now, with endless sobs,
With lifeblood drained away, his limbs began
To take a greenish hue; his hair that curled
Down from his snowy brow rose in a crest,
A crest of bristles, and as stiffness spread
A graceful spire gazed at the starry sky.
Apollo groaned and said in sorrow, 'I
Shall mourn for you, for others you shall mourn;
You shall attend when men with grief are torn.'
Such was the grove the bard assembled. There
He sat amid a company of beasts,
A flock of birds. . . .[9]

Thus the sky marks the distance between these two images and further divides these two similar forms. A quantity of trees and leaves separates the whole incipient universe here by pulling away the caulking of hell, this wool. The world of Correggio begins in this way, it begins then by opening up exactly the wrong way round.

film

The Virgin, the child's perpetual guardian, is also the guardian of his world, his imagination, or his dreams. She holds sway over time, that is, over proportions (over the little film – the martyrdom of Catherine; and the little theater – the martyrdom of Sebastian).

So she immobilizes in this child a world of covetousness or unassuaged – unfinished – desires.

Are we already justified in imagining a dark intelligence here from which would emerge, under the pressure or the sporadic bursts of lightning, some series of pictures made from the fading of this darkness, or that in flashes of sulphur and magnesium would allow the escape of agile or somber silhouettes, but silhouettes that are younger, more pale, and more untamed than the chaos of images rolling aimlessly around in the middle and the very center of this spirit that's inhabited by the desire to annul the images awakening within it? Or in imagining here a vampire passion satisfying itself only on those silhouettes that are still black, and that the light consumes grain by grain?

So, is it an interior being, one that has arrived in this fiction from some sort of wheel of existence that represents a species, a fiction simply anticipating the effects of the cinematograph? a being that is filmed by the Virgin's eye in Correggio's picture?

Illuminated from the inside, the image can no longer be reached except through this impalpable film whose figures are hardly discernible from the vegetation and dust in the background trembling in time with the figures – even though this whole world, moving at the speed of a grain of light, excludes from movement no part of the fattened and clenched objects scanned by these emulsions of photons.

This movement – whose beam is projected in a cone by this eye, enigmatically lowered onto what it contemplates, onto the implacable muteness of its imagination – allows these attenuated bodies that are loaded down by a thick whiteness that absorbs the light for them, allows them to sink or to be worn down for the sake of this minuscule picture.

Emerging haltingly in a parade of images, the scene or the narrow film strip of the martyrdom of Catherine assembles, on pale figures and silhouettes of colloid illuminated from one side, in the thickness or the counterweight of a lowered eyelid, assembles only this amorphous and liquid time, this powdery time upon which, beneath the gaze of a lonely eye, these figures seem to run around; and with their hands of dust they touch the shadow or the very time in which every form is extenuated. So the Virgin's eye – even before the light can turn the silhouettes of the martyrdom around – overtakes them in a zone of evaporation. Rolling in a chaos of images and escaping even from the pressure of this jutting forehead, like a star with no mem-

ory of colors except the increasing pallor of this suddenly returning thought or the soiled spectacle of the martyred saint, the crumbling of a slaughter is perpetrated in front of this face.

And still remaining, like bits of dust dancing in a ray of light, the body of the saint, and the horse, and the rider (who melts over her like a block of gelatine or the forepart emanating from a substance that no sunlight can reach) are transported beyond themselves; they finally function in a place they cannot reach: they encounter a sphere of evaporation, and they enter it. But they all lean away from the eye, and they glutinate, with no light, without any time.

Caught in an incessant exchange, porous, supremely uninhabited, this body is effected only by way of this putrefaction of moments in which a rapid glance can find nothing but an immediately diminished memory, the horror that grows around two bodies frozen at the moment before an ancient crime.

So, by way of an originary extinguishing of colors, the wide angle beneath the eye of the Virgin films the memory of a sacrifice; but if this memory is halted in the perpetual instant before the repetition of the murder, if this moment itself is infinitely repeated, then every figure begins to rot, or is atomized by the return of the unfinished memory, and by this other crumbling where memory no longer consumes anything but the unfinished figure of time.

Or this rough-cut film remains, and the incomplete capture of bodies in this corruption of points, corruption of matter without any exception into atoms of light. The apparition of forms from the dimmest of light resembles the sun's primitive writing on a sensitive surface, and in a moment of universal decomposition it also freezes a whole world of light, of shadow, of bodies in an infinity of powdery points. The painter immediately demonstrates that the whole picture rests beneath another light; he rounds off a world that's had no sun.

So the dust walks across a silhouette that's simultaneously black and white.

Forms, caught in an arc of extenuation, walk across a fold of clothing in this snow from which they're made, and they stumble – illuminated in the direction of their steps, or by the moment when memory freezes them once more. The emanation, the thick gas, the return of the scenery amidst the bodies launches this march against stopped time. The horseman merges eternally with the silhouette on its knees that forever crumbles before being struck by the blade. They walk on photons, in the land of the luminous ghost. These subtle bodies trapped in the middle of time can no longer stop the light that crosses them. Simultaneously black and white, they're forever falling under the same moon. The world from which they emerge doesn't reach the sun's orbit; shadow can't follow a body there, it remains within it.

This horse was never anything but a knoll, a pile of earth fash-

ioned without water. Three points disarticulate the physics of this little image: the horse collapses beneath a pile of earth, the rider drives a white standard into this powder, the woman on her knees is opposite a cloud of grass; there is no more complete body to reunite these motions, and so they disappear.

This film reinstalls a scene glimpsed in the supreme paralysis of a memory, fixed on a moment before the horror of yet another murder in the world of the living – and since this sacrifice can't be transfigured and has no place in sacred memory, the palpitation of images is immediately immobilized; they are destroyed only on these white shadows.

If the earth trembles it's because an unstoppable stream of flakes, dusts, and grains cannot be fixed and because, simply, these immaterial souls are shaking the world – an angle opening onto the darkness, before the apparition of any object, as if its speed or the first disorder of its composition had to cross the whole world; as if every object of the world (and in nocturnal imaginings) had a double somewhere in another universe where there's no matter or substance, where the only space between points is lines, where an immobile horse crosses the darkness in a seedbed of revolving points, billions of them, photons, grains caught up in a whirlwind over some of the emptiness that's limited only by the mysterious gravitation which closes up a body within this addition of emptiness; and as if, before getting to the reflection and the collapse of the rider on a protuberance of dirt, and before locking up the images of men in waves of sand, this sand, this horse, and these men were all crouching in a kind of anticipated extenuation of their substance; as if upon this angle opened up by an unknown sun in the path of the luminous ghost, the rapid dance and the flow of atoms and the enigmatic bundle above our heads (that children avoid touching for fear of being reduced to ashes by the light of this unknown world, by the muffled rattle of the projector), as if the horse that's forever falling and the woman eternally on her knees had begun by flying off into the darkness of a million dots; and as if the vermin that infests bodies whose images disappear were attached to those dots.

scrolls

The larger figures, melding with the smaller ones, the little ones finally indistinguishable from the larger – the child indistinguishable from the adult, because the former entirely takes over the latter's visible power, that is, the aureola of looks for which this mise-en-scène exists; are these figures hiding something? Aren't they hiding the very logic of the painting, whereby something disappears into a luminous tension by way of those hands; because of the forehead of

the Virgin that juts out like a star, is this something that disappears only a shadow? or all the shadow of this light erecting a wall of black cardboard cut out behind the characters? Because, then, the center of the picture is simply given back, invariably and incessantly, to a species that's perhaps only the most luminous; given back to this luminous necrosis where a metamorphosis dies, rays of looks, eternal jealousies.

Or are these figures, their skin strained, incessantly charged with just the reliefs of a red material and a yellow material, just to suppress all the shadow that disappears into them?

One figure in the picture is offered as the whole species of the visible only insofar as it stops dissimulating the actual proportions of the visible, that is, the anticipated place of the grand convergence of a geometric world that contradictorily shines from within it.

And these figures, don't they immediately become the delegation of the invisible world that, by means of such colors, is constantly gazing upon the blind spot within us that we can't manage to locate on the canvas, so uncertain remains the splitting by which we're held in the ultimate desire of obscenely recovering these three volumes of the sacred world that comes to us only in fragments? And on the Virgin's jutting brow – that's even more prominent because of her lowered eyelids – the body of a child-god, floating in the light of her closed eye, blushes, turns yellow, or is carried off like Ganymede toward the coma of the saint, and the set of a hand, the handle of a sword, of the same very elongated hand on the broken wheel, but smashed like a soft stone by the suspension of a primitive torment – and that's still revolving behind the saint's eyes and pursuing the god in a fit of haste. But that pursuit exhausts the metamorphoses, or a hook silently lodging in a fish's flesh, no cry, and so this god, huge beneath the lowered eyes, rules by a series of endless swoons, because the decrease that realizes the union of light and body ceaselessly kills the victim in an infinite desire as she offers up the expiation of her vow.

the broken wheel

Have we ever been in this picture? – we're attached to this hand, but attached like a fly; so, this figure, this little invented body, coveted, gazed at, and animated from below, like a puppet, is the only speck in the painting where we can put ourselves, *because in the end it remains incomprehensible.* That's why this incomplete body is destined to become our place of residence in the picture. So it's this incompleteness that we have to complement by way of our own incompleteness; so it's this missing or lopped-off head that our gaze can't supplement.

So you're here – or you were – so as to add nothing to what's

already incomplete. You passed this way in order to add to this albeit finished world the incomprehension of another body within yourself.

But this object that contains all the other objects, that is, the object that contains all the looks and is the limit of the imagination of all desires, doesn't go through us. This tiny or inordinate prey is the picture's highest prize. I mean also, exactly, that this graceful and obscene knot is a prisoner of space.

But why didn't we leave this circle, or the incomplete center of this circle, or this "fractured circle" of the divinity (or, finally, the shadow of this broken wheel)?

As if they had been pressed into a sphere or as if they just constituted this circle, the characters lean toward the center at varying angles. But this center is just the thing that has the power to send them back to the light, that is, back to the eye of their color.

We *are* here, in the logic of these turning bodies, the fly or the moth that's stuck to this light, the quarter-circle that isn't figured and that could close up this circle and render it invisible; a wall, or a supplementary fragment of the world where time resides and that rounds off the earth.

We can't get out of this hand, nor the long trajectory of the painted faces or the eyes resting on the hand; we can't leave this strange colloquium where we constitute a fifth incredulous gaze – like all the characters, we're incredulous at the identity of the thing we are looking at.

That thing, that's simply the smallest, has just returned us to the perpetual light of this assembly, to this light that's uncrossable only because it's round or still worn on time's dial. Because, finally, we too turn our backs on the martyrdom of Saint Sebastian, on his sky, that is to say, on that which is not transparent.

We have only ever been in this picture for a quarter of an uncertainty.

propositions

Looked at for a long time, the picture irrevocably loses its sublime character; in the incessant sliding of its forms, in the stretching and shortening or the ineluctable escape of its figures, it begins to reflect the corruption of our spirit. So it enters into these images endowed to it by the gaze of this spirit, simply corrupted by the duration of the images within it.

The same thing can't fail to happen if you yourself enter a field of mirrors: "You will see yourself infinitely multiplied, strolling now in the air, now in the deepest pits, then suddenly with two, three, four, five heads and sometimes with mutilated or monstrously deformed limbs.

"If you place yourself in front of a spherical concave mirror, at its center, your head will appear upside down, your feet will be in the air. If you get closer, your usual face will be seen gigantic and your finger will take on the dimensions of an arm.

"The huge face of Bacchus will show a finger as thick as an arm" (Leonardo, *Notebooks*).

AND then if you leave this world of linked mirrors, the image of your deformed body (the memory of being accompanied by your second monstrous figure) never leaves the picture; it actually explains why you keep looking at it – and why, as you keep searching for a sublime reflection of yourself there, your image returns with mutilated limbs.

The image you see is the figure of the whole. This whole isn't the sum of its parts, but each part of the whole that you look at is a whole image of the universe. And still you can only properly see the detail of the universe transfigured in a mirror: all worldly things are just different tokens of death.

How to paint the distancing of your figure, that is, the depth of shadow; how to add flesh to the image, the color of the invisible body: "if you want to know what depth of shadow is best for flesh, cast the shadow of your finger above it, and depending on whether you see more light or more dark, put your finger closer or farther away, and then copy the shadow" (Leonardo).

Yet, caught between the painting, the shadow, and the mirror, suppose your fingers are dangling, and are lifted up by other fingers from beneath, and another hand immobilizes this greasy flower, if stumpy fingers are then attached to your palm, you'll not be pointing to any object, any place, any point, even any name. All you'll see then will be time, and if it could move, this new hand would show only the time from which all the bodies are equidistant. You'll see time, that is, the equidistance of all bodies from the finger that you draw close to or pull away from the painting. Yet no point can mark that distance.

The center of a mirror is constituted in a point that's situated nowhere; it's a point that no finger can indicate. This point is the one from which your second image is engendered; the irreducible extremity of this point is its obscenity; this extremity is neither physical nor geometric: it is the memory of what constitutes movement in all bodies.

And if the observer steps back sufficiently far, the picture is reduced to a single point that contains all possible points. This dot is immediately the one by which we disappear from the picture.

SO it's because it isn't a mirror that the picture reflects the corruption of our spirit.

99

clocks

So we have to find out what this sublime is – a sublime whose power resides in being snatched away. Find out how, stopping all our movement to look at a picture, in the same gesture we fix ourselves alongside death. This sublime is characterized – like time's internal aspiration – by the paradoxical power of being suppressed by its very effect: it makes us enter the consciousness of death. Yet this picture doesn't represent death; rather, it represents the extenuation of the sublime upon a single figure (and this extenuation is an effect of the sublime); from that moment on, the only actor in the painted scene is the half-coma of the saint.

The picture destroys in us the picture's image; and that's no paradox.

So an hourglass hung beyond time filters the material of the world as if it were time; the grain of mankind is poured out, and the final pile of sand represents only the abandonment of the most lasting time. No hand feels this powder flowing, no finger touches this image that falls beyond time.

The sublime, then, crosses this circular look and this perpetual convocation of twirling shadows that the figures of the picture look at, obfuscating them rather, one after the other, as on a dial.

And if the image of time begins to turn, one can imagine that in taking body it immediately exposes itself to being deformed by time, or time grinds it up. And if time turns on the image of a wheel, the body attached to this time and to this wheel will lose its figure, will feel its limbs being detached.

Thus the filtered time in the hourglass, the fluid time of the water clock – since it happens across the destiny of an entire species rather than across a single body – is aware of this archaic return that recalls the medieval idea of time's "innards" in the workings of a clock.

So the notion of time and the body that no longer stretches out, no longer filters but simply begins to devour its own mechanical noise and the grinding of its wheels, hasn't managed to become illuminated except by the spectacle of an arc, of cries, a second machine of groans – or by the very idea that a body, slipping into this machine, could write down, in the sequence of beatings and sounds, the moment of its own disappearance, could inscribe exactly the time it takes for an organism to leave not only its image but also this composition of organs in which an animal body can be discerned.

Thus the grid of this time is just this battery of pulleys, wheels, gears, and teeth turning in opposite directions where there's no pointer to record the trace of any of its revolutions; it cannot but consume the creatures that have been abandoned to the experience of time.

So it's a pound of flesh that this primal machine takes, these strange wheels, this hand-powered motor where, like Moloch, a barbarian obstinately flattens, lacerates, and devours the interior of unfinished clocks.

". . . In three days four wheels, studded with iron saws and sharp nails, should be made ready, and by this horrible device the virgin should be cut to pieces, that the sight of so dreadful a death might deter the other Christians. It was further ordered that two of the wheels should revolve in one direction, and two be driven in the opposite direction, so that grinding and drawing her at once, they might crush and devour her."

The imagination of time reinstalled upon this machine, and the imagination of a clock measuring just the acceleration of the body's laceration, produce this clock without a pendulum in which a body is accelerated by the effect of its own death and, along with its dangling flesh, loses its entire image. The spoked machine whose iron teeth tear up the most rudimentary time – that which measures the span of human life – is also a machine for tearing up images. So in the grinding of the wheels, pins, and wooden joints, a body disappears: because an even smaller wheel is grinding out all its moments.

A pendulum of flesh is attached to time's torture and, since the machine's motion doesn't impose a sentence on his body that's stretched across this quarter-circle, man will aspire to rejoin the geometric image of the god of whom Plato had said: god is a fractured circle.

The missing quarter, the body curved like a bridge, would be replaced by this soldering of flesh that seals up the image of eternal time.

Or this circle that from now on is open, like a spiraling enticement, demanding of all the bodies in the story an impossible repetition, or this continual flight that invokes in them a despair of being able to stop the motion.

So they say, "Catherine comes from *catha,* total, and *ruina,* ruin; for the edifice of the Devil was wholly destroyed in her. . . . Or Catherine is the same as *catenula,* a chain; for of her good works she fashioned a chain, whereby she ascended to Heaven. . . ."

Yet no body (since the body is immediately broken), no geometric figure can remain attached to the fatality of time. Dead parts were inserted into the body and the image reveals those parts within the composition of bodies.

Thus the spiral of the story never comes back to the same place, and this ring that carries us deposits us next to historical cadavers; in the perfection of this eternal return, we're obliged to be nothing more than phantoms, that is, simply images.

but a dog

But, lying in a Titian hanging just opposite the Correggio and a bit higher, there's a dog who would see the whole painting in the blink of an eye, in a camber shot, like a long grimace of white and pink skin half hidden by the materials below, and wooded with copse, with branches and grass toward the top. This dog, probably not being able to distinguish all these hairs and fibers, would stare from his wall at the enlargement and the corruption of a lightly pinkened star opposite him; exactly to the right of that enormous frame in front of which visitors conglomerate, shuffling and whispering.[10]

a dog's story

This dog, having come down from the opposite wall and then crossed the width of the room, sniffed at a young girl lying on a museum bench, and then disappeared with a bound into the picture.

Once he's melted into the picture, the dog then leaves the thickets of the painting, its unclean undergrowth, and the groans of the metamorphoses. He goes back down the wall:

> [I] finally succeeded, with the occasional aid of projections in the cliff, in reaching the bottom without accident.
>
> It was some time before I could summon sufficient resolution . . . but I did at length attempt it. I fastened [a] rope to the bushes, and let myself down rapidly, striving, by the vigor of my movements, to banish the trepidation which I could overcome in no other manner. . . . But presently I found my imagination growing terribly excited by thoughts of the vast depth yet to be descended, and the precarious nature of the pegs and soap-stone holes which were my only support. It was in vain I endeavored to banish these reflections, and to keep my eyes steadily bent upon the flat surface of the cliff before me. . . .
>
> But now there came a spinning of the brain; a shrill-sounding and phantom voice shrieked within my ears . . . and, sighing, I sunk down. . . .[11]

This series of anamorphoses, of diversely and necessarily corrupted images, is not perceptibly different from the view that an animal would have of the world in which it defines the spheres of action. So the picture makes inhabit within us, or groan within us, this animal outline that lives on just one part of the world, on just a fringe of colors and shapes that we can see. So that's why the sublime spirit of the painting is at the same time so close to the initially inexplicable terror that it awakens in us. This almost animal awakening within an awareness of a partial world is only the liquid moment, the most submerged moment of such a consciousness: through corrupted images alone an unfinished part of the world contemplates

the universe attached to it, to its shallow perception, to a synthesis of visible objects that gains ground like a blot fatally spreading across the whole portion of space to which it directs its gaze. Where its rolling eyes make it disappear. But in contemplating this mutilated world we are nonetheless subjected to an astral journey across the imaginary circles that distance us from the contemplation of figures, hunting down within us a world that's determined not to become visible.

An animal would, then, leave this world – and if some part of the awareness of the world disappears, then immediately some part of time ceases to live within it; yet another part of the visible breaks away, leaving in its wake a field of ruins, uninhabited strips, or barer surfaces. And if a beast loses his eyes, then all its skin pushes toward the light, and it enters the picture again.

The shard of skin, constantly sustained like a miracle, turns every possible animal into this kind of nervous, weakened being, and both melt into the same figure – the spasm or the convulsion, experienced and prolonged in each of them, depending on the successive states of their movements and actions. A sort of experimental frog, anesthetized upon a table, would thus represent a second incarnation of the god in an unfinished image and a third saintly martyrdom.

Imagine, then, how this sightless body reacts to light. It can't grasp visual space, but the shadow or the disappearance of light would produce the effect of the caress of a ball of cotton wool on its photosensitive skin.

Sightless, this nervous blot can do no more than adjust the rhythm of its palpitations to the modification of luminous intensities, eyes and bodies following these sensory orders, or this disorder, this change of proportion in slight pains, making them grow, compressing them. And Saint Sebastian, who cannot touch the body attached to him just by his gaze, thus mutilates his fingers.

The painting renders this incomplete world to us as a universe of dogs, of molluscs or nervous cells – this incomplete world where we don't live, where we can't sustain any imagination of our acts for very long. The painting rejects us, then; consequently it's a mirror, parallel to our universe but in spheres a long way away from death, or in the knowledge of the deadly resemblance that delivers us up to images. Or that delivers images up to time.

And this visit to the museum lasts, for example, for only as long as it takes to expose our bodies to the picture's light; during that time these words roll around in an indistinct chaos, like the lightning of a desire to destroy these images.

It's not resemblance that guides us to this picture; it's something else, something more fragile – the allure of our own destruction, incomprehensibly attributed to the picture.

But which of all these points arrests death within us?

We approach on an axis that, the closer we get, imperceptibly deviates and makes us bang our heads against a brick wall. This curved trajectory allows the picture to pass alongside us, so we can't annul it in ourselves as we would any other memory.

The dog, invariably like the counterweight of a clock, rolls down the slippery slopes, catching onto the ledges. A strident cry in his ears had caused him to fall into the darkness.

"THE spot where the hill had fallen. The place was one of singular wildness, and its aspect brought to mind the descriptions given by travellers of those dreary regions marking the site of degraded Babylon."[12]

museum

The topic of this painting is also the story of that other "devotion" evoked by Louis Massignon in his "Preface to the Javanese Letters"; so the painting can be turned away from that mystical element of history. That's why, in another way — unpredictably, but most of all elsewhere and beyond ourselves — it manages to retain something that nonetheless strikes us as an image of the interior life.

"The Pact with God"

Circumcision sanctifies the male organ in the sight of future holy generations; Abraham makes Elijah swear 'on his loins,' when he sends him to the wells of Harran to choose the woman whom his son Isaac will marry. Circumcision is a sacred exposure of the virility of the race (we are aware of the maternal kiss given to the infant's sex, a widespread custom in the lands of the Mediterranean, the "mare nostrum"). Circumcision is tied to the imposition of the Name (known first by the Mother) that one day will "raise up" the child. Theseider has shown how far, in the unconscious of the purest and most Christian of women, the symbolism of circumcision can carry. The ring in the mystical marriage of Saint Catherine of Siena (1367) was the ring of flesh from the circumcision of Jesus; she recognized thereby her betrothal to the Faith, and her promotion to a masculine and militant role in the dialectical spiritual combat where she would have to defeat men (like Saint Catherine of Alexandria before her). We know that in 1404 Isabeau of Bavaria gave her unfortunate champion, Charles VI, the Goldenes Rössl (now kept at Altötting) in the form of a marvelous piece of Parisian jewellery that it took her twenty years to make, a reproduction (perhaps the oldest) of the mystical marriage of Catherine of Siena to whom she was related by way of the Visconti of Milan. We know, too, that Joan of Arc in her manner meditated upon the example of two masculinized holy women: Catherine of Alexandria (because of the mystical marriage that turned her into a militant), and Marguerite, alias Pelagia of Antioch (because of her audacious decision to dress in men's clothes for spiritual battle).[13]

The picture is destroyed, it's already destroyed in the space where it's shown; it's subjected to this noise of shuffling feet passing before it. . . .

The details of the picture are only its deformations, its opposite numbers, the other pictures in the museums, the painted animals hanging opposite it, the coming and going of visitors, the gigantic details of small objects within it, like a skull, for instance, as if it were only ever being dressed up by the painting. But if this object drops into the middle of the museum, it's like the remains of a wind that blows through a hollow bone.

Like the details in that strange copy done by Delacroix: the foreground brusquely disappears, something begins to weigh on the faces, as if they're beginning to realize that someone else has taken away their light.[14]

Since men's last words have always been either incomprehensible – "bread," "light," "again" – or sibylline – "the source will not flow" – theaters have had to suffice as the site for the artificial and lengthy pronouncement of such final, incomprehensible words. The same with museums . . . except the picture is destroyed. And perhaps at first by means of its image within ourselves.

A museum is also a place for conversation, whispering, confiding, for a stab at aesthetic judgment; like the conversation that follows here, for example – this monologue with a friend:

resemblance

"So is it because the picture isn't a mirror that it reflects the corruption of our spirit?"

One thing, perhaps, that's striking today when we look at the painting of the sixteenth century: in the end it's not ourselves we see in these mirrors; it's a sort of humanity that we might suspect is linked to us in some way, an anatomical resemblance, relations of color; as if guards had been placed in a circle around the human species to indicate that after or behind them there comes an end, that what we'll see will no longer quite be men. We don't know *what* we'll see – changing forms or unknown animals. As if the pictures were guarding something, within the historical memory that they constitute: the frontiers of a species that resembled itself for a certain while, and that still cleaves to those frontiers; imagination and memories will never cross those limits beyond which there is, probably, nothing. Or as if these stars were guarding some kind of gateway to the universe. . . .

This is something I've never thought about before, but we might wonder why these pictures are painted only on one side and why it's

the painted side that's turned toward us. . . . And we might reply as follows. The unpainted side of a canvas has its back turned to an unknown world, to uncreated beings, to shapeless animals. So we are there, in the middle of these faces, these pictures, and we grow older as we look at them. But the pictures don't grow older, except in the case of Dorian Gray's portrait: more than the eternal youth of the model, or the horror of growing old that's deposited in that picture, what we feel most acutely there is this suspicion that the picture is becoming porous to the point of shapelessness, that is, to the point of becoming an uncreated world; and if at that moment it reflects the physical and moral corruption of Dorian Gray, it's because he alone can reflect the uncreated world that's within him. So we can imagine replying like that, saying it first to ourselves (silence).

That is what produces the pressure that pushes us to question or to reproduce the fragments of the visible (since obviously there aren't any commercial imperatives that oblige us to do it). Where does such an anxiety come from? isn't it a case of trying to decide whether the history of art is true and, if it is, to find out what it all really resembles? and whether resemblance has by some chance already actually happened in the history of our species? Is it the case that resemblance between a present thing and a thing of the past has already occurred in the history of humankind? So we work to try to find that out, discover something that will tell us about it.

"SO the question of growing old is unimportant?"

Yes, and so are the pictures. Aging has no importance in that we're simply there, beyond anything we can do and which might after all give pleasure to someone someday (who knows who); really we're there for nothing. So growing old is not so important within that nothing – though it's fundamental just the same. It's fundamental because we always imagine that it's going to bring us closer to something, to something more important than us – I believe we still haven't found exactly what it was. Is it time that we'll finally resemble?

"AND so what did Correggio want to paint?"

The picture was commissioned and so he would have painted what he was told to, or what was suggested to him. Realistically, he painted what we see there, what we can see. So long as we go imagining what we see – since we don't see without imagining, that is, without the suggestion of some immobile movement on the part of our bodies: we can't see without this hampered motricity which makes the colors in front of us move a bit, which changes the shadows a little, because focus isn't possible in such a space – so long as we go imagining, we'll see what Correggio painted. However much we solicit this painting, this mise-en-scène, we'll always see what

Correggio painted, forever: we'll never be able to add to what he painted by adding something else to the picture. That is to say, strangely enough, this visible isn't limited; the picture's limit is always we who are looking at it (and who despair of resembling it). We used to talk about "looking at it well or badly," but it's better to say, "a lot or a little"; this is an undefined visible, unsaturated, open. Perhaps that's what painting is good for. Not so much to fix or represent figures without movement or words, mute or immobile figures where the colors don't change or vary with the lighting – a world sheltered from the wind or bad weather – but rather, to represent a world characterized by an indefinite prolongation of the visible itself: the infinite opening of the visible. And its possible opening is us, that is, we're its moments of interpretation. That's why we can recognize, for example, that it's sublime, because it contains what *of* ourselves we can never add *to* ourselves.

And yet, in front of the picture, provisionally, we become its law. We can't stop it, or fix it, or rule over it. Which means that it is the picture that adds to me at any given moment. That's why I feel so good when I leave the museum, in Brussels, where I saw this pietà by Rogier van der Weyden, for example; and that lasts for just a moment (silence).

The question could be asked whether pictures are mirrors of ourselves. Of course they are mirrors, but it's not our bodies they reflect: what they reflect is what we lack. That is, the sublime. That's why the obscene – in which we are not lacking – is always incomplete in painting.

CINEMA

This chapter on cinema is a mixture of translations from two different but roughly contemporaneous sources: the book L'Homme ordinaire du cinéma *(1980c), and a special issue of the journal* Ça Cinéma, *"L'Image, la mort, la mémoire" (1980d), which Schefer composed in collaboration with the filmmaker and artist Raul Ruiz.[1] The selection of excerpts from both these sources, as well as of the epigraphs that are interspersed here, was made by Schefer himself.*

Writing on film — mostly silent cinema — gives Schefer the opportunity to talk about moving *figures and thus entails more detailed elaboration of his notions of the imbrication of space and time in the image — notions that make a fleeting appearance in* Light and Its Prey. *It will be recalled that, in general, Schefer conceives the function of perspectival and volumatic space in painting as that of setting up a doxical figuration and thence eliding the experience of the paradoxical body, as well as its relation to time and memory; and, by showing the factitious nature of such spatial relations, he attempts to reintroduce the elements of time and memory and their attachment to the body that cannot be figured.*

So Schefer here approaches this tension once more — this time through the cinema, a form whose concomitant aporias or absences he proposes to be specifically engaged with memory. This is because in cinema the camera is effectively an eye, registering the experience of some reality; but an eye that lacks a crucial quality of the human eye, that is, memory (this is the force of the epigraph from Epstein with which these translations begin). Going to the cinema, then, involves experiencing a world projected without memory. And yet spectators, as subjects for this projection, bring their own experience and memory to bear, and thus experience the "astonishment of being able to live in two worlds at once," one with and one without a memory. In this sense the cinema is a privileged instance of the division between the doxical and the paradoxical body, since the "knowledge" that it proffers and constructs can have no subject. The experience of the spectator, then, is in effect to supply a memory to a spectacle which excludes memory. The paradox here is that the spectator's memory is both

From *L'Homme ordinaire du cinéma* (1980) and *Ça Cinéma* no. 21 (1980).

invoked and excluded, and this is the "opening" with which Schefer works in these texts.

It should come as no surprise at this point that Schefer's writing about film has little in common with most of the generally available theoretical and critical work on cinema. Indeed, insofar as he feels that such work and its version of the subject "concerns no one," his own work constitutes an implicit critique of much film theory. Schefer rejects the constitutive role of the notion of identification authorized by theorists such as Metz and Baudry. For him the spectator's attachment to the image is of a different order altogether. He proposes that rather than furnishing some process of affective replay of subjective psychogenesis through identification, the image in fact organizes a space both within and without itself with which the spectator struggles in a tension of two different orders of experience and memory. Thus the cinema is not a mirror (as even Godard has said), fixing identifications and producing cinema's dominatory effect on the subject. Rather, Schefer describes cinema as the unstable playing out of a variable relationship, something that has much more to do with cinema's motion (see the first epigraph again) than with any question of reflection or resemblance.

In that regard, the cinema's movement, its instability and variability, becomes of crucial concern here, especially in the final section, "The Wheel," where Schefer's text explicitly tries to render in writing the effect of movement in Dreyer's film, Vampyr. *He sees movement in the image as producing – and, equally, as being produced by – the collision of images, of frames. This continual series of collisions "puts the subject to death," as he says it, or invokes the trajectory of decay and deliquescence that we have seen his work deal with before. In the final sequence of* Vampyr, *with the death of the vampire in the mill and the escape of the young couple, Schefer depicts the film's movement as an oscillation that is a kind of superimposition upon the image, causing the death that haunts the divided body and produces the sense of guilt and anxiety that, for Schefer, is always related to the decay and deliquescence in the image. To hazard a generalization about a conceptually very complex passage, then, one might say that movement in the cinema is in itself a sort of anamorphosis.*

Elsewhere in the following excerpts, the guilt and anxiety produced by watching moving images are discussed in relation to two, by now familiar, elements of Schefer's writing: first, animalistic or primitive forms of the body, and second the memory of childhood. In the first instance, Schefer remarks the frequency with which film figures unformed, deformed, freakish, or burlesque kinds of body. These are all registrations of, or openings onto, the world of the paradoxical body – they are the body which proves the limits of figuration and anatomy, a whole range of avatars for the fear and dread that haunts the divided subject.[2] In the second instance, the affective dimension of that fear and guilt is tied to the childhood experience of the cinema, and to Schefer's autobiography. More than any other of

*his texts, apart from the highly autobiographical, L'Origine du crime
(1985), Schefer's work on cinema explains – and, indeed, demonstrates –
his notion of the place of the autobiographical in what are essentially
interpretative writings.*

*The first sections of the following translations go through some of these
matters, stressing the production of a kind of knowledge, the childish
knowledge that attends the recognition of the birth of the divided body and
the demarcation between knowledge and experience. Schefer's sense of
what he calls the discovery of "an internal history" should not be under-
stood as the recovery of some fixed image or some nostalgic memory.
Rather, he suggests here more than anywhere that the aporias of memory
and experience cannot be filled, but only* discovered *or* invented.
*Equally, even if their discovery is a matter for hope, it is also a matter of
illusion, and all that can be registered in our roles as spectators of the
image is the oscillating passage of shifting and variable relations between
ourselves and the image, between our experience and our memory. The
texts here attempt to* write *that passage and are thence given over to its
sporadic and dehiscent syntax. In that sense, in themselves they constitute
a special kind of cinemato-graphy.*

Cinematic reproduction captures an astonishing descriptive geometry of
gesture: gestures caught from every angle and projected onto any area of
space (or several at once), situated on continually variable and unusual
axes. You can make them appear however you want – elongated or di-
minished, multiplied or divided, deformed, expressive. For each of those
angular interpretations of a gesture has its own profound meaning which
is intrinsic to it, because the eye that reveals it is an inhuman eye, without
memory, without thought.

– Jean Epstein

The Ordinary Man of the Cinema

The ordinary man of the cinema makes a preliminary and redundant
announcement: the cinema isn't my profession.[3] I go to the cinema
for entertainment, but by chance I also learn something there apart
from what a film will tell me (a film won't teach me that I'm mor-
tal – it will, perhaps, teach me a trick of time, about the expansion
of bodies in time, and about the improbability of it all. In fact, I'm
always less the film's reader and more like its totally submissive ser-
vant, and also its judge). What I learn there is the astonishment of
being able to live in two worlds at once.

So it's a being without qualities that's speaking now. I want to say
just this: I don't have the necessary qualities to speak about cinema
except insofar as I'm in the habit of going quite often. This habit

should probably have taught me something? – naturally. But
what? – about films, about myself, about our whole species, about
memory.

So, what this "ordinary man" can say arises not from some fixed
discourse (which would have to do with the transmission of a
knowledge) but from a writing (a research whose object isn't a pol-
ished construction, but the enigma of an origin). The only origin I
can speak of, publicly ask myself about, is primarily tied to an eluci-
dation of the visible, an explanation not of its constitution but of the
certainty that it only exists with such power because it opens up and
names within us a whole world; and of the certainty that we are in
some way the genesis and the momentary life of this world that's
suspended from a collection of artifices.

So, I'm writing about a particular experience of time, movement,
and images.

But this still has to satisfy certain ideational conditions. I don't
intend to write a theoretical essay about film. It's more a matter of
lending a voice, however briefly, to a memory, to the spectacle of its
effects, and to render a certain threshold tangible. In the end, I'm
calling upon a spectator's "knowledge." That's *my* knowledge, and
so immediately some part of my own life is at stake.

A machine whirls, representing simultaneous actions to the immobil-
ity of our bodies; it produces monsters, even though it all seems
delicious rather than terrible. In fact, however awful it really is, it's
always undeniably pleasurable. But perhaps it's the unknown, uncer-
tain, and always changing linkage of this pleasure, this nocturnal kin-
ship of the cinema, that asks a question of both memory and signifi-
cation; the latter, in the memory of film, remains attached to the
experience of this experimental night where something stirs, comes
alive, and speaks in front of us.

So for this spectator the cinema is primarily something completely
different than what most film criticism reflects. The meaning that
comes to us (and reaches us by dint of our being a sounding board
for the effects of images and their depth, and insofar as we organize
the whole future of these images and sounds into affect and meaning)
is a very special quality of signification made tangible. And it's irre-
mediably linked to the conditions of our vision; or, more exactly,
linked to our experience (to the quality of this nocturnal vision, ap-
pearing as the threshold of reception and the condition for the exis-
tence of those images – and, perhaps, to our very first experience of
seeing them).

If the cinema, apart from its constant renewal in every film and
each projection, can be defined by its peculiar power to produce ef-
fects of memory, then we know – and have known for several gener-

ations – that through such memory (in this case, through precise images) some part of our lives passes into our recollection of films that might be totally unrelated to the contents of our lives.

So there was (first of all, immediately, like a residual humus that retains images) a sentiment of persistent strangeness born in "my" cinema, and I wanted to account for it. I wanted to make it apparent. It's not likely that my experience of film is an entirely isolated one. Indeed, rather than the illusion of movement or mobility in filmic objects, the illusion proper to the cinema is that this experience and this memory are solitary, hidden, secretly individual, since they make an immediate pact (story, pictures, affective colors) with a part of ourselves that lives without expression; a part given over to silence and to a relative aphasia, as if it were the ultimate secret of our lives – while perhaps it really constitutes our ultimate subjecthood. It seems that in this artificial solitude a part of us is porous to the effects of meaning without ever being able to be born into signification through language. We even recognize there – and to my eyes this is the imprescriptible link between film and fear – an increase in the aphasia of feelings in our social being (the cinema acting upon every social being as if upon one solitary being). The fear that we live out at the cinema (the first knowledge a child takes from the cinema, or that "colors" his experience) isn't unmotivated, in fact – it's just disproportionate: I've thought for some time now that *we fear* this latent aphasia because it has already cut into us.

I'm far from denying the pleasure of cinema. But I need to make something about it more explicit (at very least, its ambiguity). Briefly, this pleasure isn't simple enjoyment; it is, I think, the visible basis for all the aesthetic pleasure we take in the image's definition – that's the basis for what's sometimes called our "imaginary projection" into filmic action. The pleasure is in the enjoyment of our moral being, which is why (for me) it's so close to its opposite – fear (which is the result of a simulated realization of affects which live deprived of an object). The reality of these sentiments is our subjection to a world that's actually their derision. I maintain that this can be called an experience, to be spoken of seriously.

SUDDENLY, within these forms, in these unities of sound and vision where I have no place and of which I remain just a spectator, I find myself trying to identify what might be their essential counterbalance . . . in the end, to discover to what absence any form relates.

Unpredictably, every human form (every imitation of a destiny) responds to the expression (the necessity or the abeyance of expression) of the feelings that define humanity.

So it's not that we're projecting our lives onto forms or beings, agents of a part of identity that's the missing link in every living being, or the secret that's not fixed in an image but that keeps it alive

outside of images. It's rather that the unexpressed increases within the living being as we live – that is, it never ceases to substitute actions for the possibility of contemplating nothingness.

But these feelings, relying on a notion of the lonely profundity proper to our species, cannot be represented in the cinema except by way of *bodies in action*. To support them, those bodies have to be new to the point of indicating the reflexivity of actions – not their power of transition or their material resolution in the world. Such reflexivity can only augment the invisible world, and that's what an action is properly destined to do. (Which means that an action isn't an event. The strongest captivation of the image is finally that world; all causality in this universe of images is shut up inside a body of enigmas, as if by a suspicion of signification.)

PERHAPS such a "being without qualities" can state a truth here, ask a question, make a proposition whose goal is not to endorse an image of man in terms of any of the usually elaborated theoretical notions. That would constitute an unreasonable alteration of the image by allowing contents to enter in (the relationships of contents to representations are always precisely experiments and not representations).

So, what we might try to grasp is this: there's probably nothing, in the name of any knowledge, that we could envisage about forms or that could be said about cinema which, by theoretical strategies, would accord with or verify the protocols of anthropological content. In the cinema we are dealing with a new experience of time and memory which alone can form an experimental being.

The cinema, in that we're a part of it, doesn't compose or organize any particular structure of alienation – it's more a matter of the structure of a realization and the appropriation of some *real,* not of some *possible.* The real we're talking about here is what's already and momentarily alive in the form of the spectator. Not a momentary, suspended life, but a memory mixed with images and experiential sensations: we should, then, question the function of the scenario not as the object of a desire to exist but as the *store of affects* within this being whom I describe as being "without qualities." Similarly, the ironic structure of film is an anthropological lure. And what's more, the dream here is not the realization of a desire, but we should understand it rather – more essentially – as the *legitimization* of desire.

OF course, all this presupposes no knowledge, but at most a certain usage, the habit of a *usage within the invisible part of our bodies.* I'm alluding to that part of ourselves whose nativity is, as it were, put back into our hands for use at our own discretion. The part that, having no reflection, desperately dedicates itself to transforming its own obscurity into a *visible world.*

So the only knowledge presumed here is just that of the use of our own memory: in the end, memory teaches us nothing but the manipulation of time as an image, made possible by the purloining of our actual bodies. This doesn't respond to some theory or other, but only to a paradoxical experience – that is, to an aporistic duration (the relation of an object of thought to something that refuses itself to thought in its very activity). So it is experience itself that is the source of aporias. From then on things can't emerge from some hidden meaning, but rather from this difficult and vacillating relationship between things and their secret (and thus *our* secret, like a photo of our complete "body" that can't be developed in the realm of the visible).

So the duration of passions (what Kierkegaard used to call the character of an alternative man) can be measured only by the remnants of images – not by their cinematic duration, but by the power they have to remain, repeat, or recur. This is quite close to what defines the image's transformation into a mnesic double – that is to say, into that sort of trace or guarantee that's intrinsic to the movement of disappearance or effacement in phenomena.

THE cinema and filmic images don't mobilize for me any (technical or theoretical) knowledge as such: that kind of knowledge is inessential as far as I'm concerned. The cinema is perhaps the only domain of signification that I believe cannot have *a subject for the operations of its science.*

It is an art which awakens a memory, mysteriously tied to the experience of a profundity of feeling (but also to the very particular life of isolated phenomena).

This is also echoed in Dreyer's words: "What I want to obtain is a penetration to my actors' profound thoughts by means of their most subtle expressions. . . . [Falconetti] had taken off her make-up . . . and I found . . . a rustic woman, very sincere, who was also a woman who had suffered."[4]

That memory doesn't evoke so much as write the experience of an entire life that it induces into separation from the world. As if we went to the cinema in order to annihilate the film bit by bit (with a few retained images) by way of the sentiments it makes us feel; and as if this mass of affects progressively summoned chains of images back to the light and to the color of feelings.

I wanted to explain how the cinema stays within us as a final chamber where both the hope and the illusion of *an interior history* are caught: because this history doesn't unfold itself and yet can only – so feebly does it subsist – remain invisible, faceless, without character, but primarily without duration. Through the resilience of their images we acclimatize all these films to an absence of duration and

to that absence of a scene where interior histories might become possible.

So this chamber exists within us, where, in the absence of any object, we torture the human race, and from which the feeling or anticipated consciousness of the sublime mysteriously and incomprehensibly arises.

None of this locates the grip or anchoring of feeling within a film. Film is perhaps just a sort of mirrored surface that appears to us as such only at the moment when we are thrown away from it by the feelings or affects that it gives birth to: it only gives birth to them by simulating them in characters, through "bits of men" who have to die in order to assure the perpetuity of what's outside them.

So the sight of all this makes me take leave of myself; that's to say, take leave of the most uncertain center of myself; it makes me find some semblances of identity that then hunt me down again like a center waiting to be encircled.

So, it's not quite a merchandise (a sort of sexual merchandise), nor is it quite a pole of projection that I find in the cinema. Rather, acting out a scene there, I find affects (not quite feelings, just the stirring of feeling, tied to impossible actions), affects without a destination – that is, without a world (there's no world that preconditions this coloring of affects); affects playing out a scene – by some unbreakable alliance, playing *the visible interior of a species.* So far as the spectacle of visible man is concerned (though he's not any particular structure of enjoyment – he's simply an unknown being), it would be necessary to know that affects constitute a world – possibilities of action somewhere else, and immediately an ineluctable destiny.

Could the techniques of cinema have a finality that, in all conscience or with a little clarity, I might reduce to the production of effects? Here, all the played-out simulations are basically imperfect (or simultaneously shown to be simulations), parallel to the production of effects. What attracts me to the perfection of this world isn't its illusion; it's the illusion of a center I will never be able to approach. This illusion *has* no center but is a mechanism for the elision of objects. All in all, its bodily movements aren't gratuitous – they constitute the spectacle itself, with its freedom removed. Furthermore, it's the affects themselves, and not signification (which here is the deferral of their liaison), that construct an anterior world, a world subsisting without proportions begged or borrowed from the real. By an elementary alchemy, objects are only as privileged as they are here because they're so rare (selected) and dependent; they're not the components of the cinematic universe that we would recognize by their resemblance to all the things we've ever touched, seen, or coveted. They're woven from an altogether different material. We desire them because they constitute a fate. The dressing gown in *Little Caesar,* Fred Astaire's top hat and cane, Ketty's watch in *They Live by*

Night (whose dial is never seen but that still tells us the wrong time of that nocturnal love and shows us the curse of adolescents oppressed by a crime in the distant shadow of their lives); or Cary Grant's suit, which is both his ignorance of danger and the deferral of his fear – here I project not a sovereign consciousness but a disguised body, dressed from the start in a prism of minor passions, sequences of gestures, words, and lighting.

In films the body (in any situation) is only desirable because of the hope that its clothes can be worn, but at the same time that it can carry away with it all the worldly light in which it has bathed. The initial hallucination in which we mimicked gestures (for example, von Stroheim's little stereotypes in *La Grande Illusion*) managed to induce, in place of our bodies and like an airy chimera, the same stiffness we saw in the actor, the same pleasure in details; or it managed to teach us that the cinematic body is one that lives "in detail" (just as Bichat's old man dies "in detail").[5] What we couldn't regain was the peculiarity of a world residing in the transitions between gestures. We'd been struck, for example, by the fact that all action is accomplished in a single, sketchy movement; that a man never gets to the end of the track, but that his action is nonetheless complete because the whole world (at any given moment) can be no more than the consciousness of his escape, and because nothing escapes signification (which might be the very peculiarity of this universe). Endowed with mobile proportions, affected by changing causes, this is still only an *intended* world.

And burlesque, wasn't that in its way simply the blow-up of a single detail of our own lives? Or perhaps the entire life of something we could get to know and that would then live alone in the world (as alone as the perpetual life of a scar on the skin, a ridiculous hat on the same head, or a leg that was forever in plaster). This is a reflexivity and a perception of action which reaches a body and determines its spectacle. This is why burlesque is so frightening: those bodies are already more guilty than they are clumsy; they're just a brief, gesticulatory reprieve from our waiting for hell.

The world and its shadows rise up before our eyes, initiating in us the experience of those unrepeatable movements.

Two trees that the camera shoots from a distance, around which it begins to film, which it then shoots in an incomplete pan where the trees are successively the center and the periphery: this grouping of trees, in Straub and Huillet's *Fortini/Cani,* isn't made from trees alone, because these particular ones could only be reflections, and also because the very distance from the world we can never approach subsists within them. And this bouquet of trees is not simply all that distance preserved. Those trees, caught in a slow and brusquely sublime movement, are unnamed and unknown affects; they are a sort of silent, rigid, and delicate contoring of the most unknown

emotion. And why – unless it's because all our own movement is suspended from that sight – can we do no more than register that this is sublime?

Poe, in *Eureka,* speaks of the genesis of matter in which attraction and repulsion separate atoms: there, the soul is the product of their repulsion.[6] It is also by the unconsciousness, the ignorance of these systems of luminous dots sifting bodies and remaining encrusted on their faces, that the birth of feelings unrelated to our lives is accompanied. And blindly, across this bridge of trembling light, we enter this world. First of all, film isn't constituted in more or less perfect scenes, nor by obvious, admitted decors (such as those in *A Streetcar Named Desire,* which are just theater sets filmed in close-up), nor by the points and displacements of perspective that reveal them to me; nor are any of them either credible or *invraisemblable:* this world, beyond its artificial sets and shots in front of which I might remain incredulous – and can therefore get away with being badly done – doesn't install me within the truth of the story; it has already made me enter into the truth and strangeness of whole new affects – which, by dint of the fact that their qualities are unheard of, and because their relations to objects are unknown, easily dominate me.

I don't believe in the reality of film (and its verisimilitude is unimportant); and yet, because of that, I'm its ultimate truth. The truth is verified in me alone, but not by final reference to reality; it is, first of all, only a change in the proportions of the visible whose final judge I will doubtless be, though I'll also be its body and its experimental consciousness.

NO kind of assurance is ever added to the image, no finishing touches are given to a pluperfect image of solidity; indeed, what's added is the anxiety of the human voice (and perhaps only a hint that it can signify). From the voice I retain only certain qualities – smoothness or roughness – or its particular composition, astonishingly produced by Michel Simon in *La Chienne;* and I hear behind it, behind its memory, nothing but a feeble burbling, an incoherence, something like the bankrupt monologue of a lover's protestation. The voices in this film – those of Simon and Janie Marèze – are neither real nor copied; they're simply the truth of a given scene. The voice of Marèze is stereotyped (it's "stamped" as the historical representation of a social class, attached to the irony of the characters who choose it, to the irony of a "type"). Simon's voice is not of a particular class; it's an invention and a mixture that begins to constitute the sonorous volume of his character. This is all laid bare in the conversation scene, in the impossible confidences that precede the murder: the vocal tissue imports only the "culture" that precisely allows him to appear as an imbecile in the place where he lives. In this I can hear the beginnings of the jocular tone that is always a strain in this actor's

voice, the foundation he exploits – the strange, bleating tone of an old woman through which some emotion is always transferred along with the proper distancing of the voice from the role itself, from its utterances, and from the actor's body: this is the whistle and the toothy sound that characterize the actor's place of origin, the "accent" of Genevan Protestants. The tissue and composition of this voice are played out in the character (Legrand) as nostalgia for a place where he doesn't belong – the distance of the bleating voice and the raised accent suddenly lend him the air of a mental case. It's like listening to an opera – I can hear only the feeble strain of what the voice signifies, what protestation it makes through the totally instrumental singing that, at the height of its artifice, cannot disguise the blinding truth of the body, of that sudden apparition of visible man, trembling like a wet dog.

Spectator

Without a doubt, the only position we can conceive of for the spectator is a paradoxical one – it's not simply a matter of his being placed within the spectacle. This man invents a position; he makes an inventory upon himself of the material of unknown affects. These are, for example, the proportions of what he'll come to understand as a world, proportions living differently than in a picture or a figurative composition.

And this is called a world, its figure changing all the time; and yet it lacks a pole of reference, a constant, or a scale. As if some primary degree of existence had been attached to a variation of proportions alone.

So this absence of proportions constitutes such a world. Not that it guarantees its new appearance or its changed face. An anxiety that's not about resemblance – nor is it simply its doubt – is added to its aspect for just a moment.

So it would be illusory to imagine that merely the enlargement of a frontal image (like an amputated detail, cut from the very life of the body of a sign, or of an object which remains invisible as an entirety) could invoke something of that order: if, firstly, this absence of proportions (that is, something that doesn't allow the reduction of a filmic sequence to a figurative sequence – which is necessarily defined by an order or a structure of proportions), if this world, this mutilated space, and this fragment of a scene are not entirely visible. So I can imagine that something is accomplished by their schematism, that a world is nonetheless (or because of that fact) sketched out in them and that some intention crosses them as signification.

However, I'm equally sure that there are no scenes around which

I can construct my interpretation, no givens that need my freedom in order to complete their figures as a destiny within myself, in the way that I might construct a destiny when looking at a painting. So there's nothing to demand the limit of the completion of my death or the recognition of another world through that immediately impossible death (no longer its mad demands, and the response anticipated by the difficulty of defining the visible outside of myself). Because of these different movements, or rather because of these different movements of contemplation, I never stop substituting myself (because of my knowledge, anxiety, or pleasure) for every other possible interpreter of the picture – I never lose the ability to become its sublime insistence.

So it is, inversely to all that, that I come to know (or know again) firstly this: watching the film in its details, angles, and frames, I'm not an instance of interpretation; so (unlike when I look at a framed picture where distance doesn't make the proportions of the figuration vary, and for which there even exists an ideal viewing point), I don't have to assure myself of the visible through some other mastery of the proportions of my body.

Indeed, in that sense, if the filmic world seems not to require the type of accommodation that would make its strangeness and its essential disproportion disappear, I can say that it's not, strictly speaking, the object of a rule-bound or consistent perception, and that perhaps it has as its object the unconscious thought that's within me in any perception.

But is this how, through what this world lacks as its secret proportion, I manage to recognize its aspects and signification, without needing to interpret it? Do I recognize this as a world because of its particular way of hiding the world, of trafficking, mutilating, and representing time (as if already the final reality of these images consisted in making us *live time*)?

Do I recognize this place I've never been, even in my dreams, by its way (this, for me, is still an uncertain notion) of concealing time – that is, by the hint of a constant flux of action, somewhere else, more banal, more tragic, less colored, unanswerable? Do I recognize it because of the way all the suspense and all the heavy tragedy of life (or life's absolute indifference) are imposed upon me? And so I watch a film as if it were going to end up making me see a man with no name, a man breathing without offering me a spectacle (and as if only the most exaggerated of filmic or realized acts – since they produce a greater syncope in time – had managed to become transparent in this sort of absent proportion which nonetheless completes them for our eyes).

But what's missing isn't the sublime, nor even the guarantee of life: it's a pole of the image that, if it were there, would make the image invisible.

Is there, for example, an exchange of the visible between myself and the figures as I watch? Am I not what credits the image because I remain more visible than it does (because my interior life, still not opening onto any scene, remains instantly as the perfectly untranslatable secret of what I see)?

And is this the same as the effect by which the film's dialogue (more than roles in the theater) renders me speechless – that is, speaks in my place and causes the hope of signification to abandon me without having taught me a language?

Propositions

The image can be seen by way of what it lacks.

SOMETHING is missing that constitutes the image (permits it to conceal the world we live in, not by means of a screen with figures on it, but by means of time).

IF what's missing *were* within the image (of which we are a part – the virtual pole, or the phantom), the image would be invisible.

SO the spectacle of visible man does exist: it's the awareness of the darkness of our interior lives by which any spectacle is made possible.

The Gods

it's true that we – all of us – go to the cinema to see simulations that are terrible to one degree or other, and we don't go to partake of a dream. Rather for a share of terror, for a share of the unknown, things like that. . . . Which is to say that, at bottom, the cinema is an abattoir. People go to the abattoir, not to see images coming one after the other. Something else happens inside them: a structure that is otherwise acquired, otherwise possible, painful in other ways, and which is perhaps tied inside us to the necessity of producing meaning and language.

– Schefer[7]

The Jealousy of Freaks

A frightening idea strikes me – that the most extreme pain is silent.

In *Freaks* we had to feel (is this the film's intention, or is this film just a parade of monsters across an arbitrary scenario?), we had to register the existence of affects, emotions, pain, and anger in propor-

Fig. 4. Tod Browning, *Freaks,* 1936.

tion to the size of their subjects, all reduced to the little tantrums (the very small movements) of dwarfs, reduced to tiny clenched fists and minuscule tears. But these emotions, because of the uniform reduction of their proportions, pass beneath us, all invoking the same sense of repulsion: we don't inhabit a body like that one there because its voice is too inaudible, too highly pitched to make us really blanch, and because we don't, after all, live in the same anguish that, even in its pain of unrequited love, is for us nothing more than the fate of painfully small dolls.

That's frightening; it's the worst sort of butchery. But such is our truth that we inhabit bodies without a hint of sarcasm. How could this messenger of sublime anguish, this being in the process of discovering all the world's bitterness, how, without adding to the cruelty within us that kills off real anguish, and without bruising his own sadness by its very expression, how could he escape this tragic scene when he can't even reach the door handle?

The meaning of the scene comes later, only in the wake of the emotional instability of such tiny bodies. It arrives when we begin to ask, "Why is our hell so small?"

The Shroud

Something here isn't right: the linen, the light, the shadows, this passage along which we approach the light, the ancient filth (of poverty, or of humility?) which is like a destiny, pushing us toward this brilliance, this white cloth laundered before our eyes and that has

Fig. 5. Carl
Dreyer, *Master of
the House,* 1925.

already begun – as far away as we are – to place the film of a shroud
against our chest. It's not quite a screen that this woman is offering,
holding up an imageless innocence and a light as if calming some
savage beast. That light, uncorrupted, since it has no source and
since the gesture of its elevation produces its own cause – an immac-
ulate flash, a shining period, an entire world of snow – that light
could, within us, evoke both a horizon and a cause. This is sublime
because this soft cloth picked from the basket is, incomprehensibly,

nothing other than the approach of a suffering from which I have to reconstruct, in the repetition of this arrested movement, a threshold in myself that's still uncrossable. Leaving us seated in the dark, what's proffered – this cloth without memory, without image, and without shadow, lifting itself up and indefinitely rasping beneath our eyelids – repays us (since there's no body moving here, no fly to soil it) and repays us with this white shadow that arrives here, beyond the world.

The only scenario I can imagine would be the same scene filmed in a loop, finished in a single, infinite repetition lasting a lifetime; this woman bends over, chooses the sheet, and we – alone, and in her hands of charity and pity – can no longer exist except as this whiteness, this sheet, the wind that dries it and the incomprehensible flash that causes an altogether different darkness to remain within us.

Yet you yourself will never dance on this miraculous surface through the projection of your shadow, of your memory, of any past. We realize too late that the masses of shadow, still outlined, striated, and sliding over powder, never actually reach this flash of light. In these masses alone a story unfolds, an adventure, a commotion. And in the end this shadow only repeats words within us; in every corner it whispers memories, shadows.

A new man breathing within me? It's this handkerchief, this shroud, bursting without trace, and no one dares touch it.

The Sausage

Is this still a man, or already a monster? Is it a man other than in the face, where he can seem indifferently sublime or horrible? I don't know why this character from *Freaks,* reduced or condensed to a single swaddled limb (a limb and not an organ), reduced to this crawling sleeve, evokes the Husserlian notion of that curious reduction of phenomena which allows us to get at essences.

This being, reduced to one limb and one action (which in the film is his facility in lighting a cigarette, assuring us of his humanity), because of his crawling and his sort of monstrous tail-wagging (this is, of course, the progressively watchable horror – simply because he can accomplish this action – that of a piston joined to the head of a pirate), this creature threatens the last humanity within us. This fairground performance (an inessential demonstration carried out as a proof) can scarcely deflect us from a more disquieting question: what does such a sausage do, not about his desires or about sleeping, but what does he do with his excrement? And this sweater, doesn't it hide from us for the whole length of the film the fact that his legs and arms are factitiously bent, squashed, and provisionally miniaturized, and that this filibuster head will finally be able to emerge and

Fig. 6. Tod Brow-
ning, *Freaks,* 1936.

have a yawn? And don't we also, as we watch, feel our own arms
sticking to our bodies? What could be the destiny – that is, the dura-
tion – of such an animal?

And is that cigarette being stuffed in his mouth to prevent him
from crying out, to deprive him of the time in his whole filmic life
to speak to us, or to address a word to that part of ourselves that is
exactly "that"?

And so we are "that." And in the life of this aged larva – a bucca-
neer whose boarding career has progressively deprived him of all his
limbs, cut off by sabers, and who has been locked up in this inflated
sailor's cap (and what mother would have knitted it for him?) – don't
we tremble to imagine (or perhaps we already know) that this tube,
ingesting smoke before our very eyes, must have known the pangs
of love? And isn't that exactly what a monster is – the perpetual
torture of love, and its animal groans?

And I'm not sure why this little plinth in front of him, with its
tiny objects, immediately makes him seem like a public scribe.

*The ideal being can only be seen through the eyes of a
criminal . . .*

. . . because what he desires (and it's really only the whole era of
psychology that has shown us this) is to perpetuate or photograph
something that ought to remain instantaneous. This flash of light-
ning ought to live on only as a memory (but Renoir gives it to us as

124

Fig. 7. Jean Renoir,
La Chienne, 1931.

an image) – saintliness in abjection, gentleness in cruelty. We don't
see the words spoken, nor their reality, but we feel the presence of
this cloud around the chosen victim and we participate in the whis-
pers of love that can neither face nor turn away from the light (like
the blinding form of God revealed to Moses).

In Musil's novel *A Man Without Qualities,* Moosbrugger killed
prostitutes, but he never killed off his own horror or his desire, his
guilt or his mother, but he reached eternity – that is to say, he mor-
tally touched what was always missing from himself and from eter-
nity: the most obscure reason why no god finally wanted him.

So it is by way of this stereotyped old man, with his old woman's
voice, that the haloing light of youth appears and lasts on the scene.
We understand that it's a whole generation which has repressed him,
but it was a certain innocence, an irresponsible pleasure, that origi-
nally killed him as a man. So it's into this extremely anterior death –
which her own slaughter will not complete – that the prostitute has
to enter in order to both lose and win her light.

This flash is not just a gaze (or a desire, the coexistence here of
two superimposed images of the same body – a victim of murder
and an untouchable body); it is, equally, all the unreality of the
world that Legrand cannot enter; it is the heaven above this pros-
titute.

Criminal Life

> This flaw in our memory, grafted onto memory
> for the sake of representation, what could it
> consist in but childhood itself?
>
> – Schefer[8]

Even silent cinema could never be silent: it is more exactly a cin-
ema caught up in whispers (the subtitles, for example, read softly to
children during the show). And in the whispered silence of those
first films, the first images, the dust, the light of the cinema's gray
bodies returns within us: as if there were a child seated within us,
clinging to our hand.

In its most primordial and brutal condition cinema sustains a ter-
ror, or a vague fear, tying our whole childhood to one film or an-
other. In the end, why was every film a repetition of the war? I saw
my first films after being plunged into the scene of war (night shel-
ters, bombardments, exodus, prayers kneeling in a dark room, ex-
ploding bombs outside, dusty coffee, the march of prisoners outside
the window, truck journeys by night alone in the winter, four years
old . . .). But, exclusively, scene after scene digging out a sort of
childhood unconscious. A bewildered child for whom, in the midst
of exodus, there was still a voice, a tone of voice, music, images, and
objects that the whistling of bombs would shatter one by one – a
reserved air, a being whom catastrophes and griefs never got down;
the well, the abyss, or what still had no beyond. . . . I imagine that
in those bad old days of pain, of interrupted visits and random lodg-
ings, a voice, a reserve, and a guiding knowledge of being civilized
were never destroyed. The earth didn't open up beneath the feet of
this distracted child: nobody ever screamed in his hearing. And so
music remained, even at night, around the dimmed lights or above
the alarms. Because of what was still the great youthfulness of the
world. Catastrophe hadn't made its way through all the rubble, or
even through grief, until the day he was taken to the cinema. De
Sica's *Sciuscia* (*Shoe-Shine*): all the fear of the war and four years of
terror, broken objects, vanished faces, all fixed for an instant in that
cinema, upon the image of that first film. Then began the first illness
of which he was guilty and for which he was punished. The first
neurotic illness – that is, the first uncertain, criminal identity that a
child discovers through fear (in his first real solitude): the ragged
urchin in Italy shining shoes for American soldiers. So the world
began, and immediately it was indescribable.

The fear of war chilled so many youngsters in the same way after
the Liberation: they became aware not only of the fear of having
escaped massacre, but also of the sporadic consciousness of being
nonetheless dead, because of these films that began without the very

voice that the airplanes never drowned, without a sister, or some
comfort, without the smell. So it was in this way that aphasia began,
the family vanished, and the consciousness of a crime preceded any
real crime. Or that the fearful chattering of teeth was only because
of Charlot, Laurel and Hardy, Walt Disney. In this sense the war
never ended. *Les Disparus de Saint-Agil,* for example, made his father
die, made the house collapse. Pinocchio killed and carried off people
close to him. *Adémaï Aviator,* or some showing of *Deux Nigauds,* left
just a dining room hanging among the ruins, a wooden horse in a
livestock wagon, a Red Cross convoy, and mugs of chocolate in a
Dutch train station.

So the fear of Fatty, Charlot, Al Saint-John, began irreparably to
unravel a whole world of music, voices, pictures. So it was in the
cinema that the world began like the memory of a crime at once
perpetrated on someone and yet *constantly suspended.* So it was at the
cinema that the fidelity of a voice that was heard despite the thunder
and despite those years, an *inward breath,* came to die alone for the
first time.

So films have constituted a peculiar fear linked not only to a uni-
verse of whispering (of nonreligious whispering, and so it was some-
thing that the heavens didn't hear, like words stifled within a room)
but also to the silence of those gray bodies and their gesticulatory
granite.

But there's something other than all that in the cinema: in a bur-
lesque persistence, that is, the pure invention of the movement asso-
ciated with white faces, there is a shadow, as if the child's father had
died in the war perhaps, and – because his hide, or his body, had
remained lost – as if he had been angelically raised up by some force,
by some being, toward an unknown deliverance – or toward, cer-
tainly, the effect of an abandonment which thus instituted the delay
of the criminal act in the comic double of the world that we had to
fish for in the cinema. And as if this other side of the world – the
cohort of angels, the funeral ceremony, the mourners – could only
come from there. And as if they all came, sporadically, at such a
discount, through those gross rituals. More than that: they came in
this momentary world of unbroken granite where the succession of
images or shots, where the reason for all behavior remained a disqui-
eting enigma: that is to say, with a familiarity and a connivance pecu-
liarly displaced.

But this is it: the grotesque world touches upon that sort of dis-
tress – as its reason and its enigma – because one's father, in a scene
plucked from infancy, had one day been taken away from the world
as the very reason for the war's taking place. And amid bombarded
cities and broken bridges one supreme portrait, a photographic gaze,
still remained. And if these stony beings kept on gesticulating in

hasty despair, it was because all the great men – one whole side of
the world – hadn't exactly ceased to live, but had already stopped
coming home with outstretched arms.

BUT it's a fear of what crime? An objectless distress that fixed itself
there uncertainly, or could subsist through the removal, through the
very difference on which it stood, fixed on anything at all.

And moreover, if this grotesque world, teetering and swaying,
actually came loose, repeating within itself a whole series of catastro-
phes (that was its motor, simply the opposite of all reason), it was
because the daily world too could be threatened by an anxiety and
by a sort of laughter that had already lasted longer than all the im-
ages. Or had allowed no image to remain. . . .

A quantity and a power of affects are linked, bit by bit, to an un-
known object. They immediately have the strength of being unre-
peatable, indivisible, nonrenewable: they cannot be exported. Thus
they don't situate their subject (the very site of their constant or al-
ways probable charge) in the world – that is, in a milieu where a
series of events can survive, can be isolated, detached from all causal-
ity and not looked at. Thus the world too is caught in the freedom
of insignificance, which is why, in any circumstance, it is liveable,
bearable, and yet detached.

These unknown affects (born in or solicited by this machine of
simulations) come from a world that first of all has no exterior: de-
fined by a constant level of signification that takes deep root only by
means of those affects which, beyond their monstrous qualities, all
have their own duration, a time – an internal tension – which also
marks the place of their falling due, of their cancellation (the annul-
ment of their virtual character), or the temporal contradiction inside
of which this apparently floating world (this granite and its flakes of
images) takes its support from the subject that it presupposes. Or
this spectator who refilms that entire world and in whom a world of
granite is displaced without memory, or is seized by feelings only
because of the enigmas for which he becomes responsible, since he
is always the guarantor or the creator of their reality.

And so it is that, beyond this complex piece of machinery, what
is dispersed is what actually sees the film: the isolated, solitary or
silent instance of a return to worldly morality, enigmatically re-
turning to those qualities in a weave that is at once closed (as scenario
or image) and yet entirely destined (devoted and addressed) to the
reality of affects which is the whole expectation of the image. That
is to say, then, devoted to crime itself.

THE cinema's monsters are, perhaps, the cinema's interior being: fi-
nally, like any of its fictions, being delegated as anamorphoses of this

world that's predestined to morality or to the signification continually addressed to an unknown moral subject, to a being who doesn't synthesize them but in whom their strangeness can live as a morality, or can last without being effected by time or memory . . .

. . . but who, having been lifted (maybe thrown) into the heavens, wouldn't then fall like all those bombs, or like the descent of a body suddenly slowed down by a parachute, suspended in midair; who could emerge from a load of images, emerging from whiteness itself, touching, holding out his hands and saying, "Come!"

And this subsists, this unknown species, in whoever watches a film, in whoever sees on film a new species, this anybody, this opening, these frozen entrails, or the laugh that makes a slaughter or a war begin all over again. That is to say, the death of a being as the very reason for all the upheavals on our earth. Like a death of the humanity in ourselves which is no longer represented in the white image's face. As if this mosaic face, made up of flakes, dust and dots, quite simply and with no possible correction, had invaded the seated being with the immense extension of a being that has no present but is still exclusively tied to the mystery and horror of Time.

SOMETHING, first of all, is linked to the mystery of the meaning we add to the image in our uncertainty of being able to seize its totality, in our suspicion that such an addition would be no more than an incomplete levy of the anxieties of signification within it – uncertain, still, that what we're adding to is not primarily something we should call "ourselves": beyond the seductiveness of its images the film will keep that mystery intact (and will keep it as a part of ourselves): before any apprehension of new meanings, we learn that signification is, here, a body.

This body cannot be synthesized. It's not the sum of the parts of the face (gestures, mimes, accent), but at the same time it's a leakage of all those things, a spinning perspective, a new amputation of this incontestable unity. Such a body is, nonetheless, and quite strangely, a signification above all (or in a simultaneity we had no idea of until now, until the world into which we enter arrives with us, borne by this magic lantern), a signification rather than an anatomical reflection. Two things strike us: there is – and I don't know in what time – some meaning without signification, that is, without an operation of parts; what's projected and animated is not ourselves, and yet we recognize ourselves in it (as if a strange desire for the extension of the human body as signification could act here or begin to extinguish itself on simulations of objects felt as a supreme simulation of ourselves: what wasn't born in us can live here). Finally, without shame, we see men, that is, men who for the first time appear as the spectacle of our blank shamelessness. A species, for the first time, dedicated to the possible, unlimited, and infinitely repeatable spectacle that

breathes within us (and even becomes our inextinguishable need and craving). Thus, for the first time, and for a final moment, we see what remains of the vanished world: we see complete men and yet remain entirely innocent of the spectacle.

These men are infinite; they're constrained by the destiny represented by a history they will never cross; they are, all the same, repeatable; they cannot live easily in this universe except through its mobile objects – as if their light could be our definition and as if, within us, in a new consciousness, their very scale and proportion could change like the dimensions of our visible world. These men are there because of our own obstinacy and in order to repeat that which so improbably attaches us to everything else, the phantom link that we experience in the cinema: "I would never have imagined that a meaning could be an actual body, that is, the instantaneous disappearance of what attaches me to it."

But why do we find the words "guilty," "criminal," or "sin" attached to this spectacle? Crime isn't the act of perpetrating extortions in the world. It designates a man tied by signs to the limits of his universe, and this man, guilty even before infringing any laws, is guilty because he reveals himself as a subject in this universe, and because within him there is the consciousness of this world without freedom to which he himself is the link.

AND yet this world has already been seen by, and perhaps captured by, what we can imagine in hindsight to be a body infinitely larger than our own (and not just because the eye that momentarily projects images of it is like a lighthouse); a bigger body, unvaryingly situated behind our own, behind our heads, there where a plate of photosensitive cells, such as prehistoric animals had, is covered by bone. Thus – and I can hardly imagine it – when this giant leans across a white screen we can see these microscopic beings stirring, even though their dimensions exceed our own bodies. And so we immediately arrive at this giant anatomy, at this body that we can't inhabit with our own.

Nevertheless, this is what being at the cinema is: perhaps less a question of forgetting a body in whose image we no longer walk, and as if, because of the retreat of the clear images that it can't fix, its own weight had disappeared. We're caught between this giant we sometimes have to imagine or assume, and what his eye is continually filming from behind; the first man (the first meaning: it would be an illusion to try to separate them – sense cannot be classified; it belongs to states of the body that are successive, hinged, and incomplete), this first man is only inchoate to the extent that the world doesn't happen within him and he becomes the transition of a unity of forms and sequences against his will and that he didn't dream up;

the body that moves on the screen remains the necessary passage of the only world from which he can never be turned away.

I don't think that we're seated in Plato's cave; we are, for an unthinkable eternity, suspended between a giant body and the object of its gaze. So I am, not seated, but suspended beneath a sheaf of light. This sheaf is animated. The easy anteriority of its movement in the animation of the film's objects is visible as a scissor effect, or as if the rays hit upon legs, and from time to time crossed them, uncrossed them.

I cannot imagine how Kafka managed to write down (January 9, 1920) nor what incomplete machine – essentially incomplete but all the more active in filling the part of the visible of which it has been deprived – could finally describe that impalpable relation, that strange accomplishment of the visible world whose perception is nonetheless forbidden it, and for which it is continually an open wound, or a blind spot: "A segment has been cut out of the back of his head. The sun, and the whole world with it, peep in. It makes him nervous, it distracts him from his work, and moreover it irritates him that just he should be the one debarred from the spectacle."[9]

I don't know, either, in the confrontation of gaze and body which constitutes a spectacle, how the spectator sees in its movement, its distance, its disappearance, this body from which he is separated, any body that is destined only for action, and allows nonetheless not so much its image but its former center of gravity to stay with the spectator, the center that was needed for his immobility prior to the action and for his solitude prior to the confrontation. By means of this lost center of gravity, this body acting at a distance from us, this same being animated by light, leaves the spectator with a longing for an existence in the past. It doesn't leave its image; it allows the floating or sprouting inside of ourselves of this vague point by which we can always resemble a silent man, an immobile man. And so it infects us with all its sleep; it occurs within us.

"FILM adds the anxiety of movement to objects. . . ." And so, does it actually invent movement? These men, women, beasts, and monsters walk in vain across the whiteness of the screen: they can't quite compose the movements that we repeat and by which we imitate nature – that is, essential weightlessness. Just as the street scenes filmed in the world's cities around 1914 exposed the strangeness in the successive positions of someone walking (and that recomposed movement, the image's deceleration in bodies, the strange formal agitation of phantom limbs, helped in the construction of artificial limbs for those disabled in the war), in the same way it's necessary

for these bodies to have sensations as whole bodies. Sensations, grief and fear, are like desires manufactured in a bundling up of the world just as we experience in the cinema a sort of indifference in the material of a shot: that operation isn't a selection of details – it makes man's fragments belong to the world of objects, and it's primarily the world of objects caught in detail which must generate emotions. That world, given over to complex perceptions, can thus never be caught purely in contemplation. So these affects, born of the new and incessant disproportions of images of the world, must be what supports the trick of cinematic motion.

Some of Faulkner's novels invent the cinema in the same way – not its movement, but a sort of mobility of frame that breaks up narrative time or defines people within moving frames; we don't see everything there because the imaginary world is the one that least allows images to rest, dictating that they should be trapped not in their articulations but in their definition as a series of ruptures. Such images simply reveal that they come from a world that's initially invisible. They attach themselves to no past, nor to any possible perception; they replace it, that is, they begin to substitute for the world this improbable witness from an invisible world.

Isn't it the same as the way the tattooed body of the potter Genjuro, in Mizoguchi's *Ugetsu Monogatari,* is thrown before your eyes? It's an astonishing image, but at the same time it no longer really surprises us; we've been expecting it for a while – not as an effect, not as an image, but as a truth. Perhaps we'd been expecting to see our own body, thrown to the ground, impossibly covered with ideograms and becoming for us (for me) totally written, indefinite in its anatomy, offered up to its own dermal reading, to its own closed and unfathomable eyes: devoted, then, to another hell, and making every other phantom of our desires retreat across this inkburn.

The Wheel

Singly, [our thoughts] are every one a *Representation* or *Apparence,* of some quality, or other Accident of a body without us; which is commonly called an *Object.* . . . And this *seeming* or *fancy,* is that which men call *Sense*; and consisteth, as to the Eye, in a Light, or *Colour figured* (Et quantum ad Oculum, Lumen dicitur vel Color). . . .
We still retain an image of the thing seen, though more obscure than when we see it. And this is it, the Latines call *Imagination,* from the image made in seeing. . . . But the Greeks call it *Fancy,* which signifies *apparence,* and is as proper to one sense, as to another. IMAGINATION therefore is nothing but *decaying sense*; and is found in men, and many other living Creatures, as well sleeping, as waking (Sensio deficiens, sive Phan-

tasma dilutum et evanidum: a sensation in the process of being effaced –
that is, an impoverished imagination, without consistence).

– Hobbes, *Leviathan*

In Dreyer's film, *Vampyr,* a mill wheel, flour, the vampire pressed
against a wall, this powder falling over him: that – and the hope that
he will be swallowed up – constitutes our anticipation of time, a
paradoxical suspension which is already an end in this film, the fine
powder that paints this man in black and white inside a barred cage
(and why can't the flour flow through the bars? – it's as if this were
also an aquarium or as if the bars let only air pass through). The
mill's cogs and pulleys here are like the machinery of time whose
movements produce the disappearance of a body beneath the dust.

But there is, like the cut and floating meat in a Buñuel film, a
slowness that is not in the film itself, not in us. Which is not pro-
voked, either, by the brusque animation of a disturbed *tableau vi-
vant* – and the latter appears as such in a slight movement of distur-
bance, because its immobility *might have been* the fragility of its recall
already caught beneath our eyes: so it was, too, an immobile con-
sciousness. A quality of time, then, remained hanging over all of this
like a slight suspicion. And indeed, this is where suspicion first arose,
reaching these universes by indices, or by marks fallen like alien bod-
ies within those same universes. So they don't begin by figuring
something. And it's exactly this that worries us: we never know
whether they're going to finally die off or whether they're caught
here as a figure of eternity – because, as opposed to the bodies that
appear on screen, these bodies are primarily unrepeatable. Thus the
wheels and the flour in *Vampyr:* we can see the shadow of the ma-
chinery at work. (And I didn't know, being so young and not even
knowing my way around a town, that we could already cross conti-
nents – what were these languages, these landscapes, and all these
people?)

There are races shut up inside images (fixed as the movement and
passage of the images), as if the rotation of the reel's very pivot
achieved linear representation for a moment through the establish-
ment of the time of an action: at least, it's almost a linear representa-
tion – as if, forever escaping from his cage, a squirrel were unravel-
ing beneath his nibbling and galloping paws the very speed that
keeps his silhouette almost still, arrested in the phases of its move-
ment, in order to show us the same animated image of pulsating rays
added to and superimposed upon the squirrel's image; almost as if
the frenetic race against time in this imprisonment (in which the ani-
mal's image occasionally seems to be sketched inside the wheel) were
finally able to produce its own mad and immobile race, along with
the invisible motor that makes the cage turn the wrong way – like

the illusion of a stroboscopic disc; nothing more than the image of this cage as it turns or describes the phases (immediately imagined as successive spasms) of an animal tiring itself out against time.

So we have, before our very eyes, in a fatal deceleration, the death of Dreyer's vampire; he dies as the motor effect of several images of time, of time's mechanisms and matter – its imagination.

Just like the filmed images of a Roman chariot, or a carriage driven full-tilt, the driver glued to the reins, the foaming horses stamping and hammering at the ground, the arena's sand, the pavements of Rome and their broad stones; just as these show us, at the height of the race's thunder, the impossible image of a wheel, its spokes, the slow oscillation or swaying of its shining segments, which, like a polished disc, sweep to and fro across the circumference of the wheel, followed by the striking, the movement, almost the collapse of the spikes that suddenly begin to turn in the opposite direction to the movement that carries the wheel, making the chariot disappear before us; meanwhile, up ahead, the horses keep on foaming, gallop-ing in the wind, kicking up dust. For a fraction of a second the image of movement, as if it were still to be added to the speed, is no more than an oscillation, a sort of hesitation superimposed upon the image of this pendular motion (as if, then, the weights were upsetting the movement but not the speed attached to some fixed point between our eyes). And in this slight bloating of the stroboscopic effect, movement is thus detached from speed – because images can perhaps retain no more than the analysis of the horse's slowest movements, or the charioteer's, since they have no center and cannot annul them-selves in an acceleration around an immobile axle as it tries to de-scribe some sort of circumference. Through this movement, before our eyes, like the crossing of the threshold beyond which move-ments simply record the phases and positions of a body, speed comes away from movement (like a wheel coming off behind) and in slow motion cradles this lightly striated spherical body of light. A little as if a round mirror were immobilized in the midst of this motion (doubtless because the motion doesn't destroy its own image, but in fact stabilizes it) because in this single instant it might be regulated by the rotation of a sun, just as flat, turning opposite it.

In the same way as this image of a body that has escaped from movement and can be perceived only at high speed, producing an-other illusion of the registration of speed, in almost the same way, Dreyer's vampire expires before our eyes, caught simultaneously in the machinery's movement, in a shower of white powder (like the body of an insect falling within the sand of an hourglass), and in the silhouette of a squirrel running madly inside its cage. He dies right in the midst of this machinery, like a hand falling off a clock-face. He dies because time suddenly begins to count him and makes him die in slow motion.

So it is enough (is this the same illusion as that of the wheel repre-
senting speed of movement only as the immobility or hesitation of
rotation reversing its registration, like a halting of planetary motion,
pointing out, amongst all those harassed bodies running to their
deaths, the only geometric figure that can resist the illusion of move-
ment which is also like an eye – the eye of a hurricane or a sand-
storm – watching us in a primordial silence?), enough, then, that
time should count a single body which immediately becomes unable
to represent time; time encloses it in the machinery so that it can die.

It's almost as if the body of the vampire were sticking to the guts
of time and its markings. His body becomes shining oil in a clock-
work (as the wheel suddenly turns in the opposite direction to the
movement it carries).

(The same wheel on which movement became tired and fixed, the
same wheel it deserted, appearing to us as a genuinely mysterious
object that only the cinema could show, because it's here that we
find this enigma: that speed should be held immobile in front of us,
that we should understand time, sure as we were that in a scene such
as this the stroboscopic disc was the only thing to be looked at.)

Here, then, is a mill with its wheel turning inside. I can't see the
whole house, half of which is planted in the water; but on one wall
there is an arrangement of paddles splashing into the water, diverting
it, as if it were there that the machine's real secret lay; lifting up the
watercourse into the building – and I can't see the splashing, the
foam beneath the wooden planks, or the transparent cream that
swims and twists along the stones (this boat of cemented stone, wet
and still, allowing all the water to flow through in a sort of helix and
filter into it as it changes into light, into grains, into a dust that's like
the gathering of thousands of seconds into a swarm of buzzing in-
sects, or like the deposit of the white powder in a series of breaths
and jolts which release the successive layers).

As if the rays of light, from along which tons of very light dust
arose (dust that they could touch, engender, or set spinning at incal-
culable speed, both slow and precipitous – the mass heavy, the indi-
vidual grains madly propelled), as if these grains had been given their
head and turned one by one, indefinitely, in their peculiar disorder,
this descent of a powdery sheaf, thin as a leaf or thick as a column,
in a sort of capricious motion, a change in the geometric destination
of the grains that compose it, changing brusquely from a superficial
ghost to a deep hallucination – passing across huge trees and piles of
leaves, the sun's rays light up a forest and the silhouettes of the two
young people run silently through the leaves. As they run the young
man leads the girl, who is dressed in a white gown. They've just
been running through half-shadow on a lawn, moving away from
the front of a château before coming to the forest edge. At first we
could see only the vampire's shadow running toward the mill; as

135

soon as he entered, we saw the motionless wheels, the shadow of the
spokes, a chain, and the mill's indented wheels. The two young peo-
ple were running across the grass, away from the house. Someone
else enters the mill and sets the wheels in motion. The vampire enters
the cage and the door slams shut (he's behind a grid, shot through
panels that suddenly become the image of a cage). Then the wheels
turn and white powder falls and flows, at first unidentifiable (it's
perhaps the simple product, like a talcum powder, of the use of this
clockwork motion that we are watching). The two young people are
on a boat for a moment, escaping by water; the fleeing motion be-
gins, footsteps, running, are slowed down in the movement of the
paddles as their arms have to move the oars in the same manner as
the gears sift out a flow of powder, as the paddles pull upon the
water while the black shadow draws in flour, as here and there all
those fleeing movements begin to pull upon the same matter –
time – and the end of the flight becomes already and everywhere the
same thickening of every second of time. The gears crash on, like
rounded teeth; the flour begins to mount the vampire's silhouette (he
waves his arms as if to protect himself from a million white flies).
The boat reaches the bank; the couple walk in the forest as the rays
of sunlight fall with their dancing dust – so they move in an atmo-
sphere that is both somber and light. The flour falls thicker and
thicker, its continual descent pursued by a closing in of the frame
which seems to want to follow up on the final perception of disap-
pearing detail. The man is swallowed up. For the first time the image
of the cage is complete, a hand sticking out of the flour. Two charac-
ters walk among the trees, crossing planes of light; the light contin-
ues to range and vibrate in the forest with no object; bodies pass
across it, walking, reaching the slow winking of the light. There's
nothing behind them now; they evacuate (after the halting of the
machine with the tumble of the last grain, the stilling of the hand),
they evacuate or set in motion the remnants of time that cause them
to advance through this forest without producing any action, despite
the wheels that are now still. (Or because a remnant of time that
no action can cover remains there, exhausted, among the trees, in a
chiaroscuro, in a cloud of leaves.)

Gigantic motion grinds the vampire down and in a backward
movement reduces his eternity to a powder and deposits this powder
over the action, this powder and its musical accompaniment, eternal-
izing the youngsters lost in a wood; the movement of the inordinate
effect that has to begin this sort of reversal of time is first of all pho-
tographed through the immobility of the huge clockwork. So it's
not an action that sets it in motion and pushes those relentless teeth
against one another – less than that, it's a cause, the smallest cause;
it's the scale of movement, represented by a tiny wheel – a childish
wheel and the only piece for which we could have the key without

knowing, before it dragged in these gigantic footsteps treading upon whiteness, without knowing that such a key opened up an orifice in time: this white flow, quite simply. For a moment the white head of the aged Liszt is superimposed upon it: one of the vampires comes searching for a young girl who had fled from the house and now sits in the dark on a stone bench in the park. For a moment he stands behind her, and then he is bounding away like an animal, leaving her collapsed upon the bench. He flees, jumping like a kangaroo with the powdered wig of Liszt in his old age.

As if all these races, progressively piling up before our eyes, could produce nothing but dust, even managing to lift it up into this white abattoir, this whitewashed ward, inhabited only by wheels, a slight noise, and a growing old.

As if all the action had already been relieved by a movement, running in all directions, using up waiting-time, and allowing only a little pile of powder to build up in the midst of these geared-down movements.

And that assault, projected as a white coating, by such a wearing down of marble, causes the falling away of all the years to the moment when the world was hidden beneath a crust of snow. And the silhouette slowly stifling in the flour arouses in us (like the image of a cooked insect found in a loaf of bread) an inexplicable relief at seeing this body simply disappear without the shadow of an actual murder. This body, or this alien role, and like the shadow which, without emerging from our insides, reveals in this swallowing up of the flour, that it's separate from us and was attached only to a sort of exteriority of time – since, precisely, the role dies here as a body and the body disappears (in the slow motion of all the mill wheels), not from the movement which crushes it, but from that which, through these gears and chains, simply accompanies its disappearance – as if this death, due only to an excess of whiteness and the consumption of light, were a simultaneous moment in the action of the machine, or the clock in a theater, which like the punishment of the wheel can represent time in a single death.

Because this role dies as a body in the slow blanching of the image, and because this falling pallor (as the return of the Roman god Palor was the only color of an affect) also constitutes our complete relief at being present at this drawn-out burial and our total relief at the disappearance of the very body of fear.

So a child is seated within us watching all the wheels go round, quicker and quicker, and watching the movements begin, the smallest first – because that's what he understands and this empty rotation concerns just a body caught in the gears across a jet of flour. It seemed that this rain, this arc, and the body tortured at a distance by the gnashing of wheels – the smallest of them already grinding the flour – it seemed that all of that was building upon these images a

whole universe of causes, because at first nothing told the child that this white rain was flour, chalk, or snow, rather than a natural corrosion, a sort of leukemia, suffered by the vampire as he is imprisoned in the cage with the noise of the wheels. As if this death had been carried off and relieved of the unity of isolated enigmatic effects representing only the powdering of death.

So it's not death here, nor quite the end of its deferral, but the incredible disappearance of a body within the image. As this child, judge and jury to the world, had sat down again, at first not understanding the flour, the accident, or the cause, all figured as a race.

YET every death in the cinema relieves something within us all (and indifferently, whatever is at stake) by the way the image mounts up and reaches this sublime completion. An act we never committed is added to our consciousness of a cause that we could have retained without ever admitting it, without ever making it act. This might be the same kind of thing as when a stone is rolled away, as when a window opens upon the image: the act doesn't simply relieve us, and so it doesn't literally liberate the uncertainty of death that roves within us; nor does it assure our survival (as if by means of this murder we could still remain in the images from which a body has been detached without our help). Perhaps it just gives a figure to a period of waiting that had previously had no object?

ON *LA JETÉE*

The following article is a meditation upon Chris Marker's 1962 film, the "photo-roman" La Jetée, *and was published for the catalogue of a video exhibition, "Passages of the Image," that toured Europe and the United States in 1991 and 1992.*

Marker's film, an astonishingly powerful experiment with word and image, is made from a series of stills and a voice-over narration that tells of experiments carried out on a prisoner in the underground camps to which everyone has been forced after the holocaust of World War III. The experiments will purportedly save humanity by sending "emissaries" into both the past and the future to bring back help. The experimental subject (the film suggests this is the narrator himself) is chosen because of his obsessive attachment to an image of the past – a young woman on the quay (la jetée) at Orly Airport when he was young. Under the auspices of the experiment, he reaches the past and spends time with this woman; but he is then brought back by the experimenters and sent to the future. The people of the future offer him refuge with them, but instead he asks them to return him to his past, to the quay at Orly and to the woman – and, as it turns out, to his own death.

The arrangement of time in this narrative is what Schefer's essay is largely concerned with – what he calls its tragic syllogism of past, present, and future. That is, Marker's film replicates with almost uncanny clarity the investigations of several of the essays translated here. Specifically, Marker investigates the desire attached to memory; he understands memory as a hope – which necessarily turns out to be an illusion – of returning to a childhood image; and he allegorizes the way in which, as Schefer might say, humanity is tortured in its attachment to the image.

There is, then, a certain consonance between the film and Schefer's concerns, which he exposes. But Schefer is also interested here in something the film does not say but only enacts: that is, once again, the relation of image to writing, where the character's search for the image of childhood, the impossible secret of "ourselves," the mysterious birth of our subjectivity, is caught somewhere between the novelistic or narrative ele-

"Sur 'La Jetée.'"

ment of the film and its visual element. The central character is narratively put to death by the conflicting experience of images or by this "tragic syllogism" of time. He is caught in their collision and dies from it, because, as Schefer says, he cannot write these images down.

"This is the story of a man marked by an image from his childhood." That's the opening (the first voice) of Chris Marker's film. The phrase broaches a story (the hero will travel in time toward that childhood image); the destruction of cities and the devastation of the earth's surface have threatened the very reality of the present and have thus let loose temporal virtualities normally locked up or held captive in the past (the past consisting only of a series of images that have become autonomous, tied to the living only by some affect or trauma). The fiction of *La Jetée* is thus a certain kind of work – whose object is the film's hero – concerning the paradoxes of memory, concerning the inclusion of the past that lives on within the hero as an image, as a secret that the laboratory experiments in the underground camp will try to make him confess. The realization of the confession comes with the death of the hero himself as he relives a moment of his past, as he meets once again the girl whose image has haunted him.

So it's a science-fictional hypothesis that underpins the organization of this film and, with particular emphases (the distance of the narrator, the modesty of the novelist), regulates the metaphysical problems that are then rapidly elaborated into a science-fictional argument in such a way as to render the paradoxes of lived time with the exteriority of an implacable syllogism. That syllogism is what leads the living human to meet his death, a death whose image is his secret.

But why that hypothesis? The originality of Chris Marker's film obviously resides, as has been regularly demonstrated, in the work of the image itself: a framing of the most obscure zones of memory's fragility and unpredictability; and a montage that replicates gaps in recollection. The image itself constitutes an unusual organization of story line: Marker invents a type of narration that literature cannot often produce. Literature here appears only in the voice of the narrator–commentator: it borrows its script from the narrative mode of a Kafka.

Beyond its novelistic argument, the film consists in something other than an autobiographical project whose shape it wants to trace. These intimate recollections, essentially tied to the return of the figure of a childhood love, can only be organized in a science-fictional scenario (the role of that obsessive image is also to denaturalize the fiction): such a scenario constitutes the expansion of the field where the subject of memory, of recollection, of relived affects, is put into

an experimental situation. He is the milieu, the strictly individual and lonely guinea pig, of an experiment of which he is both the key and the secret.

I want at least to remark the way this hypothesis works around a "novelistic" autobiographical project within the framework of a science-fictional scenario: the subject of memory is implicated as the place where time itself, in some strange way, gets used up. What constitutes the subject's secret is always the image of a personal event, a mystery of his "self" that's supported and guaranteed by recourse to recollections of a person he once loved. The science-fictional hypothesis contains precisely what one might call the non-Proustian aspect of recollections in the form of images: the real time of the experimental subject isn't constituted in the kind of invisible images (syntheses of smells, sounds, forms, vague affects) that animate Proust's writing and make all his pre-scription seem symbolic, but instead is made up of alien images that frame the subject.

This experimental subject is trapped – as in a labyrinth – in the drama of memory whose whole experience consists in making something his own (in a certain way he dies within himself, by a reconciliation or a coincidence of time and images). The paradox of the experiment (extirpating the subject's intimate images) is the construction of a fiction around the very act of memory: the subject (that is, the nameless hero) is obviously constituted only by those images through which he begins, or leads to term, a kind of transaction, or in the course of which these images become the equivalent of a piece of time – and time becomes the equivalent of the object of the experiment, having no other consistent representation except in those images that retain faces and affects (affects that in a certain way indifferentiate his objects: in other words, images of the "present" alone, images of the work of destruction, are alive, and fragile). Recurring images are in fact the raw material of temporal "synthesis" – a synthesis which is not quite of the order of truth (nor of verifiability – torture is endless and ineffectual unless it procures the confession of a secret). It's that the subject (I don't know whether to call him the hero or the narrator) confesses, articulates, discovers something that is the constitutive principle of his soul (and no philosophy stops us from imagining this as the producer of synthetic time, an excess).

Also (beyond this demonstrable paradox that's the proper object of autobiographical rather than novelistic writing), I'm well aware of the actual context for the hypothesis: that is, the invention of the machinery or the narrative motor that starts up the experiment through which the subject (at first believing himself to be constrained) discovers for himself this living object mortally trapped in a coil of time.

That, for those of my generation, is the memory (an imperfect

memory, but one that induces the greater part of our sensibility), the
memory of or the kind of mnemonic damage caused by the war in
our childhood: a primal consciousness of an era of planetary destruc-
tion which has lodged a soul within us, like a bullet or a piece of
shrapnel that hit us and by chance reached a center where it could
live on after having done no more than destroy a town or kill some-
one other than us.

And yet this paradox (that is to say, this artifice) touches some-
thing very profound in us; you see it in Rousseau, in Proust: the
frailty of the intimate object, or the frailty of the secret, cleaving the
subject (the self) to this tenuous thing that we usually take to be a
sign of our unique individuality (and no doubt it *is* such a sign): our
justification and our licence for braving this waning of time (that is,
the work itself) always come by way of an insignificant little *ritour-
nelle,* a tiny machine that repeats our access to childhood.

I can't do a proper account or a real analysis of Chris Marker's photo-
novel. I can't exactly decide whether it's a film or the outline for a
novel (trapped terribly in that tragic syllogism). The striking thing –
or the impeccable thing, perhaps – is that the syllogism which de-
fines this whole theatrical act defers the death of the hero for as long
as he can speak, for as long as he can evoke the world of the living,
can say his evening prayers: the syllogism of this tragedy *is a scenario.*
That's how I explain to myself – artificially – the material of this
narration and the discontinuity in it that gives me the idea of an es-
sentializing selection, exactly; the sketchy, fragmentary aspect of the
evocation and of the narrative, the elaboration on pent-up time, re-
discovering the characters alive in that antique "place" where images
cohabit and commingle.

Can this film possibly substitute for the writing of a novel? To
whom to attribute the continuous voice accompanying the images?
By whom is this adventure told? A witness, the depersonalized es-
sence of the hero? An experimenter? Or someone who has absolute
knowledge of time, death, and the paradoxes of memory? The narra-
tor or commentator (whoever is describing the whole experiment
and its length, and who possesses knowledge of the hero's soul – of
the subject of the experiment), the one who speaks in the film, he is
not its author, but the author of the novel that the film blows apart,
sketches out, jettisons, cuts, and whose substance it reworks. That
substance is the secret: the secret that animates the novel's unending
quest for that lost face and produces the petrified image that makes
the character disappear behind the reality of an experimental subject,
this nameless hero who can't survive the conflict of images – who
can't, that is, write it down. He himself is an image, precisely the
thing that the novel disperses or can never stabilize.

The almost constantly present face of the "hero" nonetheless

makes me believe or understand that it is in fact the hero who's speaking and that it is the novelist who comes to describe the world according to his subjective science. Knowledge in process (Condillac's statue worked by way of its details in his memory: mortgaged by memory) is an image of the past (that is, something of the intimate consciousness of time).

The girl is protected (the statues, the museum, her slumber) by time. She is the face of time and, above all, the very content of time (its secret, its truth). He, as the subject of time (she is his sovereign), becomes the agent of her quiet truth: the machinery of time puts the hero to death by the coincidence of two images.

But what remains unexplained is how the past itself can be edited into a form: the form of the film itself; more exactly, how can a fiction of the past be edited into something that can represent the past for someone whose experimental life consists in being affected by a form of time as it reconstitutes the fragments of a disappeared world – fragments that make up the suspended life of this subject who is composed entirely by his suffering of time. Time isn't a content, nor a frame; it's no more than an affect, in that it is a consciousness that has become autonomous, become independent of the events that were once its form. Those events have opened up a whole world of sentiments, rather than actions.

It would be absurd and not very useful here to try to demarcate the film's objects, its degrees of reality or expressivity. Yet I feel that by attaching myself to the story I'm neglecting something. The story isn't in fact quite equivalent to the narration, which is made up of particular narrative devices (images and their continuity, the montage techniques and editing that produce the continuity). Almost the opposite, the story itself, presented in narrative form, partly utilizes that form as a sort of ephemeral theater in which another part – the part that makes this story come alive for me – remains invisible and necessarily deprived of images. This same story (it could be written) without its science-fictional alibi (that is, without its luminous originality as well), where I search for that girl from my own childhood (my life can in a way be said to depend upon her, and yet, when any event from what we call the past is thrown into jeopardy . . .), this same "written" history will have to work with still another paradox: it is an investigation of faces that have become invisible.

This film, however, is something other than that. The story (which, I tell myself, is what grips me most of all) is perhaps the alibi or the cause of the film's organization and its material, in the same way as a face, a person, or a "type" are actually the cause of a portrait rather than its object.

The extreme emotion of images fading to white, fading to black, constitutes a subvention of the film's material or its narrative mode. The destructible image in the eclipsed world (being reduced to a sur-

face, a shot), this jostled image – all its cuts, angles, and surprises –
is for me strangely linked to the whispering sound of the German
language (the film's narrative is in French, but the protagonists who
speak do so in German; they enunciate the phases of the experiment).
Why does the whole secret of the experiment reside in the *Murmeln,*
the *Flüstern,* so close to the heart of a remembered *Lied* that speaks
falteringly from out of silence? It's easy to imagine that for a long
time the war and the experiments on bodies, where humanity be-
comes laboratory material, were a German thing; to imagine that
psychoanalysis, science gone astray and applied in horrible condi-
tions, yet remaining frighteningly human to the last (according to
the admirable thinking of Robert Antelme),[1] spoke in the voice of
this German language, like the ghostly symptom of Romanticism's
sense of our species; and easy to imagine that, once it has interro-
gated Western culture, it begins its abysmal and violent descent to
insinuate itself into the memory of its subjects.

In this score, in the choir whispering this stifled *Lied,* I hear, too,
the heavy dialogue of the devils from the second Faust; the young
girl of the romantic stage is revived, the eternal mystery of survival
to a mad or dead poet; the young girl of ancient Greece in Hegel,
who represents both knowledge and the innocence of philosophy;
or the woman whom Kierkegaard imagines to know already what
Socrates does not.[2] Romanticism has translated Dante so that Be-
atrice stands for the very insistence of death because death has be-
come an amorous vocation, and the limits of the world have thus
been redefined – and that same century was discovering negativity.
So it's from this hell – that is, the place from which, progressively,
through jump cuts and flashbacks, memory's event is drawn by the
sweetness, the violence, and in any case the capture of recollection
(from a time that resists elision because a part of the subject began to
be born then) – it's from this experimental terrain (this terrain which
consists in a man navigating blindly, struggling along in a body
alienated from its own images, in the film version of his unrecogniz-
able life), it's from here that the flower of pure love arises, the object
of all of humanity's nostalgia, the memory of a love becoming inno-
cent in the image.

We're fascinated by the destruction of this image that we believe
is an essence only because it's so fragile and feeble in its characteris-
tics, and because we believe that our very existence, so dependent
upon this reality locked away in the past, is consistent with that im-
age since, in the end, something of ourselves, our soul, or our secret
(our intimate time), is affected by its fragility. We're persuaded,
equally, that this fiction of a time rolled up in time, preserving the
old film of what we once were, we're persuaded that this parentheti-
cal time within time articulates or produces or proves the approach
of an ancient death. All I see there is this: images of life sliding, being

destroyed, and growing dark within the story that they give rise to.
The beauty of this thought: that the experimental subject of memory
lives on only in the experiment; he dies from it or can't survive what
it has awoken. Just as a face can't survive the notion of resemblance
that makes a portrait something other than an idea or something
other than the representation of an absent person. A fidelity: some-
times fidelity to the game where someone sits for the painting. But
sometimes it's the fleeting fidelity to a destiny in which that game is
but a ruse.

CY TWOMBLY:
UNCERTAINTY PRINCIPLE

This essay and the one following, "What Are Red Things?" are the most recent of Schefer's writings on art to be represented in this collection. They both exemplify the work that he has carried on in recent years alongside the production of three books: one on El Greco (1988a), and forthcoming ones on paleolithic art and on medieval legends of the profanation of the Host (mentioned in the next chapter). Although these two articles might not, then, represent Schefer's most elaborated work of late, they have been chosen for inclusion here because they do help demonstrate something of both the continuity and the development of his central concerns and themes over the years. Each of them reprises in a new way the history of figuration, where that term is understood to stand at the center of the paradox which Schefer continually investigates: the paradox produced by the fact that all representation simultaneously evokes and annuls the spectator's lived experience.

We shall see in the next chapter how Schefer's thinking about the role of color in the history of this paradox has evolved from the time of the first article in this collection, "Spilt color/blur"; that is, we shall see how he now views the role of color as a kind of formal irruption into systems of representation. For the moment, in this article on Cy Twombly, we see Schefer conducting what might be considered a more epistemological investigation. That is, this article attempts to outline the role of Twombly's work in producing a certain kind of knowledge, or "science," which Schefer calls here a "childish" knowledge, pitched into an ambivalent relationship with the proprieties of rational knowledge.

To this effect, Schefer conducts a reading of what he sees as Twombly's attempt to escape the representational paradox by way of his particular practice of drawing. Twombly's extraordinary style seems to depend upon what Schefer calls a "practice of notation," as opposed to a formalized "art of composition," and is therefore peculiarly suited, among contemporary art practices, to Schefer's concerns – this "notation" is a practice that resists the codes of representation and thence produces the "openings" that

"Twombly: Principe d'incertitude," *ArtStudio* 1:1 (1986).

Schefer always tries to locate. Furthermore, Twombly's style is always close to, or always includes, writing as such. In that sense his work is congenial to Schefer's concerns in more than just its refusal of regulated or symbolic codes of composition and its resistance to figuration. Twombly's style permits Schefer's exploration of the "childish" process whereby the subject approaches the symbolic, or broaches the world of meaning (and yet finds itself unable to find itself there). That is, Schefer sees Twombly's work as inhabiting exactly that by now familiar zone where the subject's perception (the primacy of the visible) begins to touch the world of meaning (the appearance of the intelligible, or the legible).

Because they occupy such a space, Twombly's works could easily be read (and indeed, have been read) as instances of a quintessentially postmodernist production of insignificance. However, Schefer seems to want to suggest that their guiding principle is actually not insignificance. Rather, he says, the principle here is one of uncertainty or hesitation. It is the exploration of the uncertain location of both subject (spectator) and object (what is represented) in the space between perception and intelligibility that renders Twombly's work important in Schefer's understanding of the history of figuration. The work indeed allows the appearance of that uncertainty; and furthermore, it allows the subject to glimpse the realm of a "science" of memory and experience outside "science" as rational knowledge or as the systematic imposition of representational codes upon the subject's experience.

It is the emergence of the subject within the catchment of this paradoxical arena that has begun to attract Schefer's attention in this and other recent work. For instance, in his rendering of the paintings of the figurative artist Gilles Aillaud (1987), he begins to take up again an implicit theorizing of the subject. This is, of course, an issue which had been secondary to his concern for the interplay between the history of figuration and the expression of a more autobiographical – strictly subjective – affect (and the reader will in this regard recall Schefer's earlier remarks [quoted in the introduction to Chapter 8] that ruled out as mere "fiction" the usual or available theories of the subject). In the book on Aillaud (as well as in his work on the contemporary sculptor/painter Bernar Venet [1989b] and his paean to Jean-Claude Gallotta's dance company [1988b]), Schefer begins to reexamine fictions of the subject.

The present essay is interesting in that regard because, unusually and unexpectedly for Schefer, it appears to make appeal to a quite orthodox psychoanalytical schema of the subject. Schefer alludes, I think, to Lacan's notion that the subject comes into being through the desire of the other, reaching the symbolic through the effects of demand; and he refers as well as to the Freudian schema of the fort/da *game where the subject learns to symbolize the dialectic of absence and presence. It's again in this sense that the principle at work in Twombly's art is not insignificance – the subject here is not simply some a-symbolic, pre-Oedipal bundle of autoerotic pleasure. Rather, the subject is conceived as being caught in the*

uncertainty or the liminal space where meaning and figuration are still ambivalent, still in process. In this space the coded world of the symbolic hasn't yet imposed upon the subject the disinheritance from experience that Schefer says it is the role of the symbolic to guarantee.

Thus Twombly's work lives in an ambivalent space; we might say that it is a work that battens upon the wound that meaning and figuration both produce and suture. What perhaps is important to notice here is the stress Schefer places on the extraordinary movement of Twombly's line: beginning with his work on cinema (Chapter 8), Schefer has begun to install movement as an important trope in the exploration of that momentaneous wound. Movement becomes, in a sense, the privileged sign of another physiological anchoring of the memory of the experience of the subject as it engages the paradoxical space of representation.

So, this essay has been selected not only for its ability to describe in new ways some of the lineaments of the "enigma" formed in and through the stages through which perception must pass in order to become meaning. If the history of such a passage has been the burden of most of the work in this volume (particularly in terms of the historical elaboration of systems to facilitate that passage), then what this essay adds is an idea about the way in which the subject itself emerges in and through such a history.

It perhaps should be mentioned, incidentally, that this essay is the only translation in the collection which shows Schefer at work with contemporary art. While this is not by any means his only effort in that regard, it is generally true that, as he puts it in "What Are Red Things?" "my taste is classical, since I need stories, and the sublime (the sublime of pure meditation), and the capacity in what I like of manipulating resemblances, all at the same time." Such a "classical" taste can be satisfied in Twombly's work in particular, precisely not because it is modern, but because it engages the relation of figuration to the subject's knowledge and the subject's emergence. One can conclude, it would seem, that for Schefer contemporary art is rarely so concentrated on the task of showing "the subject trying to name himself in his own form."

I came across Twombly's work in a strange and even oblique way, but perhaps mostly it happened in the way of an enchantment – through the words of some of my friends (Roland Barthes, Jacques Henric, Catherine Millet).[1] This lucky introduction, however circumstantial it might have been, has left its own kind of imprint on my idea of Twombly's work: I find in his work a sort of leave of absence from modernity (a way to escape somewhat from the obligatory circulation of news and novelty that helps constitute the endless fabrication of the world of culture).

TWOMBLY offers that world enchantment, as has been said before, and he offers gracefulness, plus the subtlety of an aerial mobile: lan-

guishingly, nervously, with a kind of sustained fever – the fever of invention or the remnants of a childish feverishness. It is this "childhood" that I see, by what we might call a countersense, or through an error of interpretation to which, in spite of everything, I can only cling. Because that's what I'm most sensitive to in this work; and it leads – this is what it offers, what it elaborates (Twombly makes an art of this kind of imitation) – it leads to a truth. From one drawing to the next Twombly's work is arranged as a collection of stylistic traits; it seems usually to derive from the practice of notation, rather than from the art of composition, as if its coherence resided in what it disperses rather than in what it can pin down. It's a whole environment of gestures, stressed hesitations, as if a voice arose from this writing in order to interrupt it rather than complete it; a meandering, empty pencil-work, somewhere between writing and scribbling; two hands alternating between the pleasure of repeating signs and the pleasure of undoing them; and seeming to be always on the move, sinuously making for the place where meaning and insignificance have their common source.

Yet bit by bit, from drawing to canvas, it soon becomes clear that you can't analyze such a work, that you can't apply yourself to remarking its signifying articulations in this part or that: its meaning is organized differently – it's couched, fleeting, passing.

STILL, all these drawings offer to the world a kind of graffitied wall; they don't open out onto any particular spectacle within that world, and they offer no kind of perspective on it. This, too, has been said: despite Twombly's playful though energetic leisure, the very lines, the very speed of his drawing denies us the capacity of imitating it. This isn't drawing, properly speaking; that is, it has no form except the whole dispersive power of the line, caught up in the moment itself.

CY Twombly conducts and plays with an inimitable minimum that's strictly uncopiable: he controls the ensemble just as he controls the details. This is an enigma: beyond the subject of pleasure that we ourselves might be and we can recognize in him, the only thing that can guide us here is the pursuit of an enigma.

KIERKEGAARD: "Nothing is more different from a child than an old man who becomes a child again; in that situation the comparison is back to front because everything is turned around and their difference becomes the point of departure for their comparison."[2]

So is it that?

THE space Twombly injects into "childish" tricks is no more than a sort of breath of what lives there: the instrument that has no possible

149

use – not because it's imperfect, but because a part of the world is still stuck to it: in it is the portrait, the face, the entire world of the subject as he begins to make his way toward other people; and yet there's the space, the line, the populating of whiteness, the strategy of filling the paper, all of which would constitute the subject himself – though not in the subject's own shape: stroke by stroke a man is in the process of being born (and not by way of this portrait) and is manufacturing the most naked of images (and in the place where he's most unknowable): by way of this type of wall that's erected up front – the wall that a child constructs just so he can try to guess what's behind it.

AND yet here we're supposed to believe in signs, rather than meanings; there's an unlimited pleasure here that leaves no room for designation, figuration, or totality (world, meaning, or affects), because the whole beyond of designation, the preamble of drawing, right away defines a sort of hollow object: this is a strategy that aims at maintaining the object's hesitation principle; that is, perhaps, the terminus of a pleasure almost without tension, without negation.

AS distinct from the demands of most kinds of drawing (architectural or anatomical, etc.), what this childish gracefulness rediscovers or recaptures is the technique of a secondary movement: except for a few centering devices, the lines in these drawings aren't dependent upon other lines, or subjected to other lines, and they don't get put together in such a way as to make figures. This is the principle of insignificance, a technique of evacuation (the writing is offered to be read, but it needs to be read only so that the process of writing itself can be elided). Twombly frequently resorts to writing words (the names of gods and heroes, and there's also a whole pantheon of authors and titles in his work) and that's how he makes signs appear, traced-out lines that are like so many moments separating writing from painting, and he promenades them one toward the next; lines that are like pure, private appendages, but conversant with everything that makes up the whole ceremony of culture (from literature to painting). So what is all this? – a type of capture, the domestication of big signs (names, titles of works) into something that reduces them to a private ceremony (like the simulacrum of a consecration, an attempted sacrament).

BUT what are this sort of ceremony, dissimulated in the writing, and this empty sacrament? – it's as if the remnants of intention had been captured in forms that can't be understood (it's also a stubbornness in relation to such inoperative, noncontiguous forms). This is obviously because part of the essence of the sacrament in all childish knowledge consists in refusing to bring forms to a close, consists in

reaching with a minimum of distortion (and this is a faithfulness to a revelation) the fantasy that sees the world's heart beating in the details.

This infantile science plays with or manipulates something very specific: the child constructs his treasure from a pile of details that are hidden from the world, that is, hidden from the order conceptualized and constructed by others; what the child is looking for, what he manipulates, is a portrait made from *something that doesn't resemble.* With the most total and unconditional faith in signs, this child (and it's understood that he's just a fiction, the artist's fiction of the "subject") builds something that can only subsist by way of the stubborn application of his faith. That's the way with this science; it's the science of the sacrament: a play with figures and signs, a play that has no concern for proportions – as if the anxiety about being faithful to appearances still hasn't awoken in him. The subject plays a part, in some fashion, within the system of equivalence that manages to mark the world with stripes and streaks. He carries objects in the direction of those forms that he himself can lead by the hand – and obviously he's leading them toward nothing, toward himself.

And is that a ceremony? – more exactly, it's a constant attempt at a small sacrament in which the species don't really matter; they're there fortuitously, they just mark the way of an opening.

So, how to describe this gesture, this tenuousness, the faith (or nonreligious fidelity) that's at work in this sort of private ceremony? – the subject in fact serves and consecrates; he doesn't execute, and he produces no performance, that is, he brings no significant gestuality to the work.

WHAT is this faith, then, the faith that sustains such a minuscule miracle? And isn't it the case that Twombly's *object* is more or less constantly there, in what he operates – that is, his unpacking of the meaning that guides this transformation of small signs?

That's obviously the idea (not reality or performance, since the latter is in effect a sham, all made up, using color as well – little splashes, jets, and blots – for this partial camouflage); that's the whole idea of a jouissance that can be had from the principle of figural indecision. And it's the obverse of all our morality; strictly speaking, it's opposed to that peculiar empirical morality which tries to represent both the work and its labor at the same time. Now this apparent liberality, where signs are allowed to *come,* this skimming of surfaces, this gestureless movement – they're all a kind of portrait of the world the way an infant would imagine it. Here infantile knowledge is not a knowledge of line, nor of the object, nor of "primitive" and visually "copied" instruments and machines. Much more subtly than that, it's a matter of the world – that prop for all graphic gestures (by which the subject of the drawing tries, then, by

his sacramental act, to become nothing, tries, that is, to access the thing itself) – it's a matter of the world turning into a portrait of the subject in a revised fiction of the age when meaning is only demand; that is, the age when love is still without an object and the subject's ego desires to be given shape by the other (that's the recognition that the ego achieves by means of, or in spite of, the absent figure [of the mother]): desires to be given his shape, his name, his form, and his face.

THE active principle in Twombly's work is decidedly not a principle of insignificance; he consistently sticks to the exploration of the whole uncertainty principle in the object; thus he usually undermines emphasis on *techné* (on Art). The subject that's everywhere (or, more exactly, that's construed) in Twombly's oeuvre isn't quite the body; rather, it's a point of departure for a comparison, evoked by Kierkegaard, between the artist and the child. This work is, perhaps, just the restructured inscription of such a point – its bifurcation, its journey, its trace, and its adventure.

SACRAMENT operates by an imperceptible succession or accumulation of displacements. A principle, rather, of minimal, minuscule hallucination. The proper terms of comparison elude me, but perhaps some of Artaud's drawings (especially "God's Sexual Clumsiness") would be precursors in their use of line, the way the pencil is put to paper, the particular application of color; though Artaud's project is to frame a kind of excess of meaning and intention that furnishes his drawings with a properly tragic tension – in his work the subject curses meaning, execrates being. That kind of thing won't do for Twombly.

THIS working up in Twombly is a charm that seems to owe nothing to the profession (he doesn't seem to rely upon that rhetoric): *The School of Athens, A Murder of Passion:* what's happening there exactly? First of all, the signs are despecified; the line itself suffers a nervous exhaustion, the detail is emphasized: but it's empty, it doesn't signify, it simply cracks, like those sidelong stairs made of hanging flights of steps – and it's because the drawing is executed by a variable body, a body imagined down there because it's also (or above all) there that proportions change: those steps, for example, placed in the void, are numbered so as to mark out a troubled progression through this space; as if the space contained the scale of a minuscule desire, the loss at the heart of things, and the anchoring here and there (houses, trees, waves, or forests, all penciled, a paper kite), not of a body, but of a proxy subject; the artist – that child of the desire for comparison – is like an insect you could imagine striding up and

down. He's caught, in this miniaturized dream, by a deinstrumental-izing of all signs.

BUT in a way everything changes in Twombly's work between 1981 and 1983 with the arrival of painting expressing or offering some-thing, and obviously hardening the work. Painting – that is, both the paint itself and its application – extends the operation carried out on drawing: a work of insecurity, carried out in detail, and whose paradox is exactly that it makes art bend toward the only state (that is, toward a humor, a sort of neutral humor) that's capable of desig-nating the subject's dependence, rather than some condition of the body or of the passions.

THIS thought needs to be carried to its conclusion.

EVERYTHING points to it: in Twombly, it is, apparently, a second extenuated motion that does the drawing, with no more than a sort of mimicry of spontaneity, reflex, quick-wittedness. Moreover, Twombly works up the uncertainty principle: so it is that the re-strained body, the ductile body, the very object of his art, becomes an intermediary between subject and object.

Every drawing and every painting of Twombly's tracks this working principle at the forefront of objects and forms (a diaphanous and sketchy body, barely supported, constituting the whole opening of the world) and tracks the world that opens up there; he traces the way, the path, the childish wanderings – more exactly, it's a sort of imprecise staking out, an improvised surveying. Drawing and paint-ing combine to transform the world – the space that's put into them, simultaneously minimal and yet absolutely other, like the first alien surface the body came into contact with; and that space maintains in its dimensions a memory of tiny affects. To transform the world into a written but illegible landmark that more than anything else constitutes the subject's memory of passing, not into knowledge, nor into art (*techné*), but into sensibility. Into the mystery of the transfer from the primacy of the visible to the appearance of the legi-ble. Twombly writes nothing, and he inscribes little; he puts objects on paper in their disinheritance from sensibility – and that's what allows us to recognize a "style" in the cross-hatching, the scribbling motion, the sediment of subtle blues, reds, shaded greens, particles of whiteness; these all refer, not to the style of execution, nor to the materials themselves, but to the instruments (pencils, stump, etc.). Those instruments are particles of acts, rather than any continuous action. Pieces of acts, indeed, like those numbers climbing tiny stair-ways, those framings of the word "detail," or those titles that "com-pose" the subject.

WHAT else is there? – the tremendous elegance of the drawing, understood not as an exercise nor as a template: it's practiced *as* painting. Twombly's line retains the power to absorb and waylay the whole designatory function vested in drawing (drawing engenders a space for referential designation, and at the same time that's one of its functions, if not its most consistent or regular function). With no "unity," with little potential for emphasis, drawing here provides proof of the absence by which the figure of the world admits, not that it's incomplete, rough-hewn, or distorted, but just that it's inchoate; proof of the desire (which is, in a sense, *undifferentiated*), the desire that seeks out beneath the light masks and the subtle disguises the loss and the renewed bewilderment (with no drama, no tragedy) of its object.

The game this *writing* plays is all about the randomness of meaning (because it's manipulated from afar by peripheral elements, a supplement of intention whose writing doesn't have that sort of use); but we nonetheless recognize something in this object manipulated from afar. This failing object, this figure with no stable appearance, is almost the latent subject himself (through whom the world arrives, and by whom we recognize it). To be exact, it's a *something*: not a thing that exists out there beyond my body, at my fingertips, as a fragment of a designated reality; and it's not a spectacle that my intentionality wipes out, a spectacle or some pile of objects by which my body can measure its distance from something else. It's more than that; it's the very thing (that is, a ball of empty intentionality) that constitutes both my perception and my memory. Already the whole picture subsists (since this portrait of an intimate resemblance has no exterior lines, no face); and, because of that, the knowledge of some worldly intimacy – of some subjective identity in the freedom of desires – can engage no other representation except that of its lines of force. (It should be said, though, straightaway, that these are also lines of *weakness,* marking a kind of swoon, or a fainting, a syncope – as in the kind of hysteria where the amorous body mimics its own collapse, its abandon, or the slow death that makes it fall out of its own sight.)

SO there's something of that sort in Twombly's art – the "practice of a civility," of which Roland Barthes has produced a quite beautiful and loving reading: Twombly's nonaggressive lines and tracings sit upon this paper imitation as moments of passage: and this art sustains its principle of hesitation there as well (even if in its substance the painting effectively still represents an "energy," that is, an action exerted on material). This world, the painter might say, is form before the fact, an outside through which every measure comes back to me, but with one minimal difference: this sheaf of stammering desires enables me (and as if it were the right instrument for the job) to

designate what hasn't yet become human, to designate what the face or the body itself can't give rise to – landscapes, houses, crude machines – and simultaneously turn them into the vehicle of a mysterious affect and its portrait; turn them, that is, into pure demand.

SO what is this writing? – a way of treating words and names like gadgets, kid's trains that have exactly enough power, bulk, and solidity to detach themselves from that infinite voyage around themselves: intimate noises, whispers, a kind of scansion: the voice of mechanical noise that's now simply been displaced onto his first imaginings: a motion from within the body, subtly endowed with a neutral harmonic quality. As if, here, the left hand had called the science of forms back to the principle of their own uncertainty – back, that is, to the subject's demand, to an act of love where figure hasn't yet appeared. Where the second figure is absent because its model has indeed disappeared, and because the drawing is above all the dissimulating measure of its distance and its removal.

In this principle of hesitation, Cy Twombly clearly offers us something very precious: an art that seems to consist in giving a selection, a taste, a bit of the elegance of a few precious remains. Those are the remains of childhood, remains of discovery from the first gestures toward finding the world, since the discovery itself can't be transformed – varying those forms would destroy the world that subsists through the link of the subject's effusion. An art that offers us something that writing will then try to transform, primarily by inflecting it to its own rules (the childhood knack for writing is the opposite of the knack for drawing: it's secondary in relation to the law: it's the "difference [that] becomes the point of departure for . . . comparison" working so admirably through Twombly's oeuvre): the birth of the subject in the midst of representations, that is to say, in the midst of others who are sustained only by the subject's form, only by the impalpable body that points to them, when in fact they're only the subject himself trying to approach the others and to disentangle, line by line, the world's empathy: the subject trying to name himself in his own form.

WHAT ARE RED THINGS?

The following text, the most recent collected here, was written in response to a request from the journal ArtStudio to write about contemporary monochrome painting. In an issue where all the other contributors concentrated on contemporary or modernist experimentation with fields of color, Schefer took the opportunity to delve into the history of color. But, as we might expect by this point, this is a history in the peculiar sense that has guided much of the rest of his writing in this volume; that is, it is history as a kind of collision between the spectator's history and that of the visual text, and involving the multiplicity of the text's possible lexical coordinates.

Indeed, this article might be seen as a kind of culmination of the project – announced in Scénographie, as we have noted before – of attempting to "reintroduce the object into its text, that is, into our history." Here "our history" needs to be understood as the narrative of moments in the formation of a subjectivity that is lost even as it is formed. The exercise of the hope and illusion of attaining that moment through the confrontations furnished by the visual object here strikes a decidedly personal note in the third section of the article (on the anonymous Rhenish painting Virgin in the Garden*). In explicating the primal or originary significance of the color red in his own life, Schefer offers a by no means simply indulgent autobiographical tale. Rather, this section is the third in a triptych of moments in each of which red takes on a primal or mythical significance. First, there is Aristotle's explanation of the cause of red, and then Uccello, appearing again to implicate red into a primary piece of Christian mythologizing (around the profanation of the Host). Following – ironically, to be sure – the shape of a history of ideas, Schefer's elaboration of these moments shows how the color red becomes a mythical entity and how it is deployed in that role. But in this third section the myth is Schefer's own and, in being set alongside the other two, it specifically avows itself to be no more than provisional and fictional (factitious, at least). Moreover, as if to demonstrate that the search for the internal*

"Quelles sont les choses rouges?" *ArtStudio* 16 (1990).

history never reaches a conclusion, Schefer shows us how this article itself emerges from a particular revisionist moment – one in which a previous understanding of the painting is displaced by another, more "mythological" one. The point here is that it is not some essential or essentially hidden "soul" or image or memory that is being sought. Rather, Schefer's writing is always concerned with the shifting relations among things seen, the body of memory, and the body of experience. The point is introduced in a sense in the sections on Aristotle and Uccello, in each of which Schefer demonstrates how myths come to be formed as a product of color's trouble, its "mischief."

It is perhaps especially fitting to end this collection with a work that concentrates so intently on color, as we began with the elaboration, in "Spilt Color/Blur," of color's function in figurative/perspectival systems. The production of color as mere symbolic function, or as something which always exceeds the system and is therefore reduced to a supplementary role, is now turned on its head, so that color's excess becomes the very motor of the reading. This is a mark of Schefer's contention that, while color is regarded in the system as an excrescence, it is nonetheless attached to the signifier and therefore participates in the production of signification in a mode that exceeds the purely "symbolic" function assigned to it in classical theory. It is the coincidence of color's excess and the spectator's aporia that is liable to beget the paradoxical or inappropriate reading, the mystical, legendary, or fictional meaning. We return in this essay, then, to a highly wrought version of the oozing or leakage of meaning that Schefer spoke of in his early semiological work (and here the process is allegorized in a bizarrely apposite way through Uccello's depiction of the leaking of the symbolic Host while the profaning subject attempts to analyze it).

If it is fitting to conclude this collection with an essay on color, it is perhaps so also because this is one of Schefer's most exceptionally beautiful and provocative meditations; and it is more apposite still in that this essay ends with a particularly memorable – almost homuncular – rendition of the enigmatic body.

Monochrome painting is, or might be (but does it turn out to be?) the presentation of a field of color that figuration cannot liberate, nor allow free play, nor meditate upon.

There was something, however, that caused the domination of perspective over color, in the course of what might also be the story of color's use, or its using up. I think, though, that the figurative scene (its theater, its pantomime, its ballet) was preparing the ground, as it were, preparing a future for color that hasn't arrived in monochrome painting.

Here, I want to uncover something that happened *before* the inven-

tion of monochrome painting. It's true that my love of painting must remain somewhat suspect: it's in large part the delight I take in figures, faces, forms – and in those things I'm no doubt looking less for a truth, or for some painterly achievement, but rather more for the enchantment of what painting says to me. It must be the case that my taste is classical, since I need stories, and the sublime (the sublime of pure meditation), and the capacity in what I like of manipulating resemblances, all at the same time.

Monochrome? – it's something that pushes me more toward the ancient history of painting. Monochrome is obviously seductive: those spaces, the alchemical inebriation of manipulating essences. But, just the same, I'm inevitably captivated or haunted by the notion that painting's mode of symbolization is still bound up in mysterious ways with what it signifies, and significations are what symbolization produces or articulates. Everything I manage to write (everything I don't manage to write – that is, everything I dream) ties me to figures in a manic way – not because I like resemblance so much, but because I still don't understand what figures do together.

In a painting (almost any painting) red doesn't actually constitute the body of red things: it makes them come as close as possible to the surface. To what surface? – the surface that we ourselves become when we look at red. And things that are decked out in red aren't performing, they're not enunciating; they just say, "There!"

We'll look first of all at how Aristotle deals with red – he treats it as something accidental. And then at what Uccello makes of it – a novel, a sacred legend in which red is the protagonist (how to manage the cause while still showing the effect? – by inventing color's cause); a material that moves, ebbs and flows, as black does in Plotinus (just as there's the red of history in Uccello, in Plotinus there's the black of thought that ebbs and flows and gets caught up in the body). And after that, why is it that a red dress dictates or inaugurates the novel of my own life? – because this time red is a choice. Red (any red) is what happens. Look at the story of Maria de' Medici in Rubens: red is the very air of that painting and constitutes the imperious action of a whole life put onto canvas, its pages riffled. The red of Saint Cecilia's dress in Fra Angelico's *Coronation of the Virgin*: it's what happens – the musical duration of that coronation, the coda of the heavenly partition.

How does red happen in Aristotle? – by way of vision: as the accident of vision, a strange and incomprehensible manifestation of truth or vulgarity. It's a surface painted by the eyes.

Red comes into existence in three ways: in Aristotle (by hemorrhage), in Uccello (the bleeding of space makes painting), and in my own indecipherable enigma of a young girl posing in a red dress.

The Cause of Red

Aristotle's *Parva naturalia* offers two explanations for the engendering of color. The first, in the part "On Sense and Sensible Objects," approaches the question of color from both a physical and physiological point of view. Briefly, it's a matter of a perceptual phenomenon operating through the medium of what he calls the "transparent" (the humor contained in the eye and also the medium in which things bathe): "It is true that the eye consists of water, but it has the power of vision not because it is water, but because it is transparent; an attribute which it shares with air."[1] A similar passage in *On the Soul* allows the following propositions: "What is visible in light is color. Hence, too, it is not seen without light; for, as we saw, it is the essence of color to produce movement in the actually transparent; and the actuality of the transparent is light."[2] (Subsequently, a distinction is made between a defined "transparent" which is light, and indefinite "transparents," which are in the body.)

The real engendering of color – and thus of red as well – is an action:

we have already said of light, that it is, accidentally, the color of the transparent; for whenever there is a fiery element in the transparent, its presence is light, while its absence is darkness. What we call 'transparent' is not peculiar to air or water or any other object so described, but a common nature or potency, which is not separable but resides in these objects and in all others, to a greater or less extent. . . . The nature of light resides in the transparent when undefined; but clearly the transparent which inheres in objects must have a boundary, and it is plain from the facts that this boundary is color; for color either is in the limit or else is the limit itself. This is why the Pythagoreans called the surface of an object its color. Color lies at the limit of the object, but this limit is not a real thing; we must suppose that the same nature which exhibits color outside, also exists within. . . . It is, then, the transparent, in proportion as it exists in objects (and it exists in them all to a greater or less extent), which causes them to share in color. But since color resides in the limit, it must lie in the limit of the transparent. Hence color will be the limit of the transparent in a defined object.[3]

How, in all of this, do we get from one color to many? – first by the mixing up of objects: "But it is clear that colors must be mixed when the objects in which they occur are mixed. . . . The multiplicity of colors will be due to the fact that the components may be combined in various ratios."[4] And then how is the multiplicity of colors to be limited or at least regulated? – by way of a kind of perspective or straight line wherein an arithmetic regulates the numerical progression of colors between black and white, and this scale of decreasing numbers and chromatic darkening is confirmed by, or

originally established through, experience: "And if, after looking at the sun or some other bright object, we shut our eyes, then, if we watch carefully, it appears in the same direct line as we saw it before, first of all in its own proper color; then it changes to red, and then to purple, until it fades to black and disappears."[5]

That's found in another part of *Parva naturalia,* inserted into a little treatise on the nature and origin of dreams that's entirely dedicated to the "mischief," so to speak, of the transparent. Here again it's a problem of perception and physiology; but this time there's no longer anything metaphysical about it, but it is in some way "colored" by a particular state of medical knowledge, a fund of fabulary belief that will become grist for the discourse of alchemy, for the stories of medieval miracles, for the legends that wrap the color red in the popular horror of bloody objects and that we find in the story of a profanation of the Host (a story doing the rounds in all of medieval Europe – Brussels, Siena, Paris), an ultimate avatar giving proof of the sacrament of the Eucharist and the reality of transubstantiation (the real presence of the body and blood of Christ in the communion). There exists, then, a supplement to oneiric perceptions (perceptions supplemented by the imagination) wherein the point of the meanings isn't sin, but rather the emotions that our sensations interpret – passion is nothing but emotion blinding us to proper meanings. This supplement to the dream, in short, is the production of red, the primary material of mythology or fabulary belief. The mischief of the transparent? –

> An example of the rapidity with which the sense organs perceive even a slight difference is found in the behavior of mirrors. . . . At the same time it is quite clear from this instance that the organ of sight not only is acted upon by its object, but acts reciprocally upon it. If a woman looks into a highly polished mirror during the menstrual period, the surface of the mirror becomes clouded with a blood-red color (and if the mirror is a new one the stain is not easy to remove, but if it is an old one there is less difficulty). The reason for this is that, as we have said, the organ of sight not only is acted upon by the air, but also sets up an active process, just as bright objects do; for the organ of sight is itself a bright object possessing color. Now it is reasonable to suppose that at the menstrual periods the eyes are in the same state as any other part of the body; and there is the additional fact that they are naturally full of blood vessels. Thus, when menstruation takes place, as the result of a feverish disorder of the blood, the difference of condition in the eyes, though invisible to us, is none the less real (for the nature of the menses and of the semen is the same); and the eyes set up a movement in the air. This imparts a certain quality to the layer of air extending over the mirror, and assimilates it to itself; and this layer affects the surface of the mirror.[6]

Aristotle's digression continues with a dubious comment on linen that's difficult to bleach, and about old mirrors that have become

tainted and on which this red cloud (*néphèlè heimatodès*) makes an
indelible blot.

This is basically a sort of legendary evidence, reinforced with a
syllogism, that links the indeterminate "transparent" to a thing (the
mirror to frozen water); it's a kind of old wives' tale, introducing
into Aristotle's text the idea that color – red, in this case – is occa-
sionally a substance that can be quite exactly *photo-graphed* on a sur-
face. For his analysis of physiological phenomena Aristotle relies
upon a critique of substantialist philosophies; however, in a sense,
what he proposes is that the inside of dreams is the space where emo-
tion can govern sensation: he talks about red as if it were an event,
that is, a profoundly irrational thing whose epiphanic effect is unre-
lated to any real (physiological) cause except by way of a metaphor
that turns the mirror into a particular kind of "transparent" (this met-
aphor is also applied in its declension to the vitreous humor of the
eyes – the only water, as Aristotle remarks elsewhere, that doesn't
freeze).

This red-effect will ultimately remain resistant to classification and
be the only substance in which coloration isn't the effect of a conden-
sation of the body of the "transparent" (like the sea, sometimes
black, sometimes blue); red remains the only protected substance and
is in effect a mythical material. The object of reverence and fear
(from the red reserved for royal robes, to the Virgin's slippers at
Byzantium, to bloody rags), this color is the very object of legends –
like the one about the recycling of life-giving blood; the only human
substance that dyes materials and from which Heliogabalus made his
flags: "red, the banner of all women."

Aristotle returns to that to explain the engendering of colors: the
first time he does it mechanically and physically, the second time,
mythically, by "detaching" at least a legendary body that has no
elaboration, no name, no heroic messenger: what he describes is
properly what ethnology calls a myth of origins: a miracle.

Red Things

The six panels of Uccello's predella in the Urbino palace retrace
(more exactly, transpose to Italy) a profanation of the Host occurring
in 1290 at the house of a Jewish moneylender in the Saint Merri quar-
ter, at the site of the Temple of Billetti. The two most detailed ver-
sions I know of this story (in Villani and in Corrozet)[7] reproduce
with slight variations the legend that Uccello illustrates. A Jewish
moneylender (or pawnbroker) asks for payment in Host from a poor
Christian woman who had left some clothes with him that she now
wants to wear again for Easter: "If you bring me the body of your
Christ," he says in Villani's version, "I'll return your pawn and not

161

ask for money." The Jew, once in possession of the Host (a symbolic token that his own religion doesn't recognize), tries to handle it as if it were a living physical body; he cuts it up and tries to boil it, and the Host bleeds. The neighbors and the militia are alerted, and they arrest the Jew, who is then taken to the stake (in one version he's betrayed because his son tells people of this wondrous event); the woman, too, is arrested, rather strangely, and convicted of infanticide, and then hung (in the version Uccello seems to follow, an angel intervenes to stop the hanging). The miraculous Host is then reconsecrated; it will serve as the emblem for a community of nuns housed in the cloister of the Temple of Billetti at the site of the miracle (the "billetti" is a heraldic sign that resembles the Host). I shall save my analysis of this legend and its variations, as well as of the whole of Uccello's predella, for a little book devoted to the miracle of the profaned Host.[8]

The story as it's illustrated and transposed by Uccello is in effect a legend: this is a miracle that reveals the real presence of Christ in the Host; it is also the result of an equivocal and blasphemous operation where the sacred body is taken as a sign and introduced into transactions, as if its sacred symbolic value were equivalent to another kind of symbolic value (that is, monetary). This sign is manipulated outside its own confined symbolic space (the Christian community whose mythical sustenance it is): it is treated first of all as monetary coin, then as a culinary object (that is, it's exchanged, bartered, cut up, and cooked); the sign is undone – an undoing that one would have to call naive, though it produces in some way its own chemical analysis – what it had contained, the blood of the Savior, escapes.

Uccello's trick is the liberation and something akin to the invention of the color red at the moment when the Host is profaned, that is, at the very moment when the pertinence of the sign is questioned. His painted legend replicates a myth of the origin of red – finally, quite close to the mirror-event given in Aristotle: the plane of the mirror begins to reflect, not a figure, but its most intimate bleeding, just as the profaned Host reveals what it used to contain. Uccello's story is made out of the cloud of red that goes to constitute the invariable in each story and, specifically, drags along with it a series of associations or a series of conflagrations of symbolic spaces; a series of rituals as well, all of which have to do with the archetypal memory of the Christian ritual: the Jew will not be able to leave home without coming across the little dribble of red blood that represents the crossing of the Red Sea in the Jewish Easter; the militia that comes to break down the door of the usurer and the procession that carries the Host to the altar with the *corpus Domini* (the monstrance) are versions of two ancient Roman rituals – the *detestatio* and the *consecratio sacrorum*, both of which attended a change of residence.

Finally, there's this extraordinary etymological play on the words "Host" and "stranger" or "enemy" (*hostia* and *hostis*) in which the stranger, revealed as an enemy, stands in for every sacrificial victim – here the sacrifice is reparation for a crime, and this is tantamount to the reconstitution of the Host. For this crime two guilty parties are found, both of whom will be "sacrificed" or introduced to the space of the sacred; this accords with the etymological commentary that Joseph de Maistre gives on the Roman death penalty, *Sacer esto* (be put to death or sacrificed): "on the one hand there is the crime and, on the other, innocence: both are *sacred*."[9]

The real symbolic jubilation to which this miracle story gives rise in Uccello is that of the total liberation of red consequent upon the rupture of the sign that, in a certain manner, had placed an injunction on the image. Why? – because red is a color whose use is extremely codified; most generally, it is reserved for use in the clothing that belongs in the theater of power; there are no *red things* in nature; the color appears there in floral details, but never in surfaces. Beyond the facts of ritual (imperial and sacred clothing, things of fashion), and beyond generally economized chromatic effects (because red *attaches to surfaces, fills the void between yellow and blue* – Kandinsky – or has no opposite except in black), red is almost always the color of the arbitrary – and in two senses of the word: the color of power and protection, both temporal or spiritual (in this sense, it's properly a sign); but it's also an arbitrary color in that its use is codified (or as linguistics would say, relatively motivated) without denotation, that is, without reference to or legitimation in the natural: *red things* don't exist.

It also constitutes the beauty of this predella, its intelligence, and the meaning of its symbolic play: look at this story of the profaned Host – there's a play (a theater, a ballet, a pantomime) with the sign par excellence, the sign that's the center of the whole Christian ritual. Uccello's predella stages and animates, if you like, the profanation of that sign: once the Host is undone, then the Eucharistic species, the flesh and the blood, construct the story, the procession, or the border for the characters who are all playing within a multiplication of sacred spaces – in each of which a sacrifice is carried out, reproduced, or prepared. But again, once the institutional sign is broken, it's the very play of the arbitrary that wins out: exactly like a tide (it ebbs, flows, militates, gains, conquers the space), red invades, jumps, mounts the bodies, forces its life upon them, becomes a flag; from then on nothing legitimates this red. Its entrance onto the scene is an effusion of blood; its repeated and varied use is without authority, without memory. Banners, legs, cassocks, robes, headgear, horses and trappings, fire: this red without a memory is a sign with no institution; neither body nor figure, it constitutes the using up of form. Once again, an arbitrary freedom given to form and which,

by means of form alone, becomes its movement: this red itself makes the painting. Vasari was surprised at Uccello's extravagant fancy of putting red horses in his compositions. What is it, then, that is red? – whatever is painted red.

So Uccello's red turns the object of a story into its origin. This story derives from such wondrous origins because it wants to confirm the following: that color is something that spreads, and every color is an expansion; and this is especially true for red: this color (in Aristotle's words) is empowered in its activity – it threatens the object with a lack of form, because red is first of all simply the *expansiveness that undoes* the object.

In these two originary myths (Aristotle's "explanation," Uccello's story), fables of origin stage this phenomenon (the apparition of red) as an enigma; the surface-effect that red monopolizes will play out the role of a causal residue. So this is what the *Profanation* at Urbino *says:* each of the predella's scenes is to some extent a sacred scene; none of them, however, can ever contract the species into a sign of pure institution; the story is, in all senses, a hemorrhage of the first broken sign. The exhibition of this cause in its vagabond derivation constitutes a story that, according to the "acts" or scenes in which the moments of its recurrence consist, tries to restage a legendary body while declining its memory. Now, this body can't be reproduced: it's not a history but an institution, that is, an act; no other ritual could assemble it again: it's not a thing but a sign; no other "host" (victim) could take its place.

This play of repetition, of declension, comes back to what Augustine called the spiritual and symbolic impotence of paganism, where the search for the spiritual world led only to a multiplicity of gods presiding over the varieties of human activity. What, beyond that, does this declension construe? – the small flow or the little course of a narration that "ligatures" its elements in some way, proportions them for the sake of the story's legibility first of all, but also because the symbolic course of the little story is constituted almost entirely by the maintenance of the proportions of figures in the midst of a kind of oozing of the content that it carries and that also makes it advance, exactly like a river carrying little boats and buffeting them around. The actors are the manipulators of an invisible thing (what condemns them to the space of the sacred is a crime that's spread across these different tableaux, as the fractured Host, as the ever-expansive red). This red, along with the legendary cause of its apparition, is also the only element or part of the whole narration that has no proportion. In a way it's bigger than any body, more expansive than anything else at all, as it constitutes the very trajectory of the surface (red, assuming it finds some part of its own story in this legend, is the reason this story isn't developed along perspectival lines); so because of the decomposition of the Host, red can exist as

the only body that might be a substance, and the only substance
that doesn't experience division – a substance which in nature has no
memory except of the flow; that is, it moves without constraint.

What else? – as if this color didn't actually have a complement, an
opposite, or degrees, a convoluted sort of novel carries it and pro-
duces a cause from it in a labyrinthine way. But that cause is blind-
ing: this fiction (wounds, profanation, arbitrary poses, clothing of
rank, cast, or function) stages all the versions of red's provenance.
The fiction reinstalls, more or less as a law, the notion that red is a
cause acting through its effect. Once the first sign in the legend is
undone (how had all this managed to take hold in so little body? –
by way of the "symbol" which was, etymologically, just a contract
of alliance), the body that it liberates restores more than the sign
itself ever contained: a history.

Virgin in a Red Dress

The Virgin in the Garden at the museum in Strasbourg contains its
own kind of originary myth, only this time it's a completely personal
one. The red there is different – a red that translates, maintains, var-
ies, folds exactly, a slight affect, a confusion of sentiments for which
"blushing" is an approximate term. This young woman from the
end of the Middle Ages tells me nothing about the picture: the pic-
ture is a mirror stretching from quite deep in my own history, and
it constitutes a portrait, its details unrecognizable, of a time in love
that has been preserved by this painting alone. A mysterious link,
slowly evolving, transformed into a bare branch joining two figures;
it might have blossomed, spread its vegetation of flowers and
branches, until it imprisoned the two hearts that in reality it kept
quite a way apart, festooning the space all around with complicated
pelmets. A link dedicated to the delicacy of an old wound that this
picture maintains. A space of time offered up.

The image is constructed for contemplation; the trajectory and the
revery of contemplation linger on this pleated surface and on this
material that's been accidentally endowed with a story. There the
folds, the cracks, and the rocks make gothic figures and retain, a bit
like clouds or smoke, these indices and passages, the dismantling of
characters, the wearing down of the reliefs, games with stones that
have become mossy and smooth from movement, right up to this
face whose gentle blushing seems to be the result of light thrown
from the dress; a face that at any given moment seems to be made of
careful folds lovingly disposed, and of flames of fabric flickering up
as far as the mop of red hair; a burning bush whose fire the calm
Virgin (played by a young girl, whom I can't stop myself from
imagining in a special role) can no longer smell. The image's peculiar

life in this figure is the effusion that she's preparing for: her child's head is still chubby or already smooth, the whole surface of the image is creased by a material that, provisionally, undresses the top of the panel like a flat wall where a trompe-l'oeil juts out from a low corbelled construction and places this young girl on a sponge of moss that figures a field – this young girl with chubby knees.

In the end it's an absence of color, an absence of code, chiffoned to make a form, that constitutes the whole of this picture: its most neutral and legitimated form is a fabric, that is, a system of folds, a purely spatial strategy: rock? nothing?

The figure (reduced to a face and hands coming out of the fabric of this marionette) is not an expression but a deployment (a quotation coming from somewhere between Rogier van der Weyden and Dürer); this figure is the motif of a paradoxical effusion, the prop for a fidelity to a romantic memory which, quite probably, is always awoken by an image; she's an unfolding enigma immobilized in the red rockery, sanctified by the Byzantine gold (or the Cordovan tapestry); until this moment she has been no more than a silent character in a novel being written for the sole purpose of one day getting closer to her – that is, written in order to animate her, to give life to this illusion of a quiet or forever silenced soul.

Here, then, it is the notion of a unique destiny or of a choice that binds this image together (ligaturing it, in mystical vocabulary). So what does this red signify, these reds that are declined like things (that is, natural characters, time)? – the delicious idea of an accident with a thorn is lurking in all this, or the idea of a blushing "don't explain," the idea of an amorous touch. To whom will I finally dedicate the memory that's fabricated in this image; or – as it's still less than a memory – to whom will I dedicate the image itself, which is at one and the same time an access to the memory but also its annulment? The secret it keeps cannot be awoken without being killed off or suffocated in all those folds.

This evening, looking at this image barely illuminated by a ray of the setting sun, between the gold of the brocade background and the red of the dress (scarcely touching the folds as if the painter, wanting to suggest their relief, had only succeeded in using up all his material on the emerging folds), this evening, for the first time, the idea comes to me that this young girl with lowered eyes, the *rosa mystica* of the litanies of the Virgin, is in fact illuminated by a play of gold and purple, that the flesh of her hands and face is a product of those two colors, the insignia of majesty; and beneath the sparks of her fiery hair a light crimson tint alights upon her cheeks, flowing to her temples, pressing her eyes under what could be the skin of any young girl at all. Today, beyond this red dress (worn throughout the Middle Ages by marriageable young girls), by the light of a setting

sun whose glow tries to revive the intimate memory that this image commemorates, for the first time I see her naked skin, the chubby body and its slightly plump knees, the little dimples in her elbows, and the childish bracelet made on her wrist by the flesh that her muscles haven't yet dispersed or flattened out.

Here, then, another time is commenting upon this image, an age where these mysterious flowers still subsist – a crown of carnations, pink eglantines, and daisies, stuck there like pegs to attach the dress to the field. Is it my nostalgia for some complete innocence that has for so long been commenting upon this image or upon the belated recognition of a trifling message of love sent blindly by this child who's holding three heavily bloodied flowers in a garden where the daylight is fading, as if she were spelling something out or pointing a finger toward the wounds of the crucifixion?

This young girl and her image, or this disguised portrait of someone who inspired a first love, are the signs, or the very life, of what delights, what regrets, pain, torture, or dreams? Of how many joys and silent emotions has this little image been the guardian or the distant mistress for the whole of my childhood life, and afterward as a man, right up until I rediscover it now and, with its silent ministry, it begins to take the measure of some part of what had disappeared along with it between the pages of a book? A ray of light touches this image and reveals that this figure of a child wasn't in fact illuminated by the dawn, as I believed when I was younger, but that it had already been exposed to the setting of the sun at that moment when it simply adds the perfume of cut flowers or the kind of freshness that lingers on from dawn and its secure paradise. It's as if the painting had been badly done and couldn't dry, for example; as if the portrait remained a rebus, and then some sort of nocturnal artist comes along to apply the final touches – a whole jumble of the most trivial things, little objects thrown in at random, and they will constitute the decor, forge the portrait's landscape, and will suddenly make you realize that the face, the grace of the limbs, the fold of the eyes, or the frizz of the hair on the temples are all qualities of the light reflected in the artificial gold-brocade sky, in the balustrade with its full arches whose white stone has gone brown or partly pink as if through long exposure to the sun. And I notice these flat stones, emerging miraculously from the background of the material, halting the hillocks of short grass at the point where two little marguerites are placed at the edge of the red dress of this Rhenish virgin. I understand this glinting metallic brocade, the now pink stones on the little wall (as if they were blushing in the presence of the seated young girl, or were absorbing a bit of color from her dress), the gentle undulation of the discreetly flowered garden, evoking an allegorical possibility in miniature. And I recognize that all this is the soundless

garden of the Virgin; she is seated in the light of a shrine where the long pleats in the rockery of her dress and the undulating flow of her reddening hair bring to her face the idea of failing daylight, of a final dusk (and not of a dawn, even if her pink finger spells out a bouquet of carmine eglantines). And I discover the line of her thick knees beneath the fabric, her high stomach, her tiny breasts, and finally a face that's whiter, made of wax tinted with pink, and that bends, with almost closed eyes, so that the light emphasizes the one or two fleshy bulges beneath the skin at the base of her neck and at the height of her cheekbones and gently bathes her half-closed eyes. And this crack opens again, linking this Rhenish face, this Catholic revery, to another profile with the same nose, the same petaled lips, half-open in a sigh, and the same lowered head: the profile of a young woman in one of Utamaro's autumnal landscapes. And this light bulge of flesh that delineates her hand, for example, with its bent index finger like a young child's cuffs, circling her graceful wrist with a childhood bracelet, and sending wafting into the air a scent of milk, a scent of cut roses, and this red dress, all of them afloat in the very same light.

As if by some sleight of hand, or magic-trick, this portrait authorizes the filigreed arrival of an image, unsure in its outline: the changing image of the young girl who gave me a photograph of this very painting at the end of our shared childhood. As if this uncertain filigree – this more real but still hesitant image – actually resembled all the interpretations that I could ever give of this medieval face. The wide, red dress with its capricious folds that make figures, paths, and mountain crests, going around the knees in two hills, snaking and zigzagging, and land up dumping onto the ground a little man without a head, lying with his arms spread; a mirage, a hallucination caused by the picture-hanging where you see Christ come down from the cross, as well as the young Virgin chosen in the midst of her dreams of a childhood love. Her dress is arranged according to the heraldic rule demanding that the figures occupy the whole space, and it winds in the same capricious way as the folds of the pelmets float around a crest in fantasies of metal and silk (making this drapery of gules and argent shimmer behind her). This dress, the scenery, and the portrait's light, made up in reality of a thousand complementary details, become nothing more than that moment of summer when I hear the insects buzzing above the heath and the cackle of the poultry yard, when I abandon my scrapbook (my work for the holidays) and run to meet my friend, who'll give me as a memento of her, at the end of that summer, this image of a young girl seated in a garden – as if the unique power of this image would lead me in my turn to meditate upon the lost resemblances of memory within a painted paradise.

As if this girlfriend from long ago were still holding my hand in a little sunny lane, at the end of which everything disappears because the picture has remained unfinished, the painting undone, the sheet of paper too small to contain any scene but this.

If, as I must in front of the image of this young virgin by an anonymous Rhenish painter (one who has preferred anonymity and so named me as heir to his devotion), if I must still be dazzled by a Virgin by Patinir, because of the rocks in the miniature landscape, or succumb to the mortal charm of pietàs by Memling or van der Weyden, succumb to a morbid delight in characters who are so poignant because they're feeble and emaciated, marked by some kind of fasting or some perpetual Lent to which they submit as punishment or penitence, and the strain of the heavy loads on their backs; so, then, the sublime sadness eternally painted on their faces, the fine skin of their thin fingers resulting from the rigors of fasting (which would mean that the painter chose his models from among the communities of penitents, or from among the dying covered in the crushed rags of the hospice); all this turns into a sign, magnificently transfigured by the colors, the tears, the glinting materials of what was supposed to have been the salvation and the ransom of humanity and which, in this poem of mystical truth, is already nothing more than the overblown poetry of a religion whose painting alone could have guaranteed worship and ensured the efficacy of prayer (because it gave people faces, inimitable gestures, and finally managed to endow those ancient actors with power over our future memories). So, in those faces of the Virgin, Saint John, the holy women and the dead Christ, I would see the miracle of an ideal transposition whereby the men and women who once lived in Flanders, on the Rhine, had become pure musical expressions, through a work of ascesis, through the painter's fidelity to something other than their real faces.

But still, this little image gives me the greatest delight (as I contemplate it, trying to decipher something mysterious in this simple figure, trying to guess the reasons for my friend's departure). This gold-brocade sky – since gold has become the symbolic and totally unreal color of the heavens, this is a woven veil that I'd like to have seen torn apart to reveal the real blue and changing sky (an eternal version of which gold conventionally represents). The garden with its gentle undulations of short grass, curiously brown instead of green, punctuated by two tiny daisies and closed off by a balustrade with full arches like blank windows. Gradually I understand that this symbolic garden is an image of paradise. But at the same time I see that this paradise is like a desert where the sky has been replaced by heaven. I see that it's locked up by the impossibility of imagining any other world, any other movement or history; and I see that the

character in this golden light cannot distract the Virgin from her dream of the divine child (who is perhaps prefigured in a flowering branch that, beneath the girl's fingers, begins to look like the first strands of a crown of thorns).

Or perhaps it's because of the words with which my girlfriend accompanied her gift: "Look, I'd like you to look after this picture for me." I didn't understand straightaway that this was the omen of her departure. The time it would take me to understand that, to grasp it and get the imperfect consolation that I found in it, would be extraordinarily long – just as long and as difficult as it would be to understand this sort of concentration of light that would finally make me see the past without the disguise of the painting, see it in its proper light: in the light that would finally illuminate this desert where the virgin is seated, dressed all in red, her eyes half closed; the light that would illuminate this desert with the light of a real day.

Unpredictably, the red garnet of the dress, the carmine of the roses, the flush of her cheeks radiate across her body (it's as if the sun were about to set, just lingering upon this little seated girl draped in the red of innocence, in a primarily allegorical color – but it's also necessary to see that her figure is the effect of this whole arrangement of pinks and intense or degraded reds, in the same way as these feelings now become attached to her solitary image), so that the colors give her a kind of halo and spill across her contours: that's because she's their source or the place for their outpouring, their source or their occasion.

Because, without a doubt, this image constitutes the mysterious or undeciphered allegory of a moment in my life. For a bolt has been thrown like a finger placed across the lips, and now it perfectly signals the fact that this figure is totally exempt from representing life. And without a doubt she's there, suspended in an imaginary paradise, like a silent supplication to time, that empty space, pushed away, and composed by way of very simple devices that ought to be able to prevent me from seeing beneath these outlines the portrait of a young girl after her bath, hair sleek with a heavy balm, body energetically soaped, rubbed with a rough towel, then wrapped in the full warmth of this heavy dress in order to make her figure seem innocent but disposing the signs that could just as easily confirm the arrival of her womanhood.

Red is what *returns,* and it brings back or rediscovers this image for me because, unlike a portrait, it can dissimulate a confusion of feeling. Isn't that the kind of red-event that's commemorated in this image? Is it because the bloody blot of which Aristotle speaks, and its reflected halo, are not in the mirror? The red thing appears on the surface of the mirror without actually constituting an image. Red has

to be something akin to an affect, its constant effect – that is, its renewable occasion. So that's what it holds back by putting it on the surface.

And yet, is it me that the folds of the red dress dissimulate, like a tiny parishioner, a worshipper, hands joined, kneeling, lost in the folds of material which hide him even from my very own eyes?

NOTES

INTRODUCTION

1. See Barthes, *Roland Barthes par lui-même* (Paris: Seuil, 1975), 106.
2. For a discussion of Schefer's work on cinema, see Tom Conley, "Reading Ordinary Viewing," *Diacritics* 15 (Spring 1985): 4–14; and Paul Smith, "The Unknown Center of Ourselves," *Enclitic* 12 (1982): 32–8, and "Interview with Jean Louis Schefer," ibid., 39–43.
3. Timothy. Corrigan and Dalia Judovitz, "The Figure in the Writing," *SubStance* 39 (1983): 32. This is one of the few commentaries in English on Schefer's writing.
4. *Phenomenology of Perception* (London: Routledge, 1962), 455.

1. SPILT COLOR/BLUR

Only in this essay are notes included in Schefer's original texts; here these are marked [JLS]. All other notes and all references to English translations are supplied by the translator.

1. See Roland Barthes, *Elements of Semiology,* trans. A. Lavers and C. Smith (New York: Noonday, 1992 [1964]), 45–7.
2. A complex operation, built upon the rehabilitation of Aristotle in Averroism, a rewriting of Plato, etc., and *stricto sensu* there are no practices, but rather indexed techniques across several major systems. [JLS]
3. This and following references in parentheses are to Leonardo da Vinci, *The Notebooks of Leonardo da Vinci,* vol. 2, trans. Edward MacCurdy (New York: Reynal & Hitchcock, 1938).
4. See Philippe Sollers, "La Lecture de Poussin," *Tel Quel* 5 (Spring 1961): 22–39.
5. Sometimes *one,* sometimes *variable:* also formulated by the academy in terms of "value." [JLS]
6. For an account of the relation S_1/S_x see the translator's introduction to this chapter.
7. "Note" (1970a), 50–1.
8. Death as a signifier is definitely an object of foreclosure. Delay, *Verschiebung, Verwerfung,* the reference of death to an unassignable time permitting the man to play dead, *simulacro adsistere,* to be the real counterpart of his symbol at the funeral. This dead time, interpolated into the real, and "devoted" to the recuperation of its signifier with which

it has always exchanged places, is called representation. This is also a pressure within all symbolic economies. The fact that such a pressure has helped constitute all symbolic economy is precisely the point of my enquiry here. [JLS]

9. In more detail we would see that this function is secondary only because perspective demands a conception of perception as pure construction: "Perspective is a rational demonstration whereby experience confirms how all things transmit their images to the eye by pyramidal lines" (2:369); "The air is full of an infinite number of images of the things which are distributed through it, and all of these are represented in all, all in one, and all in each" (2:364). But this already engages Leonardo's paraphrase of Lucretius.

Leonardo: "An instance of how the images of all things are spread through the air may be seen in a number of mirrors placed in a circle, and they will then reflect each other for an infinite number of times, for as the image of one reaches another it rebounds back to its source, and then becoming less rebounds yet again to the object, and then returns, and so continues for an infinite number of times" (2:364).

Lucretius: "Next, that which is the right side of our frame appears in a mirror on the left, for this reason, that when the approaching image hits on the flat of the mirror, it is not turned round unaltered, but is thrust out straight backward, just as if someone should dash upon a pillar or beam some mask of plaster before it were dry, and if it should at once keep its shape undistorted in front and mold a copy of itself dashed backward: it will happen that what was formerly the right eye now becomes the left, and that the left becomes right in exchange." *De Rerum Natura* (Cambridge: Heinemann, 1975), 299–300. [JLS]

10. As if white were the base and the "social contract" for all colors that lose their autonomy in order to achieve, by means of *what they have lost,* an intensification of their effect. The white/black opposition has colonized the West since Aristotle's definition of space by arithmetical difference.

Engels: "Light and darkness are certainly the most conspicuous and definite opposites in nature; they have always served as a rhetorical phrase, from the time of the fourth Gospel to the *lumières* of religion and philosophy in the eighteenth century. . . . Clark Maxwell (*Theory of Heat,* p. 14): 'These rays [of radiant heat] have all the physical properties of rays of light and are capable of reflection, etc. . . . some of the heat-rays are identical with the rays of light, while other kinds of heat-rays make no impression on our eyes.'

Hence there exist *dark* light-rays, and the famous opposition between light and darkness disappears from natural science in its absolute form. Incidentally, the deepest darkness and the brightest, most glaring, light have the same effect of *dazzling* our eyes, and so *for us* also they are identical." *Dialectic of Nature* (New York: International Publishers, 1940), 210. [JLS]

11. The proper object of this history is itself insofar as it is capable of representing, in its classification, a *given:* this Lévi-Strauss theoretically refuses to accept, but the ideology given off by the representational appa-

ratus is capable – in these empirical schemas – of *producing* only the thing already given. [JLS]

12. See Erwin Panofsky, *Studies in Iconology* (New York: Harper & Row, 1962), 3–31.

13. *Skèné* in its Vitruvian ambiguity, both scene and theater; and in its etymology. *Skèné,* a hut made of planks, the covered wagon, the tent where actors played, before being "stage," as distinct from "theater." The *skenorraphos* sewed together the pieces of canvas that cover the theater, the circus's top. [JLS]

14. Mallarmé, *Oeuvres complètes* (Paris: Pléiade, 1965), 311–12.

15. The usual English translation of this phrase does not use the word *figurability,* but rather *representation.* This translation does not square with Schefer's distinction, so I have kept the French translation upon which his following remarks are based.

16. This and following quotations are from Freud, *Interpretation of Dreams* (London: Allen & Unwin, 1967), 339–42.

17. This introduction (*einverschieben*) is already produced *within* the *Verschiebung* as an insertion, an interpolation, as its interior gloss. [JLS]

18. *On Architecture,* book 1, chap. 2 (London: Heinemann, 1931), 25–7.

19. *Item* scenography: "finally," according to the delays of the hearing, of the reckonable account; so, in the third place, *item skenographia:* scenography is – *item,* just the same as – "of the same nature" uttered in the two preceding delays: thus harmony. *Item:* by the same principle, assigned in nature by the play of the compass. [JLS]

20. *On Architecture,* book 7, chap. 7 (London: Heinemann, 1934), 113.

21. Except on the feathers of birds, within the nature of flight: "In the case of many birds . . . their most striking colors appear during movement, like the feathers of a peacock or the feathers on a duck's neck": color is always tied to the most characteristic property of the object and so follows the gradient of the grossest analogy. [JLS]

22. Aristotle, *Poetics,* book 4 (Cambridge: Heinemann, 1973), 15

23. Giorgio Vasari, *Lives of Seventy Painters, Sculptors, and Architects* (New York: Scribner, 1913), 177.

24. Ibid., 191.

25. Antonin Artaud, *Selected Writings,* ed. S. Sontag, trans. Helen Weaver (New York: Farrar, Strauss and Giroux, 1976), 135–6.

2. ON THE OBJECT OF FIGURATION

1. This part of the project is carried out in Schefer's *Le Déluge, la peste* (1976); see chap. 4, where one section of that book is translated. The *mazzocchio* (see Fig. 2) plays a crucial role in Schefer's bringing of this painting "under the rubric of writing." A note in the standard translation of Vasari's *Lives* describes the *mazzocchio* as follows: "Circlets armed with points or spikes and placed on family escutcheons" and "caps of peculiar forms," or as the "heraldic cap of maintenance" or circlets of wood covered with cloth for the head.

Tom Conley, in his introduction to a complete translation of *Le Déluge, la peste,* cites a contemporary article that traces the genesis of the

mazzocchio to intarsia work used as a training in perspectival construction. But rather than seeing it as a device derived from painterly research on perspective, Schefer installs the *mazzocchio* as a privileged moment in Uccello's figuration of the paradoxical or resistant body. In Uccello's *Flood* it is an object around the neck of two of the fresco's figures, and it acts as a kind of commutational focus, or switching point, between the perspectival structure and the figurational structure while itself "belonging" to neither. In that sense, its function, akin to that of color for "Spilt Color/Blur," is in excess of the determinations and overdeterminations existing between the two structures. Or, as Schefer alternatively puts it, this is Uccello's "introduction of a heterogeneous element into the whole" (1976a, 149). For Schefer this commutational object is the painter's mark: "*mazza:* the painter's tools, his touch; *occhio,* the painter's eye . . ." (ibid., 36).

2. See the remarks in "Spilt Color/Blur" on the distinguishing function of color.

3. This alludes to book 2 of Alberti's *De pictura,* of which Schefer's is the most recent French translation (1992b).

4. The original French is "là où cela jouit d'abord, *je* surviens," an ironic allusion to Freud's well-known formula for the development of the ego from the id – where the id was, there shall the ego emerge – and probably also to Lacan's transmutation of the same phrase. Schefer suggests that the obsession with the inside of the body, and the search for a material explanation of pagan (Augustinian) or unconscious (Freudian) desires, are both symptoms of the divided state of the body in Christian culture.

5. The *nuvola* was a device used to represent clouds in theater and public spectacles in the fifteenth century, and its use in quattrocento painting as a figurative artifice has been remarked by Francastel (*La Réalité figurative* [Paris, 1965]) and elaborated upon by Hubert Damisch (*Théorie du nuage* [Paris: Seuil, 1972], 102ff.) as an important moment in the elaboration of figurative systems. Vasari credits Cecca with the importation of this device into painting.

6. This passage is in implicit disagreement with Lacan's well-known reading of the same picture in *The Four Fundamental Concepts of Psychoanalysis* (New York: Norton, 1981), 85–90. Whereas Lacan sees the anamorphosis as a cipher of the castration complex, Schefer sees it as marking a loss of a different kind – the loss of a *historical* sense of the body.

3. THANATOGRAPHY/SKIAGRAPHY

1. *Arcadian Shepherds* has been the object of many a study and critique, including an important interpretation by Panofsky himself in *Meaning in the Visual Arts* (Garden City, N.Y.: Doubleday, 1955). Some of the many other considerations of the painting are cited in the course of one particularly interesting reading, which shares important assumptions with the present essay and whose sophisticated semiological analysis bears comparison with Schefer's approach – namely, Louis Marin, "Towards a Theory of Reading in the Visual Arts: Poussin's 'The Arca-

dian Shepherds,' " in N. Bryson, ed., *Calligram: Essays in New Art History from France* (Cambridge: Cambridge University Press, 1988), 63–90.

2. T. Corrigan and D. Judovitz, "The Figure in the Writing," *SubStance* 39 (1983): 32.

3. Augustine, *Confessions,* book 10, trans. H. Chadwick (Oxford: Oxford University Press, 1991), 211.

4. THE PLAGUE

1. A complete translation, by Tom Conley, of *Le Déluge, la peste* has recently been published (1994) by the University of Michigan Press.

2. Cf. Antonin Artaud, *Theatre and Its Double,* trans. M. C. Richards (New York: Grove Press, 1958), 26.

3. This and the subsequent quotations are from Augustine, *City of God,* 1:32 (Cambridge, Mass.: Harvard University Press, 1966), 133.

4. Daniel Defoe, *A Journal of the Plague Year* (New York: Jensen Society, 1904 [1722]), 68. Apparently, the French translation of Defoe here quoted by Schefer uses the imperfect tense, as if Defoe's text ran: "and they were saying. . . ."

5. A private comment made to Schefer by Jean Genet.

6. Giovanni Boccaccio, *The Decameron,* trans. M. Musa and P. Bondanella (New York: Norton, 1982), 7–8. Translation slightly changed.

7. Jules Michelet, *Histoire de France,* vol. 6 (Paris: Marpon & Flammarion, 1875), 184.

8. Ibid., 17:289. "Le règne des forçats" is a phrase Michelet uses to describe the activity and behavior (the "devilish hilarity") of the lower-class men pressed into service by the city fathers as body-removers.

9. Ibid., 290.

10. Michelet is describing one of Tintoretto's paintings of the crucifixion, and he relates it to the plague of 1576 (291–2).

11. Translation is from Artaud, *Theatre and Its Double,* 23–4; Schefer deliberately attributes the words to Michelet, from whom Artaud had in fact roughly quoted (Michelet, 282–3).

12. Michelet, 283–4.

13. Ibid.

14. Ibid., 292–3.

15. This is probably a quotation from Stendhal, *The Life of Henri Brulard.*

16. Michelet, 319.

17. Cf. Diderot, "Letter on the Blind," in *Early Philosophical Works,* trans. M. Jourdain (New York: Burt Franklin, 1972), 143.

5. SOMEONE WRITING

1. Origen, *Dialogue with Heraclides* [*Entretien d'Origène avec Héraclide et les évêques ses collègues, sur le père, le fils, et l'âme*], ed. Jean Scherer (Cairo: Publications de la société fouad de papyrologie, 1949), 146–9.

2. Translation taken, with slight changes, from *The Journals of André Gide: 1928–1939,* trans. Justin O'Brien (New York: Knopf, 1949), 348–9.

3. This and subsequent quotations are from Leonardo da Vinci, *Notebooks,* 2:504.

6. ROLAND BARTHES

1. See Roland Barthes, *Camera Lucida: Reflections on Photography,* trans. R. Howard (New York: Noonday, 1981).
2. Walter Benjamin, "Theses on the Philosophy of History," in *Illuminations,* trans. H. Zohn (New York: Schocken, 1969), 257–8.

7. LIGHT AND ITS PREY

1. Jacobus de Voragine, *The Golden Legend,* trans. G. Ryan and H. Ripperger (New York: Longmans, 1941), 708–16.
2. Quotation invented by Schefer.
3. Heraclitus, *Fragments,* trans. T. M. Robinson (Toronto: University of Toronto Press, 1987), 23.
4. Leonardo, *Notebooks,* 2:360.
5. George Berkeley, *Philosophical Works* (London: Dent, 1975), 312.
6. Bernard Berenson, *The Italian Painters of the Renaissance* (London: Phaidon, 1967), 195–6.
7. This page from Proust is in fact from the sketches to *A l'ombre des jeunes filles en fleurs,* and the original French (slightly different from what Schefer here transcribes) is to be found in *A la recherche du temps perdu* (Paris: Pléiade), 2:968–75. The sketch is for the depiction of Elstir, modeled on Gustave Moreau.
8. Ovid, *Metamorphoses,* book 1, trans. A. D. Melville (Oxford: Oxford University Press, 1986), 17–18.
9. Ibid., 228–9 (book 10). The bard here is Orpheus, of course.
10. At the time Schefer wrote this text, *The Mystical Union* hung in the Louvre next to Leonardo's *Mona Lisa;* since then, it has been removed to another room.
11. Edgar Allan Poe, *The Narrative of Arthur Gordon Pym* (New York: Heritage Press, 1930), 247–9.
12. Ibid., 250.
13. Louis Massignon, "Préface aux lettres javanaises de Raden Adjeng Kartini," in *Parole Donnée* (Paris: Julliard, 1962), 397ff.
14. The Delacroix copy referred to is to be found in the museum of art at Lyons.

8. CINEMA

1. Raul Ruiz is a Chilean filmmaker, an exile living in France since 1974. His most notable films are perhaps *Dialogues of Exile* (1974), *The Hypothesis of the Stolen Painting* (1978), *The Three Crowns of the Sailor* (1982), and *City of Pirates* (1983). He has also exhibited a museum installation, *Expulsion of the Moors* (1989), in Europe and the United States. His stage and film productions of *Life Is a Dream* (1986) used Schefer's original translation from Calderòn.
2. See Tom Conley's thoughtful review of *L'Homme ordinaire,* "Reading Ordinary Viewing," in *Diacritics* 15 (Spring 1985): 4–14. Conley discusses particularly the role of freaks and monsters in the cinema.

3. Given the "autobiographical" nature of these texts, I have kept Schefer's gendered pronouns.

4. From "Carl Dreyer," in *Interviews with Film Directors,* ed. A. Sarris (New York: Bobbs-Merrill, 1967), 112–13. Falconetti is the stage actress whom Dreyer cast as the heroine of his *Passion of Joan of Arc* (1928).

5. Bichat was a nineteenth-century medical scientist and author of *Recherches physiologiques sur la vie et la mort;* among other things, the book minutely records the experience of death. Schefer has written an article on Bichat (Schefer 1985c).

6. Edgar Allan Poe, *Eureka: A Prose Poem,* ed. R. Benton (Hartford: Transcendental Books, 1973): " . . . *attraction* and *repulsion.* The former is the body; the latter the soul: the one is material; the other spiritual, principle of the Universe . . . attraction and repulsion are the *sole* properties through which we perceive the Universe" (37).

7. Schefer, 1979b, 7.

8. Schefer, 1975a, 27.

9. *The Diaries of Franz Kafka,* ed. M. Brod (New York: Schocken, 1949), 192–3.

9. ON *LA JETÉE*

1. See Robert Antelme, *L'Espèce humaine* (Paris: Gallimard, 1982) – a book on his experiences in German concentration camps.

2. Kierkegaard, *Unconcluding Unscientific Postscript* (Princeton, N.J.: Princeton University Press, 1944), 81–2, 180.

10. CY TWOMBLY: UNCERTAINTY PRINCIPLE

1. Roland Barthes, "The Wisdom of Art," in *Calligram,* ed. N. Bryson (Cambridge: Cambridge University Press, 1988), 166–80. I have not been able to discover any written work on Twombly by either Millet or Henric.

2. This quotation is perhaps a version of the following: "But as for the adult it is the most impossible thing of all to become a little child, so too for a little child it is the most impossible thing of all to become *as* a child, precisely for the reason that he *is* a child" (Kierkegaard, *Unconcluding Scientific Postscript,* 526).

11. WHAT ARE RED THINGS?

1. Aristotle, *Parva naturalia,* in *On the Soul* (Cambridge, Mass.: Heinemann, 1964), 224–5.

2. Aristotle, *On the Soul,* 107.

3. *Parva naturalia,* in ibid., 228–31 (translation slightly changed).

4. Ibid., 236–7 (translation slightly changed).

5. Ibid., 354–5.

6. Ibid., 356–7.

7. Giovanni Villani, *Istorie fiorentine* (1348); Gilles Corrozet, *Les Antiquités de Paris* (1532). Neither work is in English translation.

8. Schefer is currently (1993) preparing this new book on the profanation of the Host and the Uccello panels.

9. See Joseph de Maistre, "Enlightenment on Sacrifices," in *The Works of Joseph de Maistre,* ed. J. Lively (New York: Macmillan, 1965), 291–8, and Schefer (1993).

SELECTED BIBLIOGRAPHY OF THE WORKS OF JEAN LOUIS SCHEFER

1962 "Visible et thématique chez Watteau." *Communications* 5.

1969 *Scénographie d'un tableau*. Paris: Seuil.

1970a "Note sur les systèmes représentatifs." *Tel Quel* 41:44–71.

1970b "L'Image: Le sens investi." *Communications* 15:210–21.

1970c "Les Couleurs renversées/la buée." *Cahiers du Cinéma* 230:28–42.

1971 "Sur la notion d'économie signifiante." *Littérature* 3.

1975a *L'Invention du corps chrétien*. Paris: Galilée.

1975b "Sur le système hiéroglyphique." *Digraphe* 4:17–71.

1976a *Le Déluge, la peste, Paolo Uccello*. Paris: Galilée.

1976b "La Mort, le corps, rien" (on Maurice Blanchot). *Cahiers du Chemin* 28.

1976c "Entretien à propos d'Uccello." *Macula* 2.

1977 "Matière historique, matière juridique: Vico." *Communications* 26.

1978 "Commentaires de photos." *Cahiers du Cinéma*, special film photo issue ("hors série").

1979a *Espèce de chose mélancolie*. Paris: Flammarion.

1979b "Entretien: Questions de figuration." *Cahiers du Cinéma* 296:5–16.

1980a "Entretien." *Opus International* 75:52–4.

1980b *La Lumière, la proie, Le Corrège*. Paris: Albatros.

1980c *L'Homme ordinaire du cinéma*. Paris: Gallimard.

1980d With Raul Ruiz. "L'Image, la mort, la mémoire." Special Issue of *Ça Cinéma* 20.

1980e "Monstresses." *Cahiers du Cinéma,* special film photo issue ("hors série").

1980f "Roland Barthes." *Cahiers du Cinéma* 311.

1983 Editor and "Préface." Vico, *De Constantia jurisprudentis.* Paris: Clima.

1985a "Introduction" and "Commentaire de photos." In *Jean-Philippe Charbonnier.* Catalogue. Saint-Etienne: Maison de la Culture.

1985b *Origine du crime.* Paris: Café-Clima.

1985c "Remarques sur un usage du corps." *L'Ecrit du temps* 8/9:67–83.

1986a "Twombly: Principe d'incertitude." *ArtStudio* 1:12–19.

1986b *8 rue Juiverie.* Paris: Compact. (On photographs by Jacqueline Salmon.)

1987 *Gilles Aillaud.* Paris: Hazan.

1988a *Le Greco ou l'éveil des ressemblances.* Paris: Michel de Maule.

1988b "La Distance ajoutée." In *Jean-Claude Gallotta* (Paris: Dis Voir), 11–33. (On dance.)

1989a "Ouverture: La Maison du Sourd. "*ArtStudio* 14:18–31. (On Goya.)

1989b "Ligne à vif." In *Bernar Venet.* Catalogue. Paris: Galerie Daniel Templon.

1990a "Sur 'La Jetée.' " In *Passages de l'image.* Catalogue. Paris: Musée national d'art moderne, Centre Georges Pompidou; and Barcelona: Fundación Caixa de Pensions.

1990b "Fleurs, femmes, enfants." *La Part de l'Oeil* 6:180–9.

1990c "Quelles sont les choses rouges?" *ArtStudio* 16:18–31.

1990d "Préface" and notes. Rousseau, *Essai sur l'origine des langues.* Paris: Presses Pocket.

1990e "Préface" and notes. Poe, *Eureka.* Paris: Presses Pocket.

1990f "Francis Bacon." *ArtStudio* 17.

1990g "L'Interprétation suspendue." *ArtStudio* 18. (On Dutch painting.)

1991a *Kenzaburo Oē.* Paris: Marval.

1991b "Ce que nous n'avons pas vu, nous le portons sur nous." *ArtStudio* 21.

1991c "De la vie des mutants." *Trafic* 1.

1992a "Sur l'interprétation des figures paléolithiques." *Trafic* 3.

1992b Translator and "Préface." Alberti, *De pictura*. Paris: Macula.

1993 "Préface" and notes. De Maistre, *Eclaircissement sur le sacrifices*. Paris: Presses Pocket.

1994a "Le Sommeil de la surface." In *Andres Serrano: le sommeil de la surface* (Arles: Actes Sud).

1994b "Le Visage et la signature." In *Face à face* (Paris: Editions du Centre Pompidou).

In 1995 Schefer will publish three books: on Dutch painting; a critique of art historians; and on medieval legends of the Host.

INDEX OF NAMES

DATE DUE

OhioLINK		
JUL 0 3 2002		